P H I L A D E L P H I A
MURALS
and the stories they tell

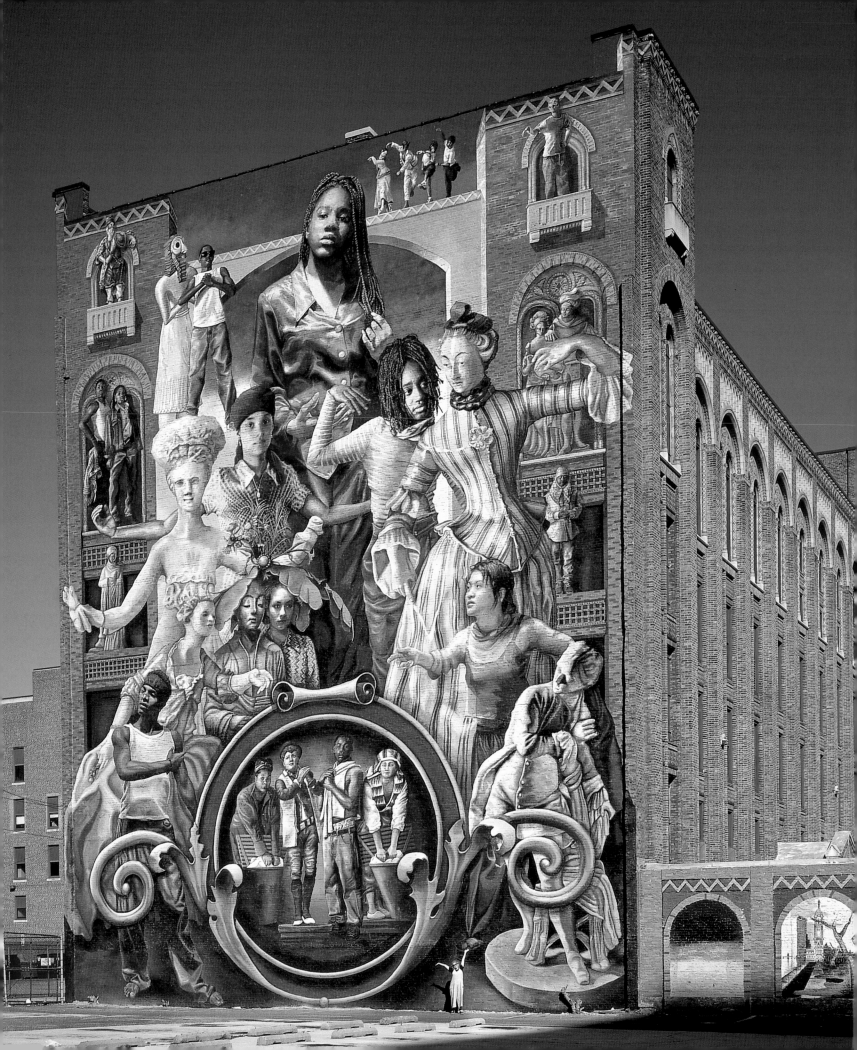

PHILADELPHIA
MURALS
and the stories they tell

Thank you for your support.

Jane Golden

Jack Ramsdale

Robin Rice

Monica Yant Kinney

Jane Golden, Robin Rice, and Monica Yant Kinney

with photography by David Graham and Jack Ramsdale

Temple University Press
Philadelphia

Development of this book was made possible by a generous grant from the Peter A. Wiley and Elizabeth Greene Wiley Fund of the Philadelphia Foundation, honoring two people who loved the city of Philadelphia.

Temple University Press, Philadelphia 19122

Copyright © 2002 by Jane Golden, Robin Rice, and Monica Yant Kinney

Photography credits can be found on page 159 of this book.

Published 2002

Printed in Spain

This book is printed on acid-free paper for greater longevity

Library of Congress Cataloging-in-Publication Data

Golden, Jane, 1953–
Philadelphia murals and the stories they tell / written by Jane Golden,
Robin Rice, Monica Yant Kinney; with photography
by David Graham, Jack Ramsdale.
p. cm.
Includes index.
ISBN 1-56639-951-3 (cloth)
1. Street art—Pennsylvania—Philadelphia—20th century. 2. Mural Arts
Program (Philadelphia, Pa.) 3. Community arts projects—Pennsylvania—
Philadelphia. I. Rice, Robin, 1943– II. Kinney, Monica Yant, 1971–
III. Graham, David. IV. Ramsdale, Jack. V. Title.

ND2638.P48 G65 2002 2002026648

751.7'3'0974811—DC21 CIP

contents

Foreword 6
Preface: What Is a Mural's Value? 10
Acknowledgments 13
How Are Murals Made? 14

chapter 1
"Cool Jane" 18
Artist's Profile: Tish Ingersoll 32
Artist's Profile: Ras Malik 46

chapter 2
The Peace Wall 48
Artist's Profile: Paul Santoleri 62

chapter 3
Norris Square: Where Art and Nature Flourish 64
Artist's Profile: Ana Uribe 76

chapter 4
The Mural Arts Program Comes of Age 78
Artist's Profile: David Guinn 84
Artist's Profile: Parris Craig Stancell 94

chapter 5
A Shift in Consciousness, South Philly Style 96
Artist's Profile: Sarah McEneaney 112

chapter 6
Meg Saligman Thinks Big 114
Artist's Profile: David McShane 128

chapter 7
A Wall of Neighborhood Heroes 130
Artist's Profile: Qimin Liu 136
Artist's Profile: Cliff Eubanks Jr. 150

Mural Map 152
Index 154
Photography Credits 159

everal years ago, I had the opportunity to ride with Jane Golden as she drove through Philadelphia's north side neighborhoods. Jane showed me many of the murals whose creation she and Dietrich Adonis had helped to oversee as part of the Philadelphia Anti-Graffiti Network.

The murals were fascinating, each in its own right reflecting the particular interests of its immediate neighborhood. But what really struck me was the reception Jane received when local residents spotted her car. The vociferous recognition, the brief conversations at the car window, the delight with which people greeted her and spoke about their murals to me, showed beyond a shadow of a doubt that these murals were painted with, not just for, their audiences.

This attention from local residents was something special. Too often, even neighborhood murals are created with only perfunctory acknowledgment of local desires. This, coupled with the presence of many murals throughout U.S. cities and the ubiquity of mural-painting projects in schools nationwide, means that murals are often taken for granted by their local audience. They are not as special as they used to be, but in Philadelphia the images retain pride of place in their neighborhoods. Clearly, they are important to their audience, and that is because of the quality of the Mural Arts Program (MAP), which exemplifies some of the very best achievements of the national community murals movement.

Now, with this book, Philadelphia's murals are receiving the attention they have long deserved. Murals of various kinds have, of course, been painted in the city for a long time, but the most spectacular are the two thousand painted since the mid-1980s. Each has a story to tell, and a story behind its creation, as you will see from the following chapters, which were written by authors who know the city and its residents and who also know the relation of those residents to the murals with which they live and work.

To appreciate the significance of Philadelphia's community murals, it helps to know something of MAP's place in the national mural arts movement, which began in the 1960s as a function of the mass political activism of the time. In the early days, many mural images portrayed urban problems such as drugs, absentee landlords, and racial tensions. Following the lead of Chicago's muralists, whose work received national publicity at the end of the 1960s, cities across the country saw the potential of the powerful public images that gave the mural movement its initial character and began painting along similar lines in their own neighborhoods.

While the obvious results of the early mural movement are the monumental public images painted in poor neighborhoods, union halls, churches, and schools—the murals we see while we are riding by on buses or city transit lines—its most significant contribution to our lives was its devotion to a democratic creative process. Being an active, respected part of a mural project provided an opportunity for thousands upon thousands of "just plain folks," perhaps for the only time in their lives, to express themselves and have a say in what they wanted to see every day in their neighborhoods. The greatest strength of Philadelphia's mural program resides in its respect for this model of community art.

In the 1960s and 1970s, mural artists developed a model, community-based process for creating community murals. Prior to that innovation, murals were public art but not community art. Projects were painted for viewing audiences and placed inside public or government buildings. The community mural movement brought both the art and the process outside, onto the streets, and developed a new kind of public art. Although community murals were painted in Philadelphia in the early 1970s under the Philadelphia Museum of Art's community outreach program, the city's major engagement with murals did not come until the mid-1980s, after model mural-painting organizations had been established in other cities.

For murals in general, the 1980s was a decade of institutionalization, when mural projects were incorporated into larger social organizations that could provide administrative, fund-raising, and material help. This efficiency was a mixed blessing: Although it provided needed support, it removed mural painting from its grassroots origins. The best programs, however, retained community involvement as an important component of their work, something more than just soliciting residents' approval of designs worked out beforehand.

Into this national context Jane Golden entered via Philadelphia's Anti-Graffiti Network program, soon transforming murals into the most visible part of the local effort to combat tagging, while never losing sight of the importance of local grassroots involvement.

The national program most similar to MAP is the Social and Public Art Resource Center of Los Angeles, directed by Judith Baca. Baca gave Golden her start in painting public murals, and the two women share many of the skills and attitudes that make their respective programs exemplary models for other cities struggling with poverty, disenfranchised populations, and, in short, typical urban difficulties. Both women are talented artists in their own right who are also committed to using their artistic and organizational skills for the general public welfare, not personal aggrandizement. And they are excellent administrators.

The most important element contributed by the national mural movement to Philadelphia's program is the commitment to a participatory and respectful creative process. It is a gesture of respect to a neighborhood to paint a mural there at all, but the Mural Arts Program (like the Anti-Graffiti Network before it) goes beyond this and bases its designs on community wishes. It does not impose its images. MAP has this in common with other successful mural programs, but also has more respect for local residents' personal desires than most. In seemingly endless community meetings, MAP demonstrates respect for people who are largely excluded from government and traditional vehicles of public expression such as the mass media. Nevertheless, these people know what they believe and have strong opinions about what should (and should not) be represented on the walls of their communities. MAP's greatest strength is in knowing how to listen at sometimes raucous community meetings, derive unifying kernels from often vaguely stated wishes, and turn them into positive visual images worthy of wall-scale public expression.

Philadelphia's murals express community, but they also help create it—all over town. While the murals can be objectively described in terms of their subject matter, color, style, and size, the impact they have on a community's interpersonal and social relationships can only be captured anecdotally. The really important aspects cannot be quantified. Philadelphia's murals have helped create communities in spirit, not just location, as I witnessed on my trip with Jane Golden several years ago. After viewing a mural of Mt. Kilimanjaro in North Philadelphia, I was perplexed about its relevance to the neighborhood. A local woman

explained, "Without that mural, we wouldn't *be* a community." She was referring to the dynamic that ensued once the mural was complete and neighborhood youth began helping their elders keep the area in front of the mural clean. The shared need brought diverse members of the neighborhood together and created a community. Besides, residents wanted to see something other than artistic representations of their neighborhood problems. Sometimes designing and producing a local mural begins a process of social connection and political activism that previously did not exist.

In Philadelphia, Jane Golden has created a superb mural-painting organization, the most prolific in the nation. One result is the city's network of community murals that are acrylic mirrors of the city's diversity, demonstrated by the range of mural locations in the city and by the variety of themes presented in the murals. There are realistic and imaginary landscapes and portraits of locally famous citizens, some of whom are also nationally or internationally known. Another result of MAP's reach is its impressively organized network of supporters throughout the region, which is more extensive and, probably, more active than similar public visual art support systems in other cities.

At the turn of the twenty-first century, some mural programs shifted toward corporate expression, not only relying on corporate funding but also working to express what the corporations want seen in urban public visual arts. Other mural programs shifted toward working with young students and with teens even more than in the past, when funding was almost always tied to "at-risk youth." Several programs have folded, having run out of funds or energy or both. And yet other mural programs, including MAP, have expanded their reach and purpose. MAP works in a growing range of media, such as mosaic (which can be worked on indoors during the winter), portable murals, and civic sculptures. In addition, MAP participates in exchanges with muralists from other countries. Recognizing that murals are part of an inexhaustible public creative process, MAP has become the preeminent civic mural program in the United States. Its murals provide inspiration, hope, and vision. They show alternatives to the often difficult daily round of urban life, especially in poor parts of town. The process of creating and producing a mural suggests how to build those alternatives.

Philadelphia is fortunate to have its murals so closely tuned to its communities. This book introduces their rich stories.

Timothy W. Drescher
Berkeley, California

Drescher has documented community murals since 1972. He is the author of *San Francisco Bay Area Murals: Communities Create Their Own Muses, 1904–1997,* co-editor of *Community Murals Magazine* (1976–1987), and editor of *Mural Manual: How to Paint Murals for Classroom, Community Center, and Street Corner.*

hen I started painting murals twenty-five years ago, I must have had an instinctive sense of the unique adventure that awaited me. It wasn't just the opportunity to paint big that was so attractive. It was the opportunity to paint outside and to have my art become part of the community. For if there's one thing you can be sure of when you paint a mural, it's that it will be a public process.

From the moment work begins on a wall, people gather, stop, and watch. Many work up enough courage to ask not only questions such as: "What are you painting?" "Where did you get that idea?" "How much does it cost?" but also: "Would you like a glass of lemonade?" and, "How can I help?"

As the image begins to take shape, the comments become more defined. A few bolder neighbors will offer their critiques. "A little more blue here, a little more red." "Do you think that hand is too big for the arm?" Others just stop to chat about something the mural has reminded them of.

One Saturday, I was working with a group of students from the University of Pennsylvania in the Mantua section of West Philadelphia, putting the finishing touches on a mural we had created for a community recreation center. Within the span of an hour, at least ten people came by and offered observations on what we were doing. Two women stopped to say they were glad to see a graffiti-covered wall disappear under our colorful abstraction. Three or four young men, hoping to capitalize on the attention the mural was drawing, wanted to know if they could set up shop next us, selling their hand-painted T-shirts. Then a passing older gentleman spent a moment reminiscing about his brief stint as a student at the Pennsylvania Academy of the Fine Arts.

Murals have this kind of personal impact. They engage you, stir questions, make you see things in new ways. I don't know whether it is their intense color, imposing size, or symbolic power, but they seem to be imbued with a mysterious energy that radiates outward, touching everyone who sees them.

Murals work on a symbolic level, providing opportunities for communities to express important concerns, values, and aspirations: their yearning to be free of violence and fear; their hope to create a better world for themselves and their children; their desire to remember those who were overcome or who overcame. The murals' images and themes reflect aspects of ourselves we rarely take the time to articulate but which nevertheless strongly influence our lives. They are our dreams manifest.

This is not to say that murals come easily—far from it. More often, they are the end product of hours of negotiation, a dynamic balance of diverse forces that find temporary resolution in the image that goes up on the wall. When the mural is completed, the artist, community, and funder move on, caught up in their respective lives. But that one moment when they all came together is preserved on the wall, vibrating with the positive force of their collective energy.

On the following pages, you will read the stories behind many of Philadelphia's most prominent murals. You will get to know a little about their history—the people involved in creating them and the unusual journeys that many took on their way to completion. Mostly, I hope these stories will give you a deeper appreciation for what goes into the making of a mural and how much of its life exists beyond the bounds of its two dimensions, in the minds and the hearts of the community members who live with it.

Jane Golden
Philadelphia, Pennsylvania

acknowledgments

Jane Golden would like to thank: My mother and father, Gloria and Sanford Golden, and my brother, Jonathan, for their unflagging faith and support; my husband, Tony Heriza, for understanding my passion about murals and believing in it, too; the Mural Arts staff and advocates, without whom this wonderful enterprise could not exist; and my many mentors, colleagues, and friends in the Philadelphia Mayor's Office, Department of Recreation, and City Council, who have demonstrated, through their ongoing support of the program, their belief that art can transform communities.

Robin Rice would like to thank: Jane, for inspiration on many levels; Monica, for professionalism and collegiality; my husband, David Utz, for his steadfast support; my brother, Jim Rice, and father-in-law, Roy Utz, for their generous encouragement; the muralists who shared their trade secrets and personal journeys; the citizens of Philadelphia who opened their hearts and homes first to MAP and later to the authors of this book; Deidra Lyngard—organizer, editor, and midnight grammarian; and Micah Kleit of Temple University Press, for his belief in the project.

Monica Yant Kinney would like to thank: My husband, David Kinney, for the love and laughter; my parents, Sandy and Larry Yant, for raising a reader and a writer; and my late grandmother, Jane McCombs, who loved art and would have loved Philadelphia murals.

David Graham would like to thank: The photo gods, for putting him in the same city with Jane Golden and the best book designer, Phil Unetic.

Jack Ramsdale would like to thank: Jane Golden and the Mural Arts staff, for the opportunity and pleasure to work with them on this project; Tish Ingersoll, for giving me my start photographing murals; Barry Halkin, for all his support and knowledge of photography; Carl Toth, at Cranbrook Academy of Art, and Sandra Brownlee for instilling in me faith in my art; Deidra Lyngard for her work on this book coordinating all of the authors and keeping us on track. I also want to express gratitude to my parents, Harry and Carrie, for giving me a set of *World Book Encyclopedias*, which was my introduction to photography.

The authors and photographers would like to thank the following foundations for their support of this project: The Horace W. Goldsmith Foundation, the Honickman Foundation, the William Penn Foundation, and the Peter A. Wiley and Elizabeth Greene Wiley Fund of the Philadelphia Foundation.

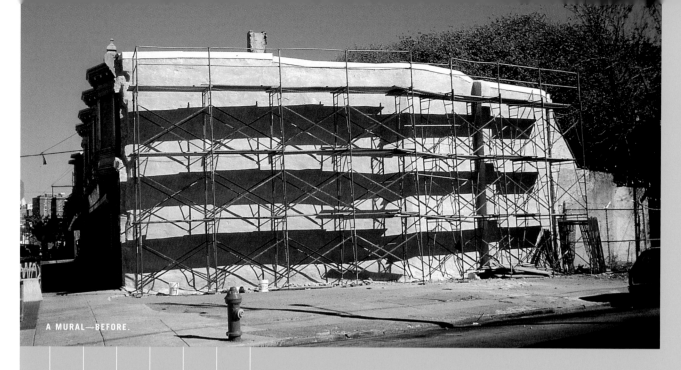

HOW ARE
MURALS MADE?

When you see a finished mural on a wall, you are looking at the result of a long process. There are many steps between the moment a mural is conceived and the day it is dedicated. These steps can vary somewhat, depending on how a mural is funded and where it will be located. Still, most murals go through the same general sequence, described below, which can take from three to six months or more.

The idea for a mural can come from any number of sources, but usually it comes from a community or a "funder." Sometimes the Mural Arts Program will notice a good wall in a neighborhood and seek out funding to put a mural there. Or, a City Council member or other public representative will request a mural in a particular district.

Since most of Philadelphia's murals are sponsored by foundations and corporations, a lot of the early work involves finding a good match between the funder and a community. Most funders do not have geographical preferences for the murals they sponsor, but they may have particular themes or subjects in mind. In this case, the Mural Arts staff tries to find a neighborhood that would like a mural with that theme. Other times, a community might have an idea for a mural, and the staff will try to find an appropriate funder.

There are other considerations that go into making a mural as well, such as ensuring that they are distributed equitably among the communities who want them. Because demand for murals far exceeds the available resources, the program recently initiated a community application process to help facilitate decision making.

STEP ONE
CHOOSING A WALL

The MAP staff visit the community where a mural has been requested to find an appropriate wall or to check out a wall that the community has identified. Murals need to be painted on surfaces that are free of major defects and water damage and that are relatively flat and smooth. And, of course, the wall should be located where passers-by can see it from a distance and in its entirety.

JANE, RIGHT, SCOUTS OUT A MURAL IN OLD CITY WITH MAP STAFFER ARIEL BIERBAUM AND A COMMUNITY REPRESENTATIVE.

Before a mural can proceed, the wall's owner must be contacted for permission. If there is an empty lot next to the wall, the Mural Arts staff will speak to that property owner as well, to determine whether there are any imminent plans to sell or develop it. Sometimes, these trash-filled vacant lots evolve into color-ful community gardens.

STEP TWO
EXPLORING IDEAS

The MAP staff and mural artist meet with members of the community where a mural is planned to discuss possible themes and designs. Sometimes the community or funder has an idea in mind, and this is explored and developed. If no idea has been proposed, MAP staff will bring pictures of other murals or show a selection of artists' portfolios to get the group thinking.

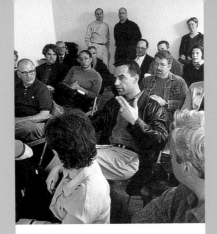

LOCAL RESIDENTS DISCUSS POSSIBLE MURAL THEMES AT A COMMUNITY PLANNING MEETING.

STEP THREE
CREATING THE DESIGN

Once a theme is decided, the artist develops an initial design, which is presented to the group for feedback. If there is no organized group available to speak to, mural staff may go door to door showing residents a proposed design and getting their feedback. The artist then incorporates their input and works up more sketches until a final design is approved. A design may go through multiple versions before consensus is reached.

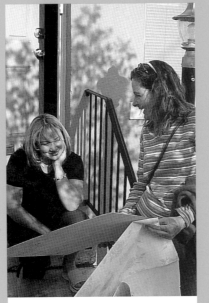

ANA URIBE GETS FEEDBACK FROM NEIGHBORS ON A PROPOSED MURAL DESIGN.

STEP FOUR
PREPARING THE WALL

The Mural Arts crew prepares the wall for painting. This process includes erecting the scaffolding and "buffing" or priming the wall by removing loose paint, filling holes, and applying a waterproof coat to protect the mural from any moisture that might seep through the wall. A clear acrylic coat is applied over the entire mural when it is finished to protect it from the elements.

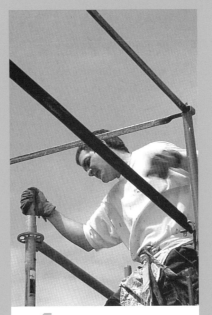

A MEMBER OF THE MURAL ARTS CREW ASSEMBLES SCAFFOLDING.

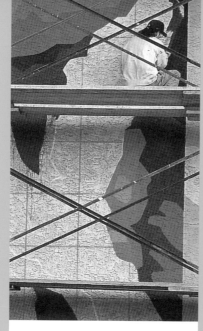

DAVID MCSHANE USES A GRID TO HELP HIM TRANSFER HIS MURAL DESIGN TO THE WALL.

STEP FIVE
TRANSFERRING THE DESIGN TO THE WALL

The most commonly used technique for transferring a design to a wall is the grid method. First, the artist superimposes a series of horizontal and vertical lines over the final sketch, breaking the composition down into a pattern of small squares. A similar pattern of squares is created on the blank wall. Each square on the wall is directly proportional to each one on the sketch; for example, one square inch of the sketch equals one square foot of the mural. The artist then reproduces the contents of each square on the sketch in the corresponding square on the wall until the entire composition has been re-created in larger scale. The process is somewhat like painting by numbers, only on a much larger scale.

STEP SIX
PAINTING THE MURAL

Most mural artists prefer to work directly on the wall, dealing with the unique challenges of each surface as they go along. Sometimes there are chimneys, ledges, or windows to work around. Sometimes there are deformities that need to be compensated for by adjusting the composition or varying the paint coverage.

Because of their particular style or the scale of the mural, artists may choose to paint the mural on synthetic fabric—once parachute cloth, now more commonly a thin, felt-like material similar to that used in fabric softener sheets. Using a slide projector or other transfer method, they re-create the design on fabric panels in their studios. When the panels are finished, they are adhered to the mural wall using acrylic gel.

LARISSA PRESTON SWABS ACRYLIC GEL ON THE BACK OF A MURAL PANEL BEFORE ADHERING IT TO THE WALL.

While this technique offers many advantages in terms of greater control and durability, it is expensive and requires artists to spend more time in their studios, away from the noise and commotion of the street and out of contact with the public. For this reason, most artists still choose to do it the old-fashioned way, trading convenience for the surprises, challenges, and satisfactions that come with exposure to the weather and being a part of the community.

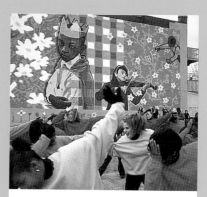

A DANCE BY LOCAL HIGH SCHOOL STUDENTS HIGHLIGHTS A MURAL DEDICATION.

STEP SEVEN
TURNING THE MURAL OVER TO THE COMMUNITY

The last step in the making of a mural is the dedication—the moment when the mural is transferred from the hands of the artist to the hands of the community. These are festive events, often accompanied by music, food, performances, and poetry readings, as well as remarks from the artists, members of the community, city officials, and MAP staff.

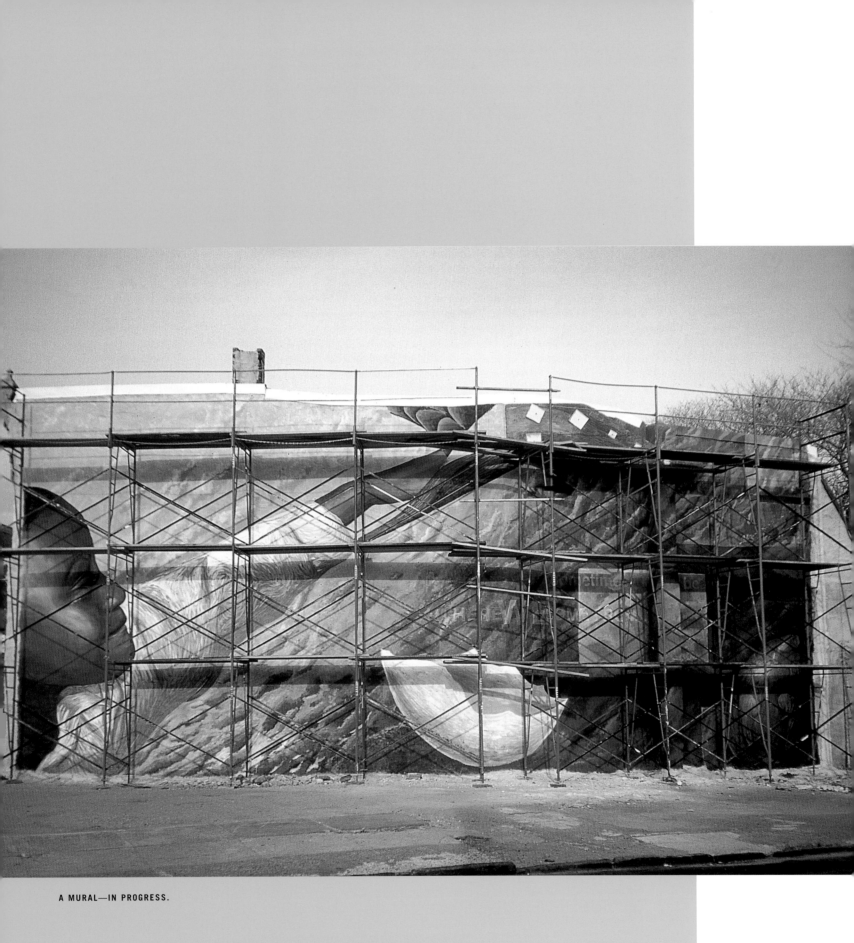

A MURAL—IN PROGRESS.

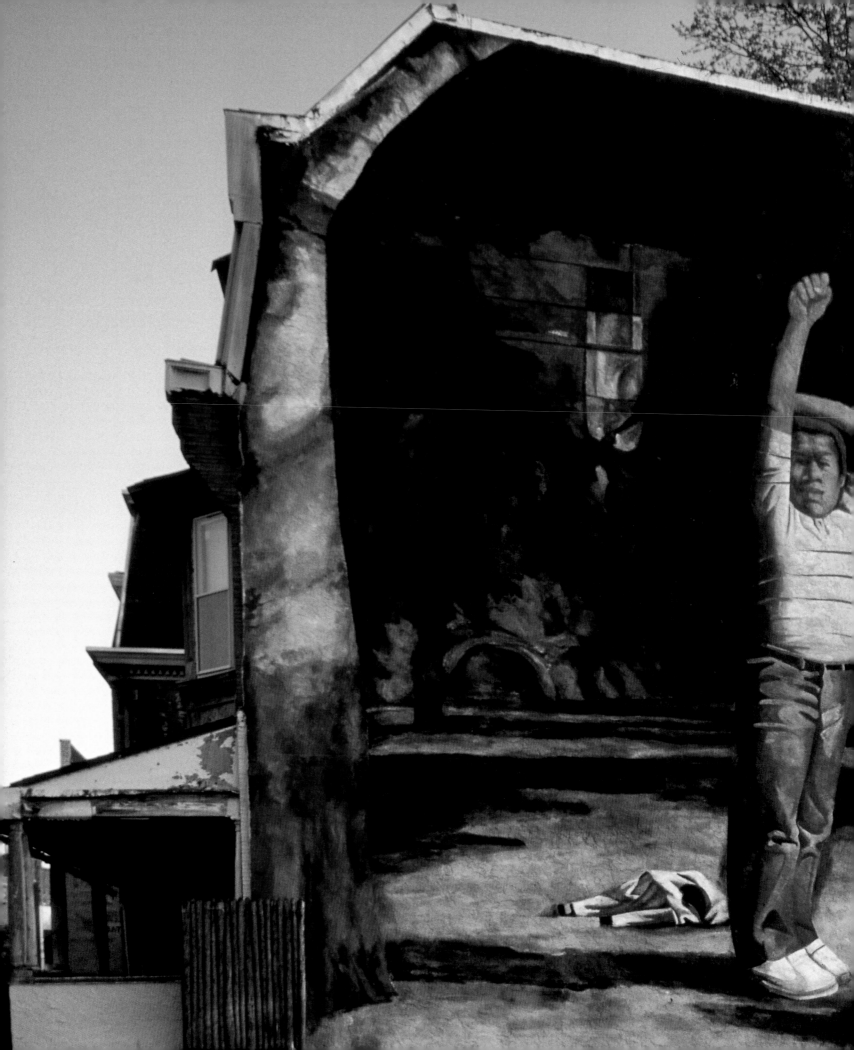

I AM LARGE, I CONTAIN MULTITUDES.

"COOL JANE"

PRECEDING PAGES NATIONALLY
RENOWNED FIGURE PAINTER SIDNEY
GOODMAN LENT ONE OF HIS IMAGES, AS
WELL AS HIS TALENTS, TO THE MAKING
OF *BOY WITH RAISED ARM*, 40TH STREET
AND POWELTON AVENUE. THE MURAL
INSPIRED PASSERSBY FOR TEN YEARS
UNTIL ITS BUILDING WAS RAZED IN 2002
TO MAKE WAY FOR NEW CONSTRUCTION.
MAP IS NEGOTIATING TO RE-CREATE THE
MURAL ON THE NEW BUILDING GOING UP
ON THE SITE.

n June of 1984, Jane Golden, a young muralist from Margate, New Jersey, by way of California, brought her talents to the streets of Philadelphia to head up what was then envisioned as a modest six-week youth program within Mayor Wilson Goode's brand new Philadelphia Anti-Graffiti Network. Back then, those who conceived the program could not have imagined how it would grow, under the unflagging energy and determination of one woman, into one of the most prolific and innovative public art programs in the country.

Today, Jane and the more than two thousand murals painted under her program's direction have become an enduring part of the Philadelphia scenery, adding a new dimension to the city's character and bringing inspiration and hope to some of its ailing neighborhoods.

Murals: Where do they come from, where do they go?

Mural painting has its roots deep in human history. Beginning with the earliest cave paintings, drawing on walls has been a compelling form of public expression, helping us capture and remember important community experiences.

Because of their intrinsic bond to architecture and the relative ease of making them, murals are among the most accessible of all public art forms. As such, they have been used over the years for a multitude of purposes: to convey the official values of government and religion, to give voice to the unempowered, and to commemorate important historic or civic events. They also have filled a purely aesthetic function, serving the public's need for art that simply pleases the eye through color and form.

In the United States of the nineteenth and twentieth centuries, most architectural murals were government commissioned and made by officially sanctioned artists. Today's murals, however, generally derive their authority from another source—the public will. For example, the subject matter for many of Philadelphia's murals arises directly out of dialogues with

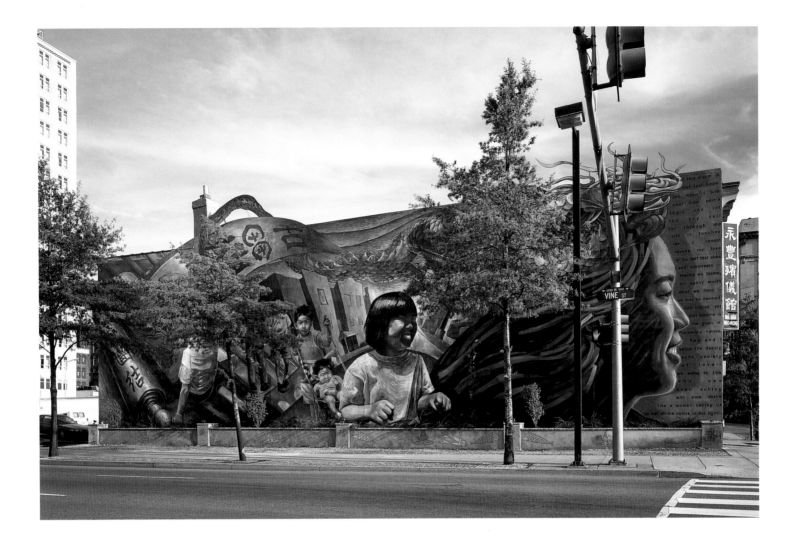

neighborhood residents. The murals' themes and symbols, even their aesthetic, reflect the concerns and character of the communities for which they are created. This grassroots genesis is both a strength and a vulnerability: Contemporary murals achieve an immediacy and relevance untouched by other forms of public art, but they are also more vulnerable to change.

Just as the symbolism of some historic artworks may seem baffling today and their styles overwrought, so too, contemporary urban murals occasionally lose relevance over time. Sometimes the dominant religious or ethnic character of a neighborhood changes. A theme that was meaningful for one group may not have the same significance for new residents. Sometimes a mural's visual style doesn't wear well. Natural selection kicks in. After fifteen to twenty years, a mural will begin to deteriorate and fade away unless there is active interest in preserving it.

MAP does all it can to preserve Philadelphia's best murals (including some painted before the city mural program began), but through lack of money, lack of interest, or the decisions of property owners, a number are lost each year.

THE USE OF ALLEGORY TO COMMUNICATE COMPLEX THEMES IS STILL A POPULAR MURAL DEVICE. IN *COLORS OF LIGHT*, LOCATED AT 12TH AND VINE STREETS IN CHINATOWN, ARTIST JOSH SARANTITIS HAS USED AN ANCIENT SCROLL, A DRAGON, CHILDREN, AND A WOMAN'S FACE LOOKING OUTWARD TO DEPICT THE CONTINUOUS FLOW OF ASIAN HERITAGE FROM THE PAST INTO THE FUTURE.

A legacy of murals

Philadelphia's murals draw on a long legacy, not only in their commemoration of shared events and experiences but also in their specific themes. In particular, popular genres of nineteenth- and twentieth-century public painting live on in contemporary murals.

The most ambitious and esteemed category of nineteenth-century painting was "history painting"—the heroic depiction of uplifting and inspiring narratives. In Europe and the United States, these mural-size paintings were a favorite form of wholesome public entertainment, and the successful ones toured from city to city accompanied by explanatory literature. They inspired sermons and debates, just as many of today's murals do. A good example is Benjamin West's apocalyptic historical allegory, *Death on the Pale Horse* (1817, see below). When it was shown in London and later at the Pennsylvania Academy of the Fine Arts, where it is still a central exhibit, it was viewed by a vast and enthusiastic audience.

A contemporary example of allegorical painting is Josh Sarantitis's *Colors of Light: Gateway to Chinatown* (12th and Vine Streets, 2000, see p. 21), which symbolically depicts new generations carrying Chinese heritage and values into the future. The different parts of the composition are united by a colorful dragon, ruler of heaven and a symbol of power and fortune. The dragon's body weaves in and out of the boundaries of the wall assisted by attached wooden supports that enable the painted image to extend into the air. The mural was dedicated in 2000, the year of the dragon.

MANY CONTEMPORARY MURALS FOCUS ON HEROIC OR HISTORICAL THEMES, SHARING ROOTS WITH SUCH POPULAR NINETEENTH CENTURY ALLEGORICAL PAINTINGS AS *DEATH ON THE PALE HORSE* BY BENJAMIN WEST.

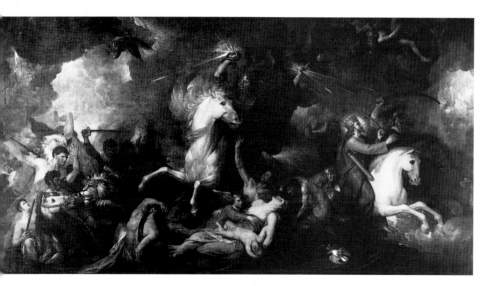

There are also numerous precedents for today's murals that examine and celebrate aspects of community history. In her book, *Public Art in Philadelphia*, Penny Bach notes that during the Great Depression, Robert E. Larter was asked to paint a subject of local Philadelphia history for his 1938 mural, *Iron Plantation Near Southwark, 1800*, commissioned by the Treasury Department Section of Fine Arts for the Southwark Post Office.

A prized local example of the regional landscape genre—an enduring, worldwide mural theme—is *The Dream Garden* (6th and Walnut Streets, see next page). Designed by Philadelphia graphic artist and muralist Maxfield Parrish and executed as a mosaic by Louis Comfort Tiffany in 1916, this idyllic scene still decorates the beautiful lobby of the Curtis Building (former home of the offices of the publisher of the *Saturday Evening Post* and *Ladies Home Journal*). *The Dream Garden* was designed as the centerpiece of a public area that includes a fountain and seating.

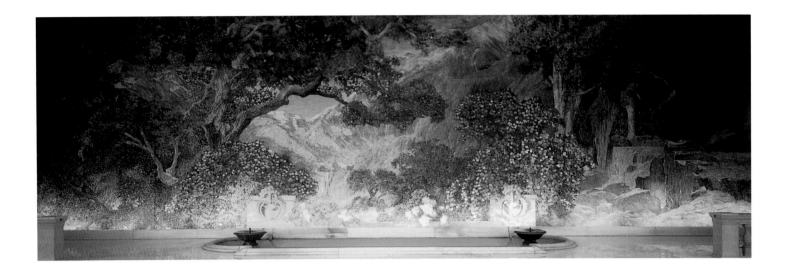

Similarly, outdoor murals often serve as integral components of larger environments. A community garden in the North Kensington section of Philadelphia offers walkways, flowers, and a cool blue vista of mountains and lake as a respite from the surrounding expanse of barren city blocks. Another example of a mural that successfully merges with its environment is Tish Ingersoll's luminous *Tuscan Landscape* (32nd and Spring Garden Streets, 1994, see p. 24), which seems to effortlessly embrace its surroundings, including the homeowner's hammock, in a panorama of golden light, its Italian arcade, and receding hills.

Today, MAP receives frequent requests for murals that depict historical scenes significant to the community. Puerto Rican residents of Norris Square wanted images from the history of Puerto Rico to teach their children about their cultural origins. The mural that was painted there is now known locally as *Raices* (Roots, see p. 70). Another mural in the Strawberry Mansion section of the city entitled *Black American Gothic* (Jane Golden, 21st and York Streets, 1990, see p. 139) recalls the rural southern background of many of that neighborhood's elders as a reminder to the younger residents growing up in an urban environment.

Artist Michael Webb was asked to come up with a theme related to Philadelphia's history for the untitled mural on the Beasley Building in Center City (12th and Walnut Streets, 1997, see p. 25). Determined to avoid what he calls a "cliché about [Benjamin] Franklin and Betsy Ross," Webb created instead an elaborate scene of modern-day workers designing and constructing a building that alludes to the city's past, including a vignette that relates to the casting of Alexander Milne Calder's gigantic statue of William Penn, which tops City Hall.

Following a long artistic tradition, portraits of real people are often incorporated into today's murals, heightening their significance to the community. The majority of these portraits are of local citizens—community leaders, residents, or neighborhood children who are singled out for special tribute or just as models. To create their two murals celebrating

THE DREAM GARDEN, DESIGNED BY MAXFIELD PARRISH AND CRAFTED BY LOUIS COMFORT TIFFANY IN 1916, IS AN HISTORIC EXAMPLE OF HOW MURALS CAN ENLIVEN AND ENRICH THEIR SURROUND-INGS. IT IS LOCATED AT 6TH AND WALNUT STREETS IN THE CURTIS BUILDING.

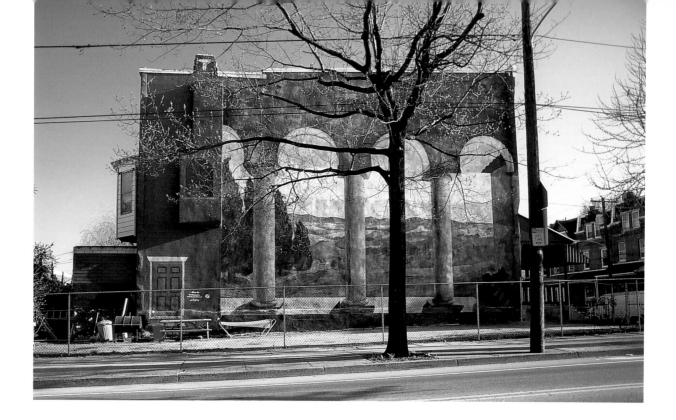

TISH INGERSOLL'S *TUSCAN LANDSCAPE*, AT 32ND AND SPRING GARDEN STREETS, FITS COMFORTABLY INTO ITS URBAN SURROUNDINGS, EMBRACING EVEN THE HOMEOWNER'S HAMMOCK.

the annual *Black Family Reunion* (40th Street and Girard Avenue, 1988; 20th and Watkins Streets, 1993), Jane Golden and Dietrich Adonis borrowed images from residents' family photograph albums. The *Casa di Pazzo* mural in South Philadelphia (12th and Federal Streets, 1999), painted by David Guinn and Barbara Smolen, is based on treasured vintage photographs of people who grew up together in the neighborhood and now belong to the same social club.

Other murals celebrate native sons and daughters who have achieved public fame or made a significant contribution to the community. They include musical entertainers such as *Mario Lanza* (Diane Keller, Broad and Reed Streets, 1997, see p. 102), and Marian Anderson and the Heath Brothers in *People of Point Breeze* (David McShane, 1541 S. 22nd Street, 1998, see p. 26); famous athletes such as *Jackie Robinson* (David McShane, 2803 N. Broad Street, 1997, see p. 129); and *Wilt Chamberlain* (John Lewis, 1234 Vine Street, 2001). Social activists and political figures are also honored, including *Roxanne Jones* (William Freeman, Broad and Clearfield Streets, 1997, repainted by Peter Pagast in 2000), the first black woman to serve in Pennsylvania's state legislature. Jones was a staunch advocate for Philadelphia's disenfranchised. Pagast also painted the portrait of activist entertainer *Paul Robeson* (4502 Chestnut Street, 1999, see p. 35).

Allegories speak to our moral and spiritual aspirations. Beautiful landscapes satisfy our longing for a moment of peace in hectic urban surroundings. Historical scenes remind us of our journeys and why we are what we are today. And portraits, whether formal tributes to eminent individuals or informal likenesses of our neighbors, help to show us who we are, even as we grow and change. In these ways and many others, murals offer us a wide range of perspectives—on the world around us and into ourselves.

Urban problems—urban outreach

Philadelphia's contemporary mural movement began in the 1970s, when artists Don Kaiser and Clarence Wood became coordinators of the Environmental Art Program for the Philadelphia Museum of Art's Urban Outreach Department and began to include community murals among their many activities. Inaugurated by David Katzive and continued under the leadership of Penny Bach, the program received international recognition in 1972 when one of its murals, thought at that time to be the largest ever, appeared on the cover of *Paris Match.* Designed by Washington Color School artist Gene Davis, *Franklin's Footpath* consisted of eighty different colored stripes, each 11 inches wide and 414 feet long. The mural was painted directly on the street, covering a large section of the Benjamin Franklin Parkway in front of the art museum.

By the time the Environmental Art Program ended in 1983, Kaiser and Wood had painted more than one hundred walls in Philadelphia neighborhoods. Their work included jungle waterfalls, various compositions incorporating portraits of local children, and even enlargements of children's dinosaur drawings for a school on Lancaster Avenue.

INCORPORATING ELEMENTS FROM MANY OF THE CITY'S BEST-KNOWN MONUMENTS, THIS UNTITLED MURAL BY MICHAEL WEBB AT 12TH AND WALNUT STREETS CELEBRATES PHILADELPHIA'S ARCHITECTURAL HISTORY USING THE ALLEGORY OF AN IMAGINARY BUILDING UNDER CONSTRUCTION.

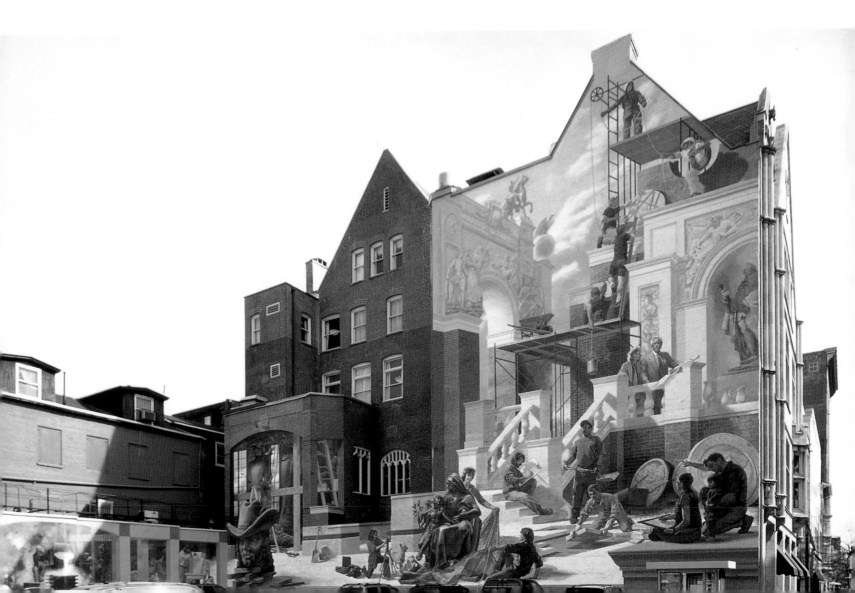

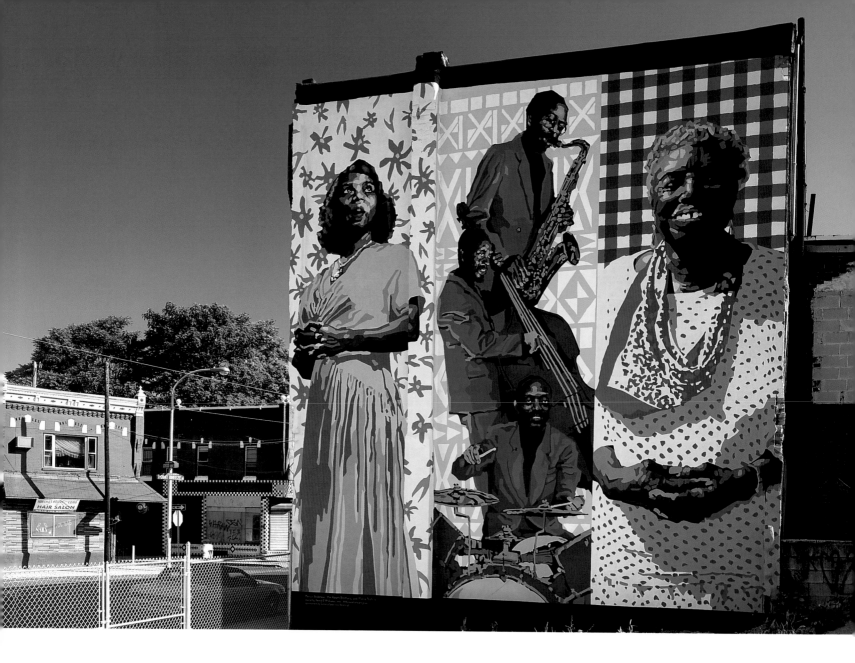

DAVID MCSHANE'S *PEOPLE OF POINT
BREEZE*, 1541 S. 22ND STREET, IS
ONE OF MANY MURALS HONORING
NEIGHBORHOOD STARS, PAST AND
PRESENT. THIS ONE PAYS TRIBUTE
TO MARIAN ANDERSON, THE HEATH
BROTHERS, AND COMMUNITY ACTIVIST
MAMIE NICHOLS.

Together, Kaiser and Wood developed a mural process model that included in-depth community meetings in which local residents were invited to suggest themes and even submit mural designs. The two artists avoided proposing subject matter to the community or steering them toward any particular design. While Wood and Kaiser's community process model was more leisurely and open-ended than that followed by the Mural Arts Program today, its spirit and many of its strategies live on in the commitment to seek the input and approval of communities in which murals are painted.

In the 1950s and 1960s, Philadelphia was a city troubled by gang warfare and graffiti. By the 1970s, gangs were weaker, but a large percentage of the graffiti was still gang related. The fact that murals were rarely attacked by graffiti writers suggested that murals could be part of a solution—not to the gangs themselves but to the plague of wall writing. Wood and Kaiser never saw their mission as combating graffiti, but in the 1980s, Mayor Wilson Goode's Philadelphia Anti-Graffiti Network did.

Combating the lure of graffiti

Goode based his citywide effort on a modest neighborhood program, the Anti-Graffiti Task Force, developed by Tim Spencer, the young director of the Haverford Recreation Center in West Philadelphia. Spencer's friendly style attracted teenagers to the program; among them was Theodore A. Harris, who today describes himself as the former "poster boy" for the task force. Harris was always fascinated by art, especially surrealism and abstract expressionism. He entered the graffiti subculture at age thirteen because kids he knew were doing it.

In those days, wall writers organized competing organizations. "I formed a club with one of my graffiti mentors, MEKA [his tag]. He taught me how to print my name and gave me a 'style,' in other words. My graffiti name was KNIFE. MEKA was the president of the club, and I think I was the vice president." The club was called "EUL I" for "Experience UnLimited I."

"The whole thing with graffiti is to get away with what you're doing and to leave something of beauty," Harris explains. Today the grown-up Harris retains a certain appreciation for the elongated arches of the classic Philadelphia "wicket style" of tagging. But young Harris found that Spencer's task force ultimately offered more than the excitement of graffiti clubs.

"People donated markers, boards, and art supplies, and young folks who were wall writers came together in a nearby church to do work for a traveling exhibition of our graffiti art," Harris recalled. "We had a good time doing that, and Tim came up with the idea of organizing a show at Makler Gallery," then a prestigious commercial gallery in Center City. Although the traveling exhibition never happened, the Philadelphia exhibit attracted a lot of local attention. It included paintings by young people like Harris, as well as work by established New York graffiti artists, including Lady Pink, Dondi, and Futura 2000.

Spencer also organized neighborhood efforts to clean up graffiti. Although murals were not central to the mission of his task force, one of them garnered national attention for the program when a story about it appeared in *USA Today*, with Harris's picture on the front page. "I was always talking to the press," Harris recalled. "I was the person they put out front, saying things like: 'We changed his life, and we can change yours, too.'"

The mayor's solution

Like Spencer, Mayor Goode chose the carrot over the stick. His plan for eradicating graffiti focused on rewarding correct behavior, although the possibility of prosecution was never abandoned. Philadelphia's teenage wall writers received amnesty from prosecution for earlier graffiti crimes in return for signing a promise to give up graffiti. They called it "The Pledge."

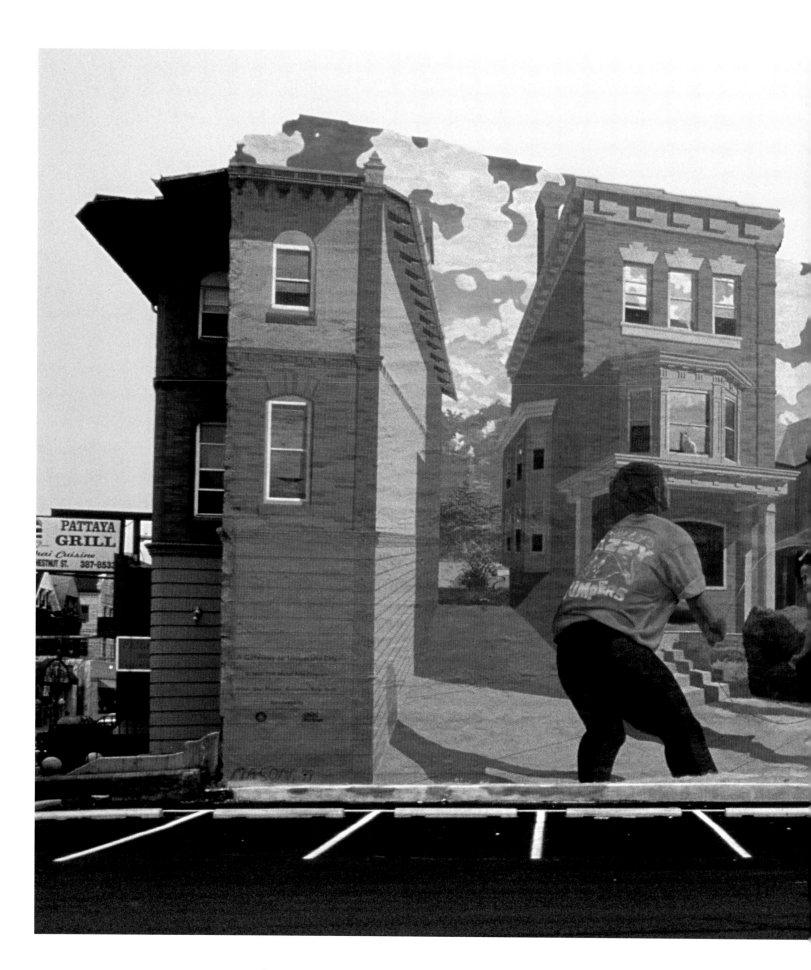

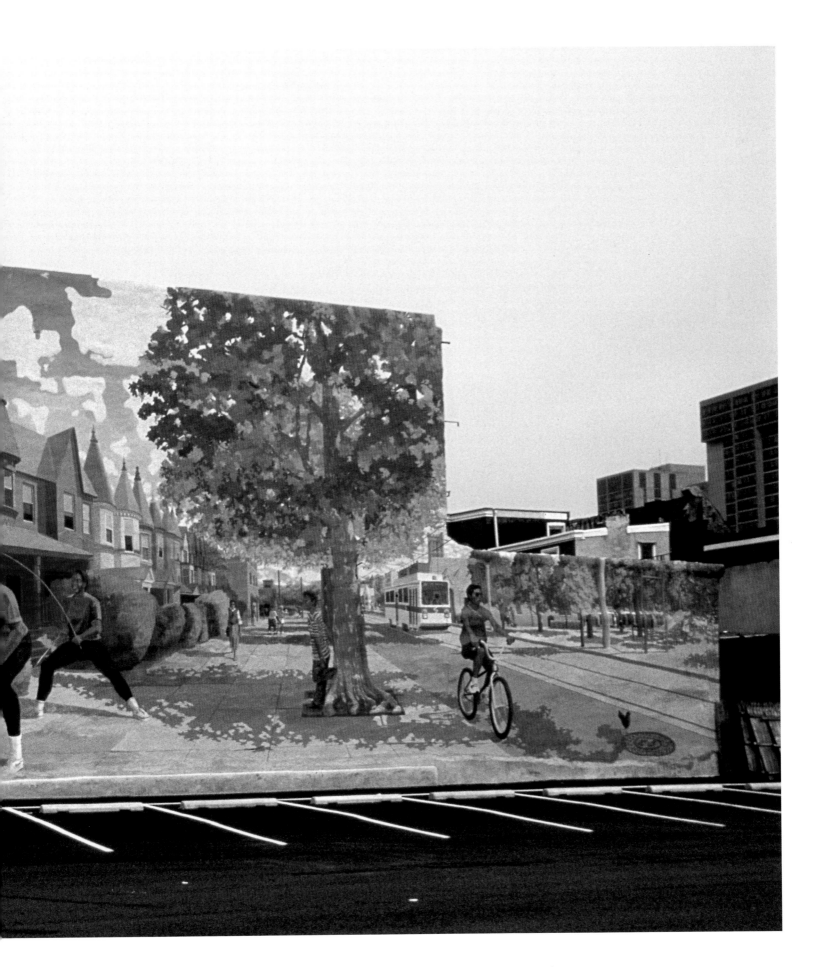

PRECEDING PAGES MAX MASON'S
CLEVER USE OF TROMPE L'OEIL HELPS
TO INTEGRATE REAL AND PAINTED
ARCHITECTURAL ELEMENTS IN THIS
BUSY SCENE DEPICTING *A DAY IN THE
LIFE OF WEST PHILADELPHIA*, 2000,
AT 4008 CHESTNUT STREET.

Goode broadened graffiti-removal efforts and expanded Spencer's program of art work-shops to include potential youth employment. After working at volunteer jobs such as cleaning and preparing walls for repainting, former writers were eligible for paid jobs with the city. Almost as an afterthought, a mural or two were proposed to help celebrate the hoped-for success of the Philadelphia Anti-Graffiti Network, as the new independent citywide program was called. However, in future years, the opportunity to paint murals would become the key to success for many more young people.

See Jane paint!

While graffiti ran rampant in Philadelphia, the person who would become the Anti-Graffiti Network's artistic director was learning her trade in Los Angeles. Born in Minneapolis, Minnesota, Jane Golden grew up in Margate, New Jersey, on the Atlantic Coast. She attended Stanford University where she majored in art and minored in political science. After graduation, she moved to Los Angeles to, in her words, "try to figure out what I could do with a B.A. in art."

Jane had always been enamored of murals. As a child, she studied the work of Diego Rivera, who played a pivotal role in the Mexican mural renaissance of the 1920s and 1930s. She also admired the Works Project Administration and other state-sponsored art programs of the Great Depression. She believed, and continues to believe, that art can be a tool for social transformation. When she learned of grants sponsored by the Citywide Mural Project in Los Angeles, Jane realized what she had to do with her art degree.

"I was always intrigued with murals," she said, "because they are able to break down barriers about where art should and should not be."

Though she had never painted a mural and the deadline had already passed, Jane boldly sent in her application, exaggerating her experience. On her own, she located an available wall in Santa Monica. "I called the Mural Project on a daily basis for months," she laughs. "I drove them crazy until they gave [a grant] to me." In an almost Cubist manner, Jane's first mural, *Ocean Park Pier* (Ocean Park Boulevard and Main Street, Santa Monica, CA, 1976), records a scene from an earlier era of a pier that no longer exists. Even though the work has been documented in at least seven books and the building site has been declared a historic landmark, Jane was more moved by the fact that "people felt that *they* owned the mural. They responded in ways that were very personal. Senior citizens remembered the pier, and the young people who had only heard of it wanted to see what it was like."

With this large project under her belt, Jane then followed through with seven years of commissions and residencies in the Los Angeles area. She painted jungle scenes in children's rooms and murals, including a copy of Botticelli's *Birth of Venus*, on the bottom of swimming pools. The well-known photorealist-muralist Kent Twitchell hired her as an assistant on

one of his large portrait murals. She also organized a nonprofit group of independent muralists who worked with at-risk kids.

Unexpected walls

Her career as a muralist was progressing well when Jane noticed she was sick. She felt as if she had the flu all the time, with fevers, aches, and red patches on her face. Worst of all, she could hardly use her hands. In the fall of 1983, the twenty-seven-year-old artist was diagnosed with lupus, a chronic disease affecting the immune system, joints, nervous system, and skin. Jane decided to return home to the Jersey Shore so she could participate in a highly regarded treatment program at then-Hahnemann Medical Center in nearby Philadelphia.

Battling lupus will always restrict Jane's activities. "A bad cold can turn into a real crisis," she admits, "but I try not to let lupus limit me." Although exposure to the sun can trigger a systemic response, including joint pain and fatigue, Jane believes "murals have been helpful in combating the chronic pain, because I love the work and I can immerse myself in it. The doctors complain that I push myself a bit too much, but they concur that I'm the healthiest lupus patient they have."

ARTIST EUHRI JONES'S *AFRICAN WILDLIFE*, 2001, AT 4947 LOCUST STREET, EVOKES A COLORFUL ANIMAL KINGDOM FAR FROM THE STREETS OF PHILADELPHIA.

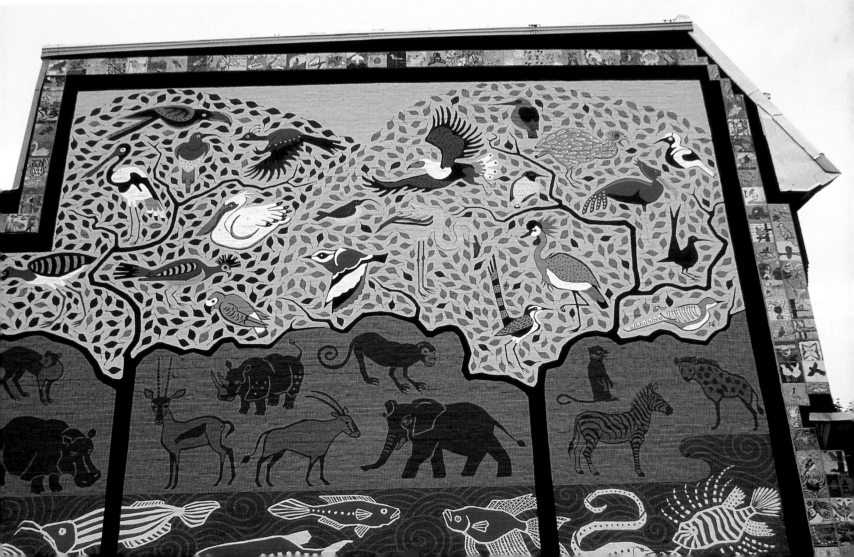

TISH INGERSOLL

"Heat is the worst thing about mural painting. It wears on you. This summer when I was painting on a wall that faced east, I was thinking I was a wuss, but I took a thermometer—It was 115 degrees," Tish Ingersoll recalls with remembered surprise. "After a while, I couldn't think clearly. I was having trouble figuring out perspective. I thought I was a little gaga. I went to my doctor, and he said I was getting dehydrated, that I should drink not water but Gatorade."

Primarily a studio painter and teacher, Ingersoll is a graduate of the University of Pennsylvania and the Pennsylvania Academy of the Fine Arts. She already knew she wanted "to experiment with murals" when she met Jane through a friend. She volunteered her services to the city. In the spring of 1993, Jane offered Ingersoll a wall at 32nd and Spring Garden Streets, a location with a lot of automobile and pedestrian traffic. "People stop by, but they're not from the neighborhood," the artist observed. Ingersoll's lush *Tuscan Landscape* (restored 1999, see p. 24) on that corner is one of the city's signature murals and often photographed, partly because the scale of the arcade in the foreground interacts so effectively with nearby cars and people.

So far, she has done six murals for the city. "My work is usually about landscape and getting into a beautiful place. People like to be reminded of that," Ingersoll believes. She likes to discuss ideas for a proposed mural with community residents. "I can let my ego go a little bit and accommodate [others' ideas] and not lose my integrity as an artist. There's a balance."

At 420 feet, Ingersoll's *Manayunk Views* (Ridge Avenue and Main Street, 1997, see next page) is one of Philadelphia's longest murals. The cement rampart on which it is painted stands at the lower end of "The Wall," Manayunk's famously steep hill that makes or breaks many a cyclist competing in Philadelphia's annual First Union U.S. Pro-Championship bike race. Because Ingersoll's mural would serve as part of the background for this international athletic event—reaching audiences around the world—it offered an exceptional opportunity to say something about Philadelphia.

Manayunk, a historic working-class factory community, has recently attracted younger, professional residents, as well as fashionable restaurants, gift shops, and other businesses that appeal to visitors. Ingersoll describes her initial discussions with Manayunk residents as "kind of dicey. A lot of people were skeptical. They didn't want something political, and they thought it was going to be a huge eyesore. There was a man [at a community meeting] who said, 'I think murals are the equivalent of a boom box.'" When Ingersoll mentioned Mexican muralist Diego Rivera, the skeptic snapped, "I lived in Mexico, and I hated Diego Rivera."

However, Ingersoll persevered. "By the last meeting, I came to the front of the audience and showed my drawing and explained the thought process behind the drawing, and they were okay with the explanation." In a comic twist, Ingersoll's design was embraced too ardently by one resident who announced his intention to put it on a T-shirt and refused to understand that murals are copyrighted works of art.

Ingersoll likes to frame her landscapes in an architectural setting. For the Manayunk mural, she chose the arched supports of a bridge, which seem to be holding up the roadway above. The bridge's arches, painted to simulate rusticated stone in a nod to Manayunk's Victorian past, frame a series of lush local vistas.

The scenes in each arch are subtly unified through the use of color and the horizontal continuity of the summer sky, vegetation, and flowing water. A bridge over Wissahickon Creek leads to the central triad of views. A steep flight of steps ascending to a historic Victorian mansion flanks an aerial view of the town nestled among steep hills. A bucolic scene of the Manayunk canal, once an important means of transporting goods to and from the town's textile mills, mirrors the receding linear perspective of the Victorian steps in the next scene over. The sequence concludes with the Green Lane Bridge over the Schuylkill River.

Working on thirty-foot scaffolding, Ingersoll had help on the mural, but she did most of the painting herself over a period of six months. The community showed its appreciation for *Manayunk Views* by asking the artist to paint *The History of Industry and Canals in Manayunk* (4400 Main Street, 1999). For this mural, she worked with local school children and spent a lot of time researching the textile industry. Ingersoll says the big *Manayunk Views* project

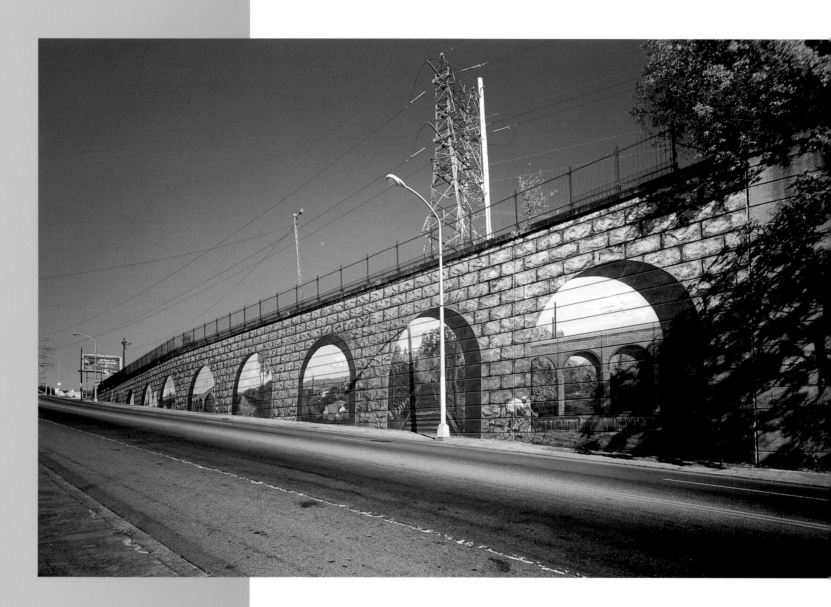

changed her painting. "It made my gestures very spontaneous. Now, when I'm working on small things, I trust my brain to be working with my hand better."

"For me, it's been an enriching experience to go to the public level. It's made my message more of a universal message, which in the long run is what I am as an artist. I want people to think when they look at my work. I want a reaction, and I want them to understand what I'm trying to say. The murals have not only helped me understand the city better, but also to understand a universal feeling about certain things. I am so grateful that I've had this opportunity because it's helped my work."

As her symptoms gradually improved, Jane started working in one of her parent's China Outlet/Gourmet Garage stores and ended up painting a view of the Atlantic City Boardwalk on the side of the store in Somers Point, New Jersey. In June 1984, a friend told her about the mayor's new graffiti-abatement program. Following a positive interview with Oliver Franklin, then deputy city representative for arts and culture and a former filmmaker familiar with her work in Los Angeles, Jane was hired by Tim Spencer along with two others to coordinate a six-week summer youth program.

"I was not hired to paint but to work with the kids part time every day from nine to twelve. I was still living at home in Margate, and in the afternoons I'd work on my mural there or paint down at the Shore," Jane recalled. "Tim had alluded to the fact that the three people who were hired for the summer program would compete for a full-time position in the fall. At the end of the six weeks, I told Tim how I really wanted to paint murals. Just at that time, we were driving over the Spring Garden Street Bridge, which was *covered* with graffiti, and he asked if I could do murals on both sides of the bridge with kids from [the] Mantua [section of West Philadelphia]. He asked if I could finish them in three weeks so they could be dedicated on Labor Day. Tim later said that Wilson Goode had told him, 'If that girl can do it, it will be a miracle,' and that I would get the full-time job. So, I did what I do best: I can out-work anybody!"

Located in sight of the majestic Philadelphia Museum of Art, the bridge was enclosed by six-foot-high corrugated metal walls, each six hundred feet long and utterly unsuitable for mural painting. The roughly joined metal sheets sizzled in the August sun as Jane and her teenage helpers applied gallons of chalky green, beige, "Ranch Red," and "Crisp Blue" house paint with clumsy brushes.

"I kept running to the art supply store to buy these little pints of acrylic paint to tint the house paint. I started painting at six in the morning and worked seven days a week into the night. I would sketch, sketch, sketch—and the kids filled in tremendous areas with paint. I had teams of kids. The total number must have been around one hundred. I loved the kids and really bonded with them. I had a great time!"

The difficult conditions, poor materials, and inexperience of the painters ensured that the Spring Garden Street Bridge mural (which has since been repainted in part) would have a naive charm at best, but Philadelphians saw it as a major improvement to the busy thoroughfare. "People loved it. The kids were seen as heroes. I remember people pulling over and stopping traffic on the bridge, beeping and waving, and the kids taking bows. Really, it wasn't about art, it was about the fact that kids were doing something productive for their community." At the end of the summer, Jane was invited to join the Anti-Graffiti program's full-time staff.

"Really, it wasn't about art, it was about the fact that kids were doing something productive for their community."

Street savvy

Initially, Jane was the only professional artist and the only person with a college degree on a staff of ten or so field representatives. She recalls her colleagues as "grassroots guys with street savvy and a lot of charisma." The legendary local wall writer Cornbread, famous for tagging an airplane and an elephant with his peace sign, even took a job with "the Anti's," as the program was called on the street. A few of the field reps were just out of prison.

Each rep was assigned to a neighborhood and worked with the police to recruit wall writers for the program. As one former writer explained, "If you knew they were looking for you and you didn't come into the office and join up, you'd be in trouble."

Jane invited young people to join the program when she made presentations in schools and other community locations. Some would-be Diego Riveras were referred by the courts, and others were pressured into joining. Not all were former writers. Many simply wanted the opportunity to paint or joined at the suggestion of their teachers. "We give the kids a chance to use their talents properly instead of illegally," Jane explained in the late 1980s, when the education program was at its height. Looking back, "one aspect of Anti-Graffiti was the reality of having kids learn about discipline and responsibility. Many had limited options. We hoped they would come out of the program with a sense of their own identities and values so they could go on to live normal lives and not end up dead or in jail."

"I'm glad that program came along and was there for people who were serious about changing their ways," said Rocco Albano, a writer once known as PEZ and also as NOT (Number One Terrorist). For this young man, as for many others, graffiti was inextricably intertwined with drugs and alcohol. He believes his "addiction to graffiti" was the hardest of the three to kick.

Now in his thirties, Albano works as an Internet consultant. He credits a twelve-step recovery process for much of his turnaround, but he also feels that Jane and the program were crucial supports that were there when he needed them. "Quitting graffiti was a

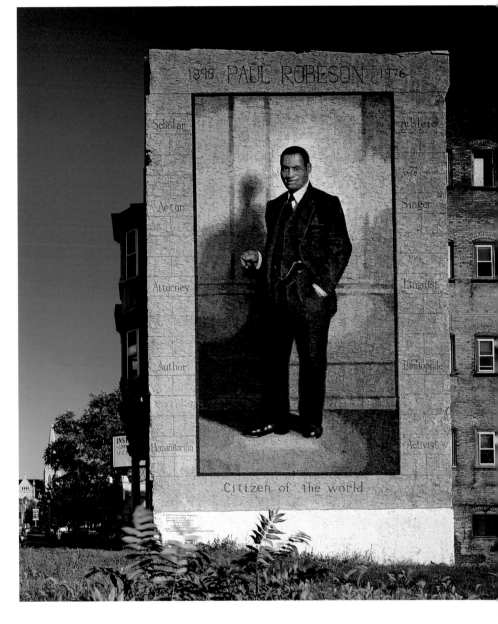

NOT FAR FROM HIS HOME, THIS STRIKING PORTRAIT OF PAUL ROBESON, PAINTED IN 1999 BY PETER PAGAST AT 4502 CHESTNUT STREET, REMINDS US OF THE MANY ACCOMPLISHMENTS OF THIS MULTITALENTED PHILADELPHIAN.

gradual process. Unconditional acceptance made it possible. I got to a time where I realized that what Jane was offering was better," he said.

Jane liked the kids and relished her growing knowledge of the raw side of city life. She was impressed with the power of Goode's vision. "At the 1984 press conference introducing the Anti-Graffiti Network to Philadelphia, Wilson Goode had five hundred kids from all over town taking The Pledge," she recalled. "Of course, they weren't *all* going to stop writing on walls. Maybe they didn't even *plan* to stop writing on walls. They were there because they knew they could possibly get a job. They were going to do whatever it took."

Today, most murals in Philadelphia are painted by professional artists. Young people often participate, but in carefully controlled ways. In the Anti-Graffiti days, kids had a larger role in many murals and the results reflected their lack of training. Jane, who was later named artistic director of the program (Tim Spencer was the executive director), led art workshops, designed murals, and supervised the kids who worked on them. "I liked it, though it was chaotic," she reminisces.

Jane was also delighted with the warm reception she received while painting in a variety of impoverished and neglected Philadelphia neighborhoods. "There's something about doing a mural that's different from other art; you have to be in people's homes, getting paint, using their water, developing relationships. I expected to encounter more racism than I did. In one black area, I remember the neighbors inviting us to lunch every day. And when the [black] guys on the crew weren't with me, they'd still invite me to lunch. I wasn't sure that would happen. I think murals have an interesting power to transcend hostility and racial barriers. I don't want to sugarcoat it, but it is an interesting dynamic."

The write stuff

Jane's first assistant was a former writer who had the tag TRAN. She quickly realized that TRAN and another field rep familiar with the drug scene were her ticket to the graffiti world. "We went to a drug corner, and the field rep's friend goes, 'That's C K. That's Dan. That's Louie-Louie.' Those were their tag names. We got out of the car, and the field rep went up to C K, who was holding a car stereo in his hand, and asked, 'What've you got there C K?'

"He looked down at the ground and said, 'We just stole this.'

"I said, 'C K, have you ever thought about a career change? Do you want to paint a mural with us?'

"He said, 'Where's that going to be?' Then all the guys he was with started to gather around.

"I said, 'It's at 5th and Allegheny, if you're not afraid to work on scaffolding.'" Jane was well aware that the young men were attracted to danger.

"And," she added, "there's pay, but you've got to sign The Pledge."

Intrigued, C K put down the stereo. He joined Anti-Graffiti and stayed with the program for two years.

Jane, who fantasized about being a spy as a child, felt a special satisfaction in infiltrating the network of writers and graffiti gangs and befriending people like the writer LOS, who led a graffiti club called the High Class Lunatics. "It was 23 degrees. I met him late at night in a rough neighborhood behind a recreation center to talk about painting murals," Jane recalled. "He was very skeptical at first. I was white. I was not from the neighborhood. I was talking about not using spray paint. I clearly had everything going against me, *but* I was clearly sincere. I remember thinking, 'Oh boy, am I naive!'

"People now talk about how difficult it is to reach kids between the ages of twelve and eighteen. That's who we had back then. It's no mystery," Jane insisted. "In order to connect with kids, you have to be emotionally present, physically present, and paying attention to them in a personal way."

PEZ

One evening in 1985, as she drove over the Spring Garden Street Bridge, Jane was dismayed to see tags all over the just-completed murals. "I saw 'NOT' and 'PEZ' everywhere in green paint. I was working with graffiti writers, so I figured nobody would write on this bridge, but the mural was just demolished. It was about seven at night, and there was some paint in the back of my Honda. I worked until about ten getting the graffiti off the bridge. I was really aggravated with NOT and PEZ, whoever they were." The next day, Jane learned from former writers on her painting crew that both tags belonged to the same person.

"A few weeks later, I was working on a mural at the corner of 32nd and Powelton. We were all painting when the guys on the crew said, 'Jane, see that guy coming up the street? That's PEZ.' I said, 'No! He's coming up here? I can't believe it.'

"I grabbed a gallon of green paint and hopped off the scaffolding and went up to him and said, 'So, you're PEZ.'

"He said, 'Yeah.'

"I said, 'Great! I'm really glad to meet you. Now I want you to understand the meaning of graffiti—what it feels like to be graffitied.' I went like I was going to throw the green paint on him.

"People now talk about how difficult it is to reach kids between the ages of twelve and eighteen. That's who we had back then. It's no mystery," Jane insisted. "In order to connect with kids, you have to be emotionally present, physically present, and paying attention to them in a personal way."

THIS EARLY "TRIBUTE MURAL" FROM
THE ANTI-GRAFFITI DAYS, AT 17TH
AND WALLACE STREETS, HONORS
ONE OF THE WORLD'S FOREMOST
MURALISTS, DIEGO RIVERA.

"He said, 'Whoa! Nobody told me you were crazy! I came here to apologize.'

"I put down the paint and said, 'That's really interesting. What do you mean?'

"He said, 'Well, I'm PEZ and my other name is NOT. I started thinking about it, and I realized that I was mad at your boss (Tim Spencer) and I wasn't really mad at you, and it was wrong of me to destroy the bridge.'

"I said, 'Okay. I have an open mind. But I don't think you should get off the hook that easily. If you really want to apologize, I'm going to tell you what to do. You have to volunteer with us. Then, if you put in some time and you do a good job, maybe we can hire you. And,' I said, 'you have to sign The Pledge.'"

PEZ was curious. He asked Jane where she would be painting next. She told him about a mural project that was about to begin in Center City. "If you show up," she told him, "I'll know your apology was sincere."

The mural began without PEZ. Fall became winter before Jane finally heard from him. Despite the cold conditions, this time, he kept his word. "He painted every day for three months, and he was clearly committed. He was climbing all over the scaffolding and lifting and loading and dragging stuff, cleaning the brushes and doing the grunt work that nobody wanted to do," Jane recalled. "As time went on, he did sign The Pledge, and I was able to get him three hours of employment a day. He did really well."

Eventually, PEZ was given a full-time city job, with benefits. It was not a magic fix. PEZ was a troubled teen with serious drug and alcohol problems. When he was ready to earn his GED, Anti-Graffiti paid for it. Jane introduced PEZ, along with other young participants, to poets, authors, and painters. "The mural program was an anchor in his life against everything else that was going on," Jane recalled. "He was always in a state of turmoil. But he did love mural work, and he was good at it. He liked going door to door, getting signatures from neighbors saying they wanted a mural. He was a good emissary to other writers, too."

"I am large. I contain multitudes."

Theodore A. Harris (a.k.a. KNIFE) met Jane when he dropped by to see a couple of friends who were working on the original Spring Garden Street Bridge mural. At that point, Harris had drifted away from Tim Spencer's original Anti-Graffiti group in Mantua, but he found Jane's knowledge of art irresistible. He had some art books with him, and he and Jane were soon talking. He "buffed" or primed walls, erected

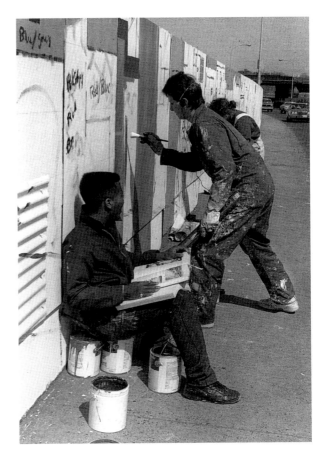

scaffolding and, when the rough work was done, got out the brushes. "These muralists now have got it easy," he half jokes. "They don't want to help with the scaffolding. They don't want to do the priming."

For Harris and other wall writers, the transition from graffiti to city-sponsored murals involved more than working on "permission" walls. If it's graffiti, it's got to be painted with spray paint, and not just any spray paint—it's a point of pride to steal the paint. And yet, in the Anti-Graffiti program, spray paint was banned by mayoral mandate. In fact, Mayor Goode's opposition to spray paint was so strong that the program's logo was a red circle with a diagonal slash across the silhouette of a can of spray paint.

Getting wall writers to change mediums was a hard sell for Jane. "Many of these kids are experts at spray painting, and there is nothing more I can teach them about it," she often said. "I want to build a bridge to other mediums."

Although some of the spray can virtuosos wouldn't make the switch, many did—and flourished because of it. Harris, whose politically oriented collages have appeared in several literary publications, is currently working on a book with seminal black writer and activist Amiri Baraka (formerly LeRoi Jones).

Harris traces much of who he is as an adult to his early experiences with Anti-Graffiti. "I've had so many good experiences painting murals," he said. "I've gotten to work with artists I admire whom I would never have met. I heard Sonia Sanchez read because a friend from the mural program asked me to go. After I heard Sonia, I went right out and got one of her books. I started buying poetry books and started writing poetry and publishing my work. Now, I've been published *with* Sonia."

Harris particularly enjoyed his work on *Boy with Raised Arm* (formerly at 40th Street and Powelton Avenue, 1992, see p. 18). In the original painting by celebrated Philadelphia realist Sidney Goodman, the African American boy in a striped T-shirt is one of several children at play. In the mural, he stands alone against a dark ground, his arm raised in an ambiguous gesture resembling a Black Power salute. Goodman himself worked on the mural, concentrating mostly on the boy's face. Jane, then assistant art director Dietrich Adonis, Harris, and others completed the figure and landscape elements. Young people assigned to Jane by the juvenile court system were put to work filling in flat sections of the background.

Before painting on the Goodman mural could begin, a lower horizontal section of the wall had to be repaired. Then came the question of how to use this extra space. Harris had the idea of adding a line of poetry. Goodman chose the quotation from Walt Whitman that completes the mural: "I am large. I contain multitudes." The words are laid out in white lettering against a black background. Because of its beautifully rendered, poetic subject and

its location near a busy intersection, "I am large," as it is often called, was one of the best-known and best-loved murals in the city. In 2002, its building was demolished to make way for new construction. MAP is negotiating to re-create the mural on the new building going up on the site.

A certain kind of magic

Illustrator and art teacher Dietrich Adonis was in his early twenties when he joined the Anti-Graffiti staff in 1985, about six months after Jane. He worked as assistant art director through the early years and later as assistant director. "We had a certain kind of magic in the early years," he reflects. "Tim [Spencer] had a vision; Jane had a vision; and I had a vision. We had different personalities, but it just worked."

Cooperation was central to Anti-Graffiti. In addition to developing designs like *A Tribute to Diego Rivera* (17th and Wallace Streets, restored 1998, see p. 38), Adonis contributed to murals designed by others, helped supervise "graffiti abatement" (cleaning or repainting walls in flat color), evaluated potential mural sites, and met with community leaders and organizations to discuss proposed murals. He also did a lot of the teaching.

In 1989, the program moved from its original headquarters in the City Hall Annex to 1220 Sansom Street. Another location, at 808 N. Broad Street, became the center for its after-school arts workshops until 1996. From 2:30 to 6:30 P.M., the place was jumping with kids who came to make art. They were given art supplies and even transit tokens to get home.

"For some crazy reason it worked," Adonis marvels. "We had guidelines, but we didn't have a curriculum. We just started where the kids (age eleven to eighteen) were and dealt with them on an individual basis. They came and had a boss time."

"People hung out back then," Jane recalled. "Kids would sit around the Anti-Graffiti offices and draw." She was impressed by their self-taught knowledge of art history. "I thought, they've dropped out of school. How do they know about Rothko and Klein and these Abstract Expressionists? I asked one, and he said, 'Are you kidding? I've been stealing *Art in America* for years.'"

Jane's rapport with young writers had some unexpected consequences. One evening, KNIFE, BABY-ROCK, and a couple of other Philly writers with all-too-familiar (if sometimes illegible) tags visited Jane's apartment to look at her art history books. They had a good discussion, but when Jane set out for work the next morning, she was appalled to discover

their show of thanks: The young men had spray painted at least thirty "COOL JANE" tags between her house and her office.

Although the tags testified to Jane's "coolness," they were also a subtle challenge to her mission. She recognized that her response, though diplomatic, must be unequivocal. "When they asked me if I'd seen [the tags], I said, 'I really appreciate the thought, guys, *but*....'" She made it clear that no matter how flattering to her, graffiti would not be tolerated.

Expanded opportunities

The burgeoning arts program expanded rapidly. From one workshop at the Philadelphia Museum of Art, it grew to include workshops all over the city. Art shows, auctions, a visiting artist program, and more speakers were added. It even sponsored field trips to the Museum of Modern Art in New York City.

"A beautiful landscape mural can be a sign that people care and that things can change. So, a three-story waterfall is totally uplifting. It's a political statement."

By the late 1980s, Jane's staff included ten or twelve former graffiti writers. Between 1986 and 1992, her summer programs employed hundreds of kids. In 1986, 1987, and 1988, two thousand kids removed graffiti and painted murals.

"If you were coming into the program," Jane recalled, "it was for more than a six-week arts and crafts class. We offered kids something substantial, a program that was ongoing and would be there for the next few years of their lives. It was a very different concept from what had been done previously in the neighborhoods where I was working. Everywhere I went in those years, kids said, 'Oh, you work for Anti. That's so cool.'"

Social statements

Even though the program could claim solid success in helping many troubled teens like C K, PEZ, and KNIFE, some Philadelphians felt and continue to feel that graffiti writers should be imprisoned rather than educated. "My reply," Jane said, "is, 'We can't even keep murderers in jail. There's got to be another response to nonviolent offenders.'"

"There's often a class difference between people who love graffiti and people who hate it," she observes. "Those who see beauty in graffiti are generally people from the middle class or upper middle class. In impoverished neighborhoods, people see graffiti as a symbol of hopelessness—a manifestation of the forces threatening their survival. They have to worry about their kids getting shot, and the fact that quite literally every exterior surface is covered with graffiti is a reminder that the neighborhood is out of control. A beautiful landscape mural can be a sign that people care and that things can change. So, a three-story waterfall is totally uplifting. It's a political statement."

The walls made other statements as well. Inspired by similar murals in Boston, three murals in different Philadelphia neighborhoods were dedicated to young people who died violently. Portraits of murder victims, often killed in drug-related disputes, have long been

commissioned subjects for gang-related graffiti pieces. In contrast, Parris Stancell's *Stop the Violence* (7th Street and Susquehanna Avenue, 1992) memorializes victims without glorifying gang life and drugs. Stancell painted three pairs of hands of different complexions lifted up to the names of the dead. A few simple flowers ornament the corners of the wall.

"We got the list from Homicide, and then we had to go to the homes of the kids who had been killed to get permission to use the names," Jane explains. "Often [the families] would show us photographs of the kids who were killed. It was very difficult."

Troubled times

Under Wilson Goode, the program's annual budget sometimes exceeded $2 million, an incredible amount of money given the nature of the work. At the dawn of the 1990s, though, Jane and her crew would begin to feel the financial crunch as federal funding was cut and city money became scarce.

Amid Anti-Graffiti's impressive achievements, which included the completion of more than a thousand murals and the instruction of thousands of kids through unprecedented community service, Executive Director Tim Spencer remains an ambiguous figure. Supporters point out that at the age of twenty-six, he had neither the training nor the experience to cope when his small community program ballooned into a citywide operation with a huge budget. They speculate that his management difficulties and erratic behavior were the result of his naiveté and a growing array of health problems that led to frequent hospitalizations over a period of years.

From the beginning, there were serious problems. As early as the summer of 1986, city police descended on the program offices. The city controller, inspector general, and district attorney all launched investigations looking into alleged financial mismanagement. Every full-time employee, including Jane, was questioned about purported abuses involving money, drugs, and sexual harassment. Jane was stunned by the intensity of the investigation. "It was like *Dragnet*," she recalled. In the end, two staffers were arrested for stealing payroll checks. Spencer was never charged with a crime, but for the rest of his life the press linked his name and the program to questionable fiscal practices and other wrongdoings.

In the Anti-Graffiti offices, colleagues called Spencer a "megalomaniac" who verbally abused subordinates. Sometimes he vetoed an artist simply because he took a dislike to the person. Yet even those who felt the director's wrath could not ignore the good work being done under his watch. Ex-graffiti writer Rocco Albano, who had his share of negative run-ins with Spencer, remembers with gratitude an occasion when Spencer "went to bat" for him when he was unfairly arrested. Albano praised Spencer's "vigilance" for persuading SEPTA, the city's public transit system, to keep their walls graffiti free. "Tim was no angel," explained former wall writer Harris, a loyal supporter who knew Spencer well, "but he started something beautiful in this city."

Initially, Spencer welcomed Jane to the program with kindness, but as time passed, he grew increasingly quarrelsome and enigmatic. "Tim was like a character out of a Shakespearean play," Jane recalled. "There was almost a sense of greatness about him. His early work in Mantua was compassionate and effective. It received well-deserved recognition. He came into all this money and power at a young age, and then he couldn't handle it. The management of Anti-Graffiti reflected his internal conflicts. At the core was a wonderful vision, but its daily implementation was unstable."

From its inception, the Anti-Graffiti Network was something of an anomaly within Philadelphia's city government. It was not an official department, but it had its own operating budget. This arrangement gave Spencer unusual latitude in spending, with virtually no accountability. "Money never seemed to be a problem," Jane recalled of the early years when federal, state, and city funding was plentiful.

During his 1991 campaign for mayor, Ed Rendell promised to shut down the troubled Anti-Graffiti Network if elected. Nevertheless, he spared the program and even declared January 5, 1993, "Philadelphia Anti-Graffiti Network Day." The certificate presented on

that occasion praises the program for removing graffiti from 3,200 locations, painting fifty murals, and counseling two hundred youths. All this was accomplished in one year, 1992, and all in spite of a 71 percent reduction in funding, from $1.5 million to $430,000.

In the early 1990s, as the city nearly slipped into bankruptcy, no one was spared. Harsh budget cuts were exacerbated by the loss of federal and state funding for education and arts programs. Anti-Graffiti's summer program was cut to one hundred kids, and after-school activities were totally eliminated. Jane managed to pull together a few additional workshops, but she struggled with fewer jobs for kids and a reduced staff.

Spencer, at this time, was facing increasing criticism on several fronts. In 1995, the Philadelphia *City Paper* wrote an investigative story about the program that included allegations of sexual harassment against Spencer. At the time of his death on April 21, 1996, he was reportedly under investigation by the city's Commission on Human Relations. A well-informed outside observer said simply, "Tim was killing the program and he was dying himself."

During this difficult period, both Jane and Dietrich Adonis were so demoralized that they made plans to leave. Jane even applied to Temple Law School but ultimately decided to stick it out at Anti-Graffiti a little longer.

Following Spencer's death at the age of thirty-seven, there was a dramatic public display of grief. In spite of his failings—whatever they may have been—Spencer had forged meaningful bonds with many people in the city. His funeral at the Metropolitan Baptist Church overflowed with hundreds of mourners. He was eulogized by two mayors and other prominent Philadelphia politicians.

Although she might have felt relief to be free of such a difficult and controversial boss, Jane recalled feeling "a deep sense of loss. Tim and I were partners for years." She mused, "I really grew up at Anti-Graffiti. I learned about community transformation and working with people there. Tim gave me an entree into the black community that I could never have had otherwise. In spite of our many conflicts, he gave me the opportunity to develop the mural program and to work with so many young people. For that I'll always be grateful."

RAS MALIK

"As my Yoga teacher says, 'When the student is ready, the master will appear.' I've found that in life," contends muralist Ras Malik. Although he envisioned himself as an artist from childhood, he says, "I put in a lot of time and made a great sacrifice to paint murals like I do. It's a type of devotion."

Malik had only eight years of education in a one-room North Carolina schoolhouse before he had to drop out to work full time in the tobacco fields with his mother and four siblings. His father died when he was seven. "Sharecropping is a very meager type of living," he explains. "You have to share half [of] whatever you raise on white man's land with the land owner. You have to borrow to get stuff to eat and then pay your debt. I saw this as a dead end situation from an early age." When he was eighteen, Malik came to Philadelphia at the invitation of a childhood friend. He worked various jobs, finished high school, and started a commercial art course before he was drafted in 1957. While he was serving as a medic in the Army, his art talent was discovered and he was drafted again—into making signs and later doing anatomical illustration at a medical facility. This gave him an opportunity to study the human skeleton and muscular system.

Upon his discharge, his impressive portfolio and the GI Bill enabled him to study illustration at the Philadelphia College of Art (PCA), now the University of the Arts.

Almost simultaneously, Malik began work as a corrections officer at Holmesburg Detention Center House of Corrections, where he remained from 1961 to 1974. "It was an extremely hard place to work. I can still smell it—the most horrendous odor in the jails. I can still hear that profanity."

One day, during Malik's senior year at PCA, the warden saw him drawing and said, "Oh, you're a very good artist. Why not teach some art classes?" Some of the men were very receptive. "It was a good way to get them to open up their minds to creativity. It was a good rehabilitative tool." Later, he formed the Bastille Art League with some of his former students who were no longer incarcerated. The League served as a support group for artists and writers. At least one former member now paints murals with the Mural Arts Program. Malik has worked as a book illustrator and had his own sign-painting business for some fifteen years. He has also done a lot of teaching. In the late 1980s, he showed Jane his portfolio. She immediately hired him to teach in the Anti-Graffiti workshop at 808 North Broad Street.

In 1994, William Freeman offered Malik his first crack at murals. Freeman needed help painting a series of sports figures on the columns beneath a PennDOT overpass at Ridge Avenue and Ferry Road, just off Kelly Drive in the East Falls section of the city. "It was a very good experience. We inspired each other," Malik remembers. The paintings were seen by large numbers of commuters and aroused positive comment.

Following the program's reorganization in 1996, Malik began to receive solo commissions. After painting his second mural, the landscape *Forest Green*

(Emerald and Dauphin Streets) in mostly Puerto Rican Norris Square, the dread-locked African American decided to move to the welcoming neighborhood despite his rudimentary Spanish. He joined the board of the Norris Square Civic Association and began teaching art to neighborhood children after school. He has since painted several more local murals there, including *Recuerdos de Nuestra Tierra Encantada* (Memories of our Enchanting Land, 2200 block of North Howard Street, between Susquehanna Avenue and Dauphin Street), picturing a rural Puerto Rican landscape with a field of brilliant tulips and a flaming Royal Poinciana, or *flamboya,* tree.

Malik believes *Compassion* (55th and Regent Streets, 1997, see next page) was his third individual effort. At the time, the West Philadelphia neighborhood was overrun with drug dealers and seriously demoralized. "Everybody wanted what they called a 'spiritual type of mural'— something that would unite the people," he recalls. His first idea was rejected. Then Phyllis Walker, a well-known community leader, came across a calendar picture of hands over a table with plenty of food and suggested using this idea for the mural. Malik agreed, but then the image prompted other possibilities. "I got to thinking: The hands were the essential thing. Once I began to visualize hands in the sky, something just clicked in my head." In his next sketch, divine hands reach down from the sky, pouring blessings onto a block of row houses that almost mirror the real houses across from the mural. He submitted it to the group, and they were pleased.

In addition to depicting neighborhood houses, the artist says, "I was looking at people and putting them into the picture as I went along. I do that a lot of times."

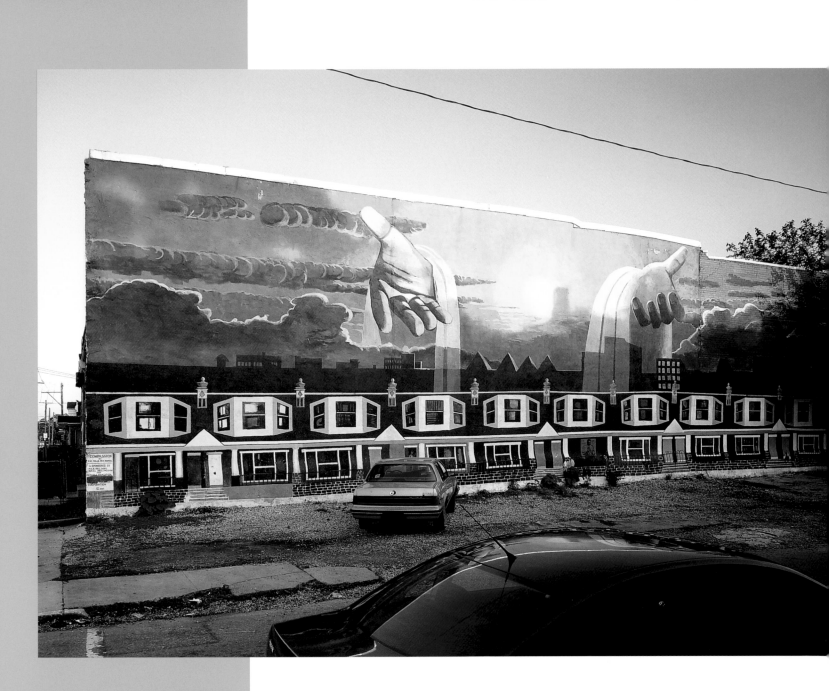

COMPASSION, 55TH AND REGENT STREETS.

Although Malik did not ask anyone to pose, he closely observed residents, including a "lady who was always ready to offer me some milk or cookies or something. She had a very open personality and was respected by everyone else in the neighborhood."

"As the mural progressed, the people showed me how they really appreciated it. The wall was on an old dilapidated lot with paper and junk strewn around, but they began to transform the lot into a nice garden area with flowers and everything. It's a great feeling to do something that can change a neighborhood."

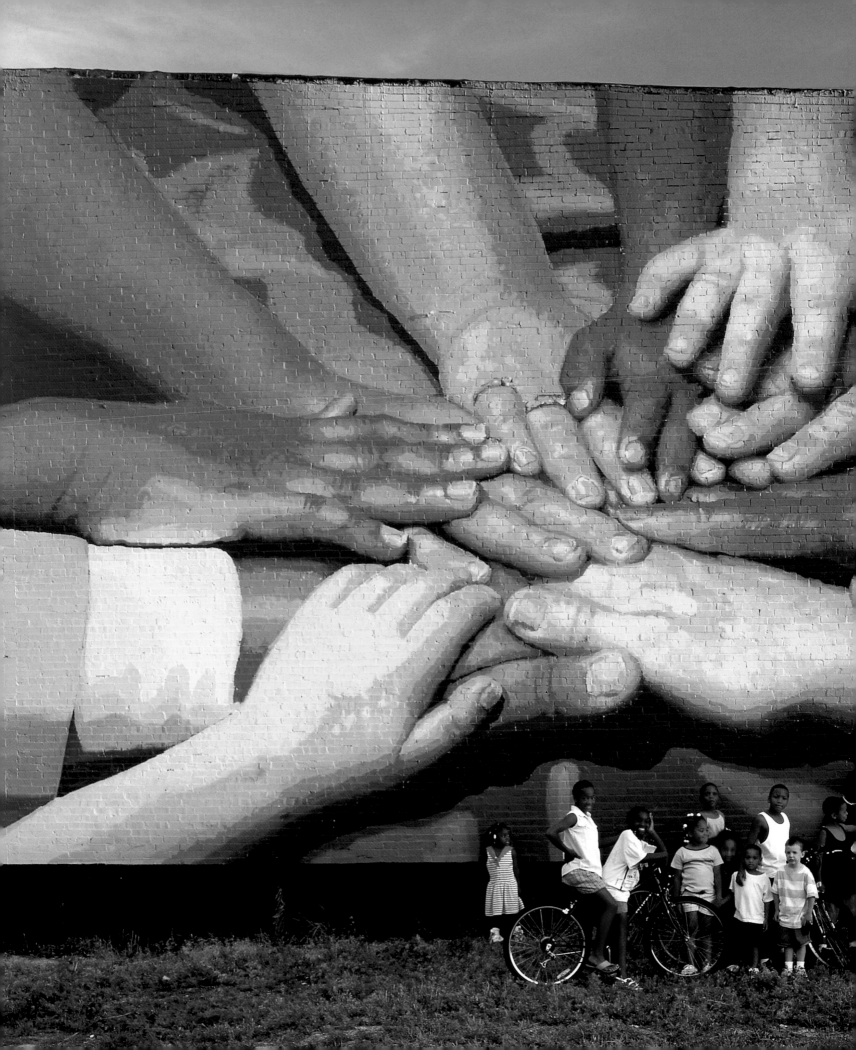

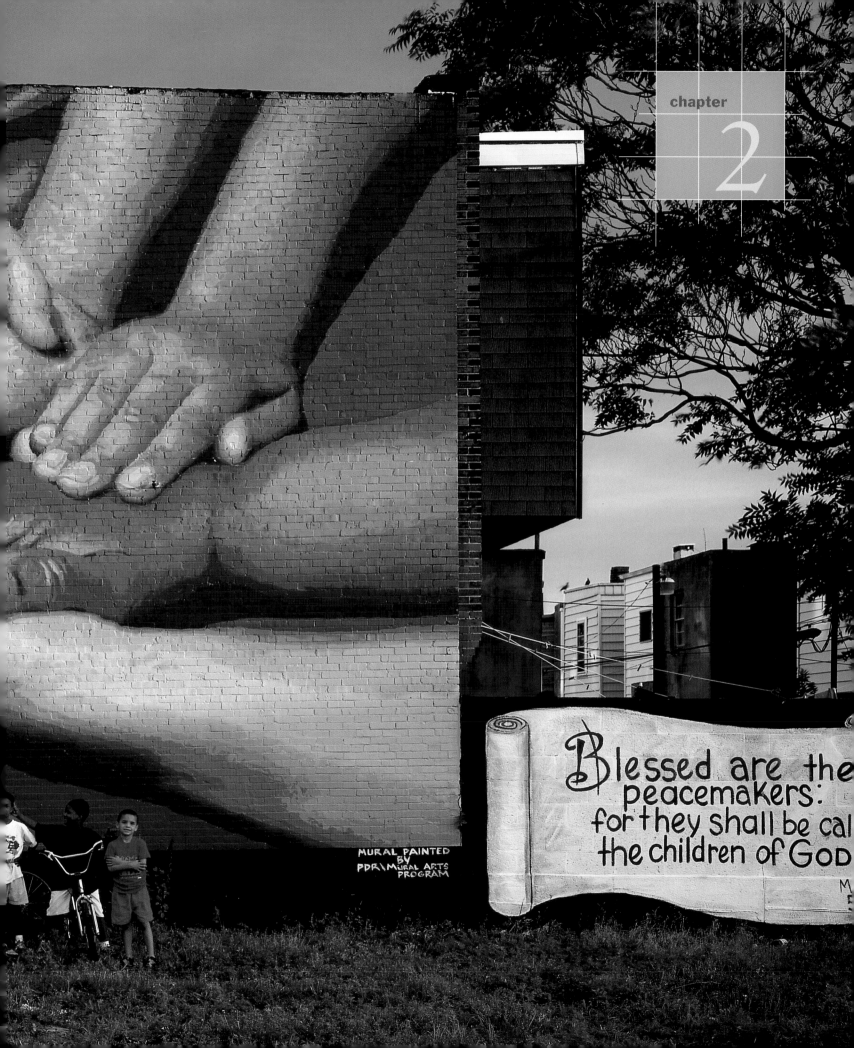

MURAL PAINTED
BY
PDR\MURAL ARTS
PROGRAM

Blessed are the
peacemakers:
for they shall be cal
the children of GOD

THE
PEACE WALL

PRECEDING PAGES RISING ABOVE THE
STREET AND ITS TUMULTUOUS ORIGINS,
THE PEACE WALL, 29TH AND WHARTON
STREETS, STANDS AS ONE OF
PHILADELPHIA'S MOST ENDURING
ICONS OF HOPE.

One day in the summer of 1997, Jane Golden and Lillian Ray went knocking on doors. They were an unusual pair in the racially charged South Philadelphia neighborhood called Grays Ferry: Ray, an African American community activist who had lived all of her life in the area, and Jane, a white outsider who ran the citywide mural program. The women shared an artistic vision. They wanted to help divided residents find common ground through a mural.

Jane and Ray knew it would be a tough sell in the long-troubled cauldron that is Grays Ferry. The neighborhood had crime, abandoned buildings, isolation, and poverty to deal with, and earlier that year it had been rocked by a wave of racial unrest that caught the nation's attention. The wounds were still fresh and showed no signs of healing anytime soon. After holding a series of community meetings with sparse or no attendance, Jane and Ray hit the streets to pitch the mural and search for models. They stopped children on the sidewalk, asking them to fetch their parents. Over and over, the pair pleaded: Come to the church to be photographed. "Would you come down," Jane urged, "and literally lend us your hand?"

After about an hour, the duo returned to the Lighthouse Christian Church at 30th and Wharton Streets. For the first time in a decade of working in Philadelphia, the always-optimistic Jane had serious doubts about one of her mural projects. Some white residents had slammed the door in her face. Black residents who listened to the pitch still couldn't be moved to participate. Struggling with her emotions, Jane hardly noticed that the church had started filling up with people. Residents filed in, unsure exactly why they had come but believing somehow the message made sense. More than twenty volunteers arrived. Jane's husband, Anthony Heriza, assembled them in a circle. He climbed on a ladder and began snapping pictures of all the extended hands piling on top of each other, like a multicultural basketball team joining in a pregame huddle. "Everyone was reaching for each other. It wasn't a cure for racism, but it was important," Jane recalled. "I felt stirrings, that's what I felt."

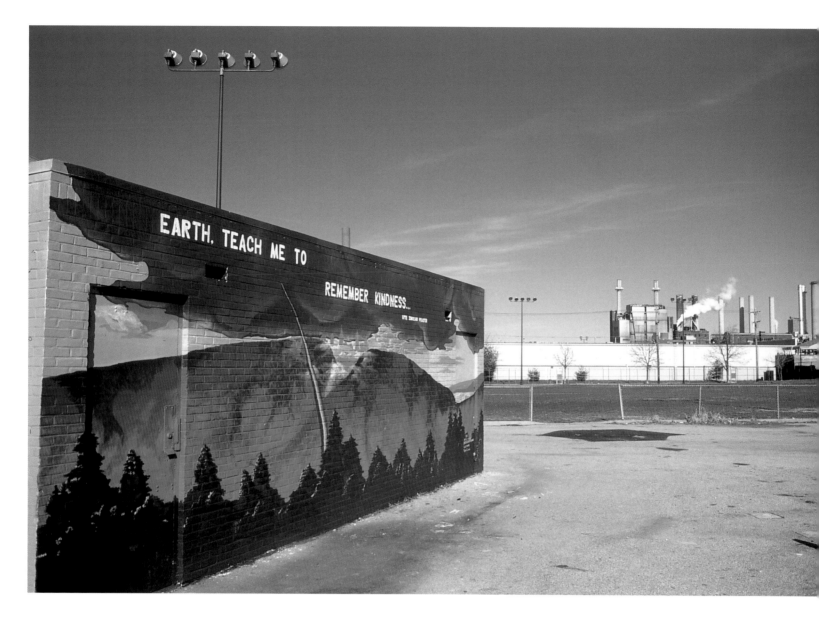

Within the mural: EARTH, TEACH ME TO REMEMBER KINDNESS...

A fractured community

Kevin Spicer grew up in Grays Ferry and remembers how the mood there changed during the 1960s. Many white families moved away, fleeing the neighborhood and the city. Those who couldn't leave grew more frustrated by their surroundings. Philadelphia's manufacturing industry had collapsed, saddling residents with economic and personal hardships. Then, rioting rocked the city in the early 1970s, leaving a wake of racial tension and fear. In Grays Ferry, Spicer recalled, some blocks were safe for African Americans to travel, while venturing onto others almost guaranteed a fight. "You learned quickly around here where you belonged, and where you didn't."

Lillian Ray had spent all of her nearly seven decades on earth in Grays Ferry. In 1988, she started a basketball league at nearby Finnegan Playground with twelve teams—eleven black and one white. The white team lost to a black team in the playoffs. The next day, Ray found all of the basketball nets cut down.

A SECOND *PEACE WALL*, PAINTED BY NEIGHBORHOOD KIDS AT FINNEGAN'S RECREATION CENTER, 29TH AND WHARTON STREETS.

JANE ADDS A DOVE AS A FINISHING
TOUCH TO *THE PEACE WALL*.

Jim Helman arrived in 1995 from Baltimore. As a white retiree moving into a largely black section of the neighborhood, Helman said he was soon exposed to what he calls "intolerant, hateful" messages coming from other whites toward their African American neighbors. Making matters worse were the two dueling community groups claiming to speak for the neighborhood. One was all white, the other nearly all black. The only thing the organizations had in common was mutual animosity.

The neighborhood friction was at its worst, symbolized by an ugly annual tradition. Each summer, vandals threw bottles into the outdoor public pool at Vare Recreation Center in an attempt to keep African Americans who lived in the nearby public housing project from using the pool, which was located in a predominantly white part of Grays Ferry. By trashing the pool at night, the vandals were able to shatter enough glass to keep the pool closed the next day.

Despite this history, people in Grays Ferry coexisted in relative peace throughout most of the 1990s. All that changed one night in February 1997, when a group of white men left a beef-and-beer party at St. Gabriel's Roman Catholic Church. Outside, the white men got into a fight with two black men, the son and nephew of a woman named Annette Williams. During the melee, the white men smashed the front windows and door of Williams's home, punching her and using racial slurs. Then, three weeks later, two black men were arrested and charged in the shooting death of a white teenager during a robbery at a Grays Ferry pharmacy.

The brawl and the shooting put Grays Ferry in an uncomfortable national spotlight. Suddenly, the neighborhood was being held up as an example of the troubled state of race relations for all of America. Calls for thousands of African Americans to stage a protest march through the neighborhood had Lillian Ray worried: "All I could see was a chaotic situation, where if things got out of hand, the only thing that would be represented was hate."

The day before the march was to take place, Ray reached out to all of the smaller community groups in the area asking for a meeting at nearby Finnegan Playground. Eight of the ten organizations came, their members agreeing to form a new group called "Grays Ferry United." Their mission: to bring the neighborhood back together, to forge peace between whites and blacks.

The march took place without incident. So did an antiracism rally, which drew hundreds of people, including then-mayor Ed Rendell and controversial Nation of Islam leader Louis Farrakhan. Once the network television crews went home, Rendell set about finding long-lasting solutions to the problems in Grays Ferry. He assigned then-recreation commissioner Michael DiBerardinis—a tough-talking former community organizer who had street credibility with activists of many races—to be the point man in the neighborhood.

The city's recreation department invested $200,000 in murals and renovations at recreation centers in the heart of the troubled community, hoping to give young people something more constructive to do with their time than fight. Private foundations chipped in $100,000 to help a new, integrated community development corporation get off the ground. Other organizations financed summer job programs for area youths.

While the groundwork was being laid, Jane was at work, as usual, hunting for walls that would make good mural canvases. She had a $32,000 grant from the William Penn Foundation to do three murals celebrating Quaker history and philosophy, themes that are close to Philadelphians' hearts. The first was *Immigration and the Dignity of Labor* (8th Street and Fairmount Avenue), completed by David McShane in 1996. Then came *The Underground Railroad* (2902 Germantown Avenue) by Cavin Jones. Next up was *The Peace Wall*, honoring the pacifism that defines the Quaker faith. Originally, Jane intended to paint the mural at 13th and Market Streets in the heart of Center City. Halfway through the design process, the wall's owners backed out. Then it hit her: Grays Ferry. Given the divisions and distrust between the residents there, she said, "It seemed to me like an obvious place to do a peace wall."

What neighborhood are they talking about?

Jane called Lillian Ray after reading about her new unified Grays Ferry organization in the newspaper. The women realized they shared a vision for making the community stronger, and both were keenly aware that there could be no progress unless black and white residents chose to work together. Jane and Ray met and began hatching their plans.

From the beginning, there were skeptics. Some in the neighborhood thought the mural idea was ridiculous, even hypocritical. Others accused City Hall of imposing its will on the community. Kevin Spicer, the lifelong resident, called it a "waste of time," a "spoon-fed" response designed to force unity whether or not the residents really wanted it.

> From the beginning, there were skeptics. Some in the neighborhood thought the mural idea was ridiculous, even hypocritical.

JANE TAKES A BREAK FROM WORKING TO SPEAK WITH NEIGHBORHOOD KIDS.

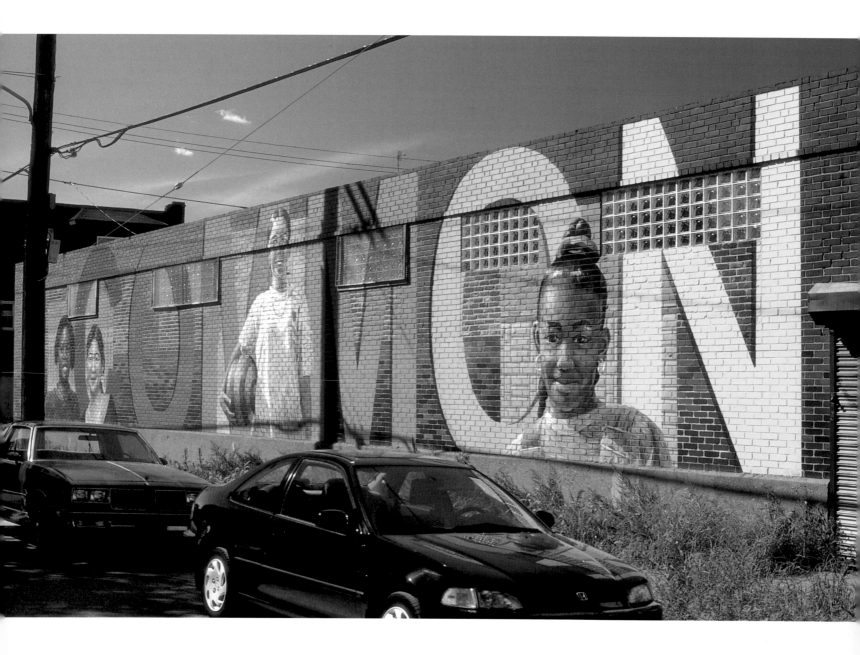

Charles Reeves was livid that his organization, the Committee of Concerned Citizens, wasn't involved in the process. Then again, he really didn't want to be a part of it. During the uproar over the Annette Williams incident, Reeves emerged as Grays Ferry's loudest malcontent, an African American filled with years of stifled rage who was unafraid to shout about it each night on the local television news. Reeves was among those who equated murals with deterioration and demise. He did not think Grays Ferry needed any more reminders of its problems—especially not some painting implying a warm, fuzzy togetherness that just didn't exist. "I thought it was a joke," Reeves recalled. "I wondered, 'What neighborhood are they talking about?'"

Lillian Ray and the members of the new Grays Ferry United would not be deterred. They wanted a mural, a painting with a spiritual theme whose message would represent the many racial and ethnic groups in the neighborhood. They met with residents to toss around

ideas. One woman wanted a dove carrying an olive branch in its mouth. Another favored a more religious mural with Jesus surrounded by a group of multiracial children. An older man advocated for a mural featuring adults showing children right from wrong. Ray nodded, and then she suggested a mix of young and old hands. Jane waited for a moment to gauge the group's response. When she saw approval, she smiled and said she could already visualize painting a mural full of hands. "That could really be dramatic."

Two weeks later, the group reconvened. Jane brought several sketches, imploring the residents to think carefully about the choices because the design is "where the mural is born." She did her best to guide them without imposing her views. "I see murals as a sort of autobiography of the city," she often tells community groups. "Murals provide people with a voice. It's their statement, their history, their future." This time, her sales pitch for lengthy contemplation fell flat because the sketch of the interlocking hands was the clear

PAINTED NOT LONG AFTER *THE PEACE WALL*, JOSH SARANTITIS'S 1998 *COMMON GROUND*, AT 30TH AND DICKINSON STREETS, OFFERS ITS MESSAGE OF RESPECT AND UNITY IN DIVERSITY ON BEHALF OF THE CHILDREN OF GRAYS FERRY.

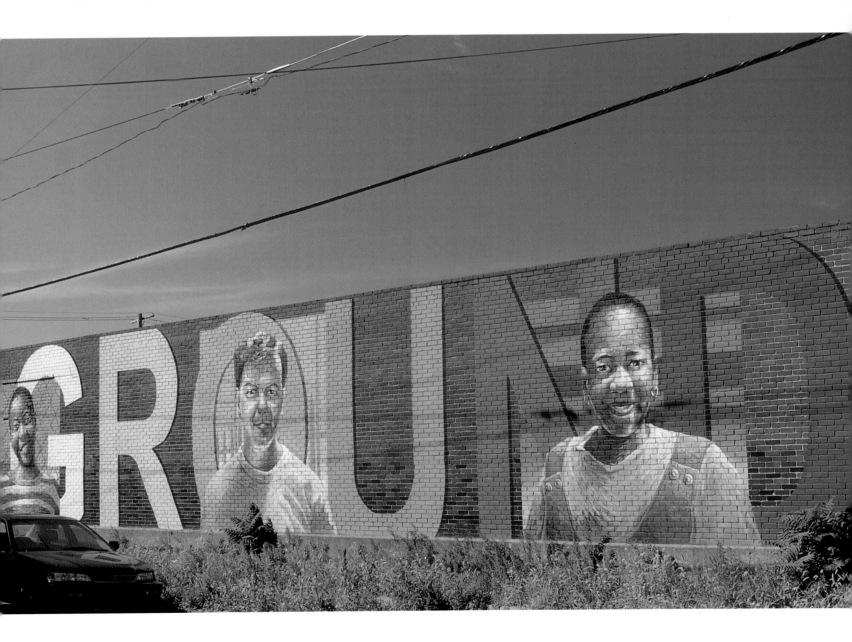

favorite. Something about seeing the dark and light hands touching one another resonated with the room of people who had endured struggles over skin color all their lives. "We were the peacemakers," Ray explained. "We wanted to bring a calmness, to prove all races can love each other."

Jane explained that to make the mural lifelike, she planned to photograph the hands of neighborhood residents. That image would be transferred to a digital slide. Then, the slide would be projected onto a wall, twenty-two feet high by forty feet wide, like a movie, with artists sketching the outlines and details of each hand. The projection process took three long October nights. Each night, both black and white neighbors came out of their homes to watch the work at the wall at 29th and Wharton Streets, across from the city-owned Finnegan Playground. The residents offered cookies, tea, and encouragement.

GRAYS FERRY RESIDENTS JIM HELMAN (LEFT) AND CHARLES REEVES, EARLY SKEPTICS OF *THE PEACE WALL*, ARE NOW PROUD TO HAVE MURALS LIKE IT AND *GUARDIAN ANGELS*, 32ND AND REED STREETS, IN THEIR COMMUNITY.

Up on the scaffolding, Jane and Dietrich Adonis, the mural program's assistant artistic director, worked in tandem in their own exhibit of racial harmony. Though he's black and she's white, after a decade of painting the city together, they would always tell people they didn't see each other in any color.

Once the image was projected onto the wall, Jane and Adonis traced the design—the broad outline of eleven hands, plus every crease and wrinkle in each finger, thumb, and nail. Although the rough sketch looked like a confusing mess of dots and squiggles, it would later help the muralists more accurately depict the tones and colors of the actual hands. Peter Pagast, a muralist known for his precise photorealist style, was brought in to fully capture the human elements of the hands.

Jane, Adonis, and Pagast spent six weeks painting the mural. Neighborhood children, black and white, participated in "peace workshops" and painted minimurals at three Grays Ferry recreation centers. Each day, a police cruiser idled nearby, protecting the artists and their space. One resident, a white man, came by the site several times complaining and suggesting that the mural would be vandalized as soon as it was finished. Surprisingly, Jane found herself nodding in agreement. Of the 1,500 murals in the city at that time, she figured none was as likely to be a target of vandals as this one.

The mural was completed just before Christmas 1997 and dedicated a month later. From a distance, the finished product looks like a giant photograph. Eleven hands—five black, six white—fill the width of the wall: The wrinkled and worn hand of a grandfather touching the smooth skin of a child; the hands of a black mother reaching out to a white mother; a woman wearing two rings; a child with pudgy knuckles; a man's wrist covered with a starched white shirt and gray suit jacket; a black hand with bright red nail polish on neatly manicured nails. To the right of the mural is a low wall with a white dove painted on a black background and the biblical message, "Blessed are the peacemakers, for they shall be called the children of God."

At the dedication, residents and city officials held hands and sang songs. Ray was among a mixed-race crowd feeling the emotions jump off the wall. Years later, she still feels it: "The mural was a symbol of the love that was here in Grays Ferry, as opposed to the hate," Ray says. "It's utopia."

Small steps to progress

In the summer of 1998, a year after the incident at Annette Williams's house, vandals again attempted to keep the Vare Recreation Center pool closed by littering it with glass. This time, they were met with resistance. Michael DiBerardinis stationed police officers at the pool during the day and paid guards to sit outside all night. At the end of each day, the pool was drained. That way, even if bottles were thrown in the dark, the empty pool could be swept clean of glass in the morning and refilled before the children arrived. Given the

"The mural was a symbol of the love that was here in Grays Ferry, as opposed to the hate."

water and labor costs, it was an expensive solution. But it worked. For the first time in memory, the pool stayed open all summer for all neighborhood residents to use.

After *The Peace Wall,* Jane and Ray felt that Grays Ferry residents were ready to experience more murals. In 1999, the Vare Recreation Center was chosen to be part of a new Mural Arts Program educational effort known as the "Big Picture." This multiyear program teaches children mural history and technique and gives them experience painting murals with professional artists in the neighborhood. "It just seemed like the natural thing to do to continue our work in the community," Jane said. "If people didn't buy into the mural, maybe they would buy into the Big Picture program. It's hard to say 'No' to art education for kids."

At the first meeting to discuss the new venture, Jane was surprised by one name on the sign-in list: Charles Reeves, the African American activist who was a longtime mural foe and fairly regular opponent of City Hall initiatives. "I had so feared him," Jane recalled. "I couldn't believe he would come and be supportive."

For the new venture to work, Jane insisted that it serve a mix of white and black students. This was not easy. Mural program staffers had to be vigilant about calling parents and making sure children felt safe and welcome. Unfortunately, as black children began attending in greater numbers, white children started dropping out of the program.

Although Kevin Spicer was not a big fan of *The Peace Wall,* he agreed to let the Mural Arts Program paint the side of his house—in part out of a belief that more murals would benefit the area, in part because he wanted the wall repaired and restored. Even with Spicer on board, Jane knew that some residents in the territory-conscious neighborhood would not be happy with the location. Spicer lived at 32nd and Reed Streets in the far western border of the neighborhood, near Stinger Square Park, a van's ride away from the Vare Recreation Center where most of the children were studying.

Finding a wall was just the first step. Reaching consensus on a theme in the still-splintered neighborhood proved equally difficult. Some wanted a person reading. Others wanted people singing and playing instruments. Some residents wanted to memorialize people from the community who were dead, while others wanted to honor Grays Ferry's living heroes. Jane dared to speak out at one community meeting in an effort to get people to meet in the middle. It did not go well. "We had this little tussle. I could tell they were angry with me. I said, 'Let's pare it down. You're going to have visual cacophony. It's going to be just a mess,'" she recalled. "I said, 'You've got to just work with me here. We're the experts. We can do this. It's a leap of faith. You've got to trust us.'" The group finally agreed, settling on a theme honoring William "Whip" Griffin, a deceased community leader who had been a father figure to many in the neighborhood.

The multiyear program teaches children mural history and technique and gives them experience working with professional artists on painting murals in the neighborhood.

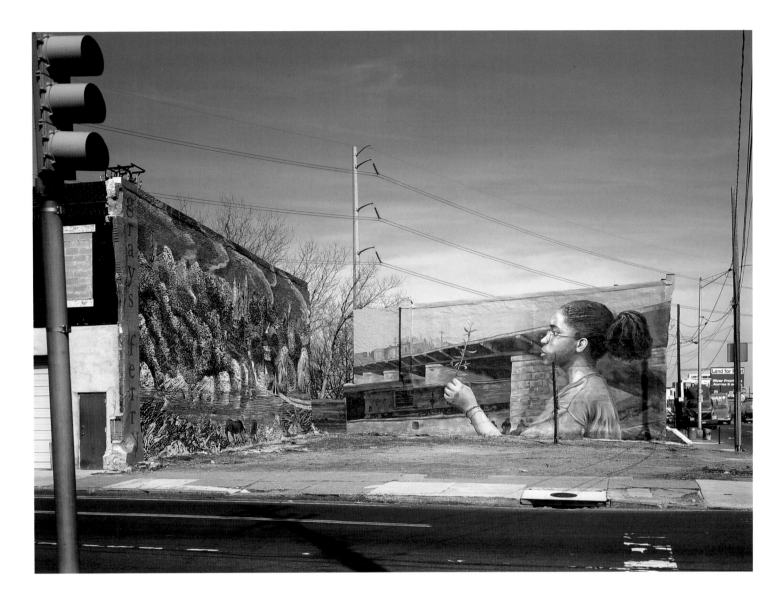

In the summer of 2000, *Guardian Angels* (32nd and Reed Streets, see p. 56) emerged from the hands of two young muralists, Jason Slowik and Eric Okdeh, seniors at Tyler School of Art working on their first major project. In a small space, they captured several images from life in the neighborhood: A father helping his child learn to ride a bicycle; a woman reading to two children; a man assisting three youngsters on an art project; another man coaching a group on the basketball court. At the center of it all is Griffin, watching over his neighbors as they tend a community garden. The mural itself is painted to resemble a work on cloth, being held up on the wall by two cherubs. Facing *Guardian Angels* is another small mural across the street, this one the handiwork of children from the Big Picture program. That mural proclaims in a rainbow of colors that "peace is power."

Unlike *The Peace Wall*, *Guardian Angels* was positively received from the moment the scaffolding was removed. "This mural is ours. We planned it," explains Jim Helman. He is now such a fan that he testified on the Mural Art Program's behalf before Philadelphia City Council, urging politicians to continue the program and increase Jane's funding. Kevin Spicer smiles

THIS *HISTORY OF GRAYS FERRY*, 2001, BY JOSH SARANTITIS, AT 34TH AND WHARTON STREETS, IS TOLD ON TWO WALLS, CAPTURING BOTH THE COMMUNITY'S PAST AND ITS FUTURE. A SCULPTURE GARDEN IS PLANNED FOR THE AREA IN FRONT OF THE MURAL.

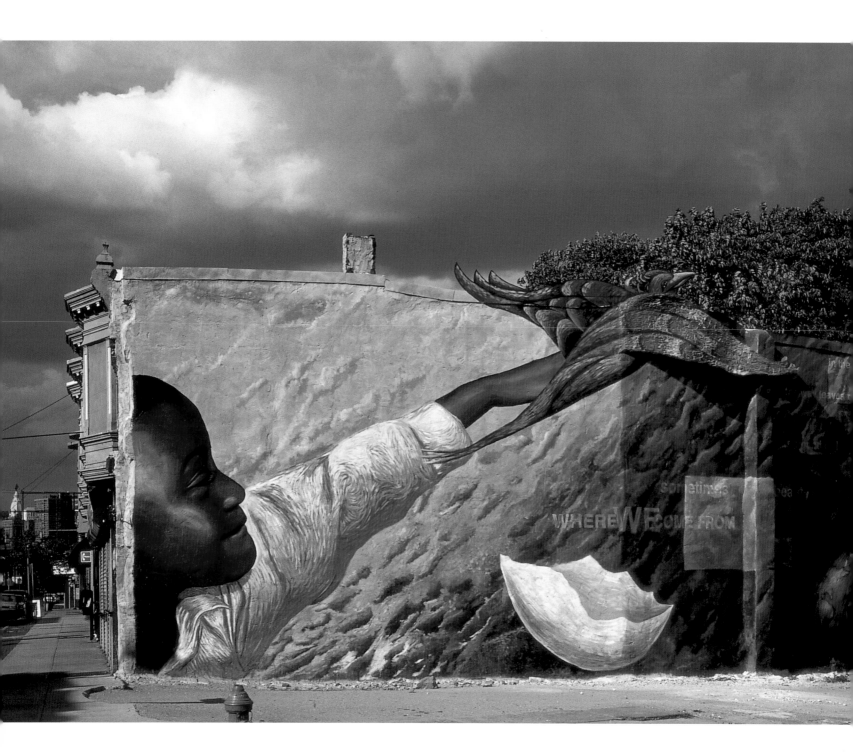

EXTENDING BEYOND THE ROOF OF THE
BUILDING AND INCORPORATING INSPIRA-
TIONAL TEXT, *DREAM IN FLIGHT* BY JOSH
SARANTITIS, 2000, AT 1453 POINT
BREEZE AVENUE ENCOURAGES US TO
ASPIRE BEYOND OUR LIMITS.

when he talks about *Guardian Angels,* saying the mural on the side of his home instills "self-pride" in the neighborhood. Charles Reeves, once one of the program's harshest critics, now says murals "light up the community."

Lillian Ray marvels how, despite the continued economic decline of the neighborhood, *The Peace Wall* has never been attacked with graffiti or vandalized. She wants to add lighting to illuminate the mural and work with residents to create a garden with benches to make the space welcoming for reflection.

In the summer of 2001, the neighborhood got its first "landmark mural," a colossal piece of art painted by Josh Sarantitis on two adjoining walls at the corner of 34th and Wharton Streets (see p. 59). The mural, called *The History of Grays Ferry,* has two parts contrasting the neighborhood's colonial past and industrial present: One wall celebrates the first bridge to cross the Schuylkill River into Grays Ferry in the neighborhood's early days; the other depicts a girl looking back into the past, in front of an image of the modern bridge that leads into the community. The location is key, given that thousands of drivers whizzing by on the busy Schuylkill Expressway see the mural each day.

Just a few blocks away, artist Cliff Eubanks painted *Morning Landscape* (28th Street, near Wharton), the third new mural in Grays Ferry in 2001. (Fourth, if you count the small antiviolence, antidrug mural at 27th and Dickinson Streets painted by children in the Big Picture program.)

Now, even some of *The Peace Wall*'s harshest critics have found themselves changing their minds about the mural that got it all started. The most skeptical, hardened Grays Ferry residents acknowledge that the mural's positive message has done more for the community than silence. "I like it now," admits Charles Reeves. "I'm hoping we will someday be at that point" where black and white really do come together.

Jim Helman, Reeves's white counterpart, testified before Philadelphia's City Council in early 2001: "Having been tested by time, Grays Ferry residents tend to be opinionated, outspoken, and stubborn. There are those who scoff at *The Peace Wall,* saying it is simplistic or idealistic. But, a growing number of residents glance at *The Peace Wall* whenever they pass it and think of the possibilities. They think of what Grays Ferry can be, what Grays Ferry should be." He told the roomful of elected officials: "*The Peace Wall* is a vivid display that the strength of our community is in the diversity of our residents, residents of every faith and belief, of every economic level, and of every ethnic origin. *The Peace Wall* is a great example of the powerful statement that can be made through mural art, even in a troubled community."

"*The Peace Wall* is a vivid display that the strength of our community is in the diversity of our residents, residents of every faith and belief, of every economic level, and of every ethnic origin."

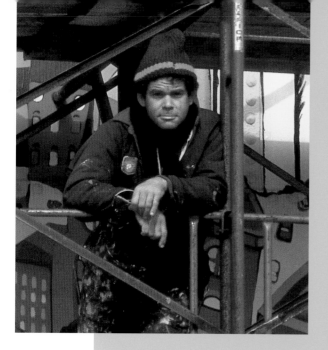

PAUL SANTOLERI

Among the dreary oil refinery operations on Interstate 76, near 26th Street and Penrose Avenue, one oil tank stands out, a peacock among round gray pigeons. "Welcome to Philadelphia" it proclaims above Paul Santoleri's jazzy aerial view of the city. With its playful and varied postmodern skyline, historic red brick Federalist buildings, handsome beaux-arts libraries and museums, and expansive Fairmount Park, Philadelphia is one of the nation's most architecturally engaging cities. When the Philadelphia Tourist Commission and Sunoco sought an artist to preview Philadelphia's charms on the side of an oil tank near the Philadelphia International Airport, Santoleri was the perfect choice.

Covering some 150 feet, almost half the circumference of the sixty-foot-tall metal cylinder, with his mural, Santoleri captured what he describes as, "the busyness and liveliness of the city, with a bit of exaggeration in the architecture." The title *Philadelphia on a Half-Tank* (Penrose Avenue at Platt Bridge, 1999, see next page) spoofs the popular nickname for Botticelli's *Birth of Venus,* "Venus on a Half-Shell." Like the Goddess of Love, the City of Brotherly Love is depicted surrounded by water. Bracketed by two rivers, the condensed scene is "what you would see if you shot up five hundred yards from where I live, in the top of an old false tooth factory," Santoleri says. "I have a really good view from my loft of all the cars, trains, and planes."

To passing commuters and visitors, the mural proffers the heart of Philadelphia like a chunky bouquet trailing ribbons of bustling highways and bridges. Venerable City Hall, topped with a statue of William Penn that is the largest cast-bronze figure in the world, is dwarfed by bobbing and weaving skyscrapers. The Cathedral of Saints Peter and Paul, the Franklin Institute, and the Free Library ring Logan Circle Fountain. To one side is the Philadelphia Museum of Art, where tourists still jog up the "Rocky" steps to dance triumphantly with arms upraised. Santoleri freely rearranged buildings and "threw in some yellow and bright pink to animate the nature of the city." The mural also reflects the artist's child-like fascination with satellite dishes and other curious structures on top of tall buildings.

"When I draw something, I like to be able to dance in and out of it." Rhythm flows from outlines filled in with flat color and shaded with cartoon-like hatching. Santoleri studied art at the University of Arizona, where many of his teachers were muralists. He has done a lot of drawing and painting—sometimes murals—in places like Spain, Italy, and Mexico, where he almost compulsively documents hills, valleys, buildings, and roads in journal-like fashion. He has always enjoyed working big. "I'm able to do large-scale things quickly. I enjoy the physical activity of making huge drawings—instead of using your wrist, using your entire body. I grew up doing construction; I like to work really hard physically. Climbing the scaffolding and that kind of thing feels good for my body, as well as my mind."

When he received his first commission from Mural Arts, Santoleri had just returned from a teaching job in the Dominican Republic. "All those amazing tropical colors down there really changed my palette," he says. There, he also learned how to make three-dimensional relief tiles from a fellow artist. He later incorporated this technique in his first Mural Arts mural—an untitled "tree-of-life thing" (1997) made of tile mosaic at 31st and Baring Streets in West Philadelphia.

Santoleri likes to combine bas-relief tiles with painted areas. *Passion Flower* (4221 Powelton Avenue, 1998) incorporates big tiles about fourteen inches square. The central flower, almost seven feet in diameter, represents the purple-and-white blossom that the artist first saw just before he returned to Philadelphia and was asked to do the mural. He suggested this as the subject matter.

"*Passion Flower* sits right under three large housing projects, and the residents can look down on it," the artist explains. As a background to the gigantic flower, he incorporated one of his characteristic aerial views of the neighborhood, integrated with more distant parts of the city. Although popular tradition links parts of the elaborate blossom to Jesus' wounds, the crown of thorns, and other elements of the Passion of Christ, Santoleri included the words "Passion Flower" in the mural to focus attention on the mysterious energy he associates with the plant, hoping it may become a talisman of power and rebirth for the community. "I wanted people to think of that," he explains. Santoleri structured the design so that it could be partially executed by youngsters participating in a workshop sponsored by the Philadelphia Museum of Art's Education Department. A tile border of grass along the bottom of the wall was easy for the students to create from ceramic pieces and equally easy for them to apply.

Santoleri, who tries to do a couple of murals a year for the Mural Arts Program in addition to his other work, says, "I have a strong sense of my own aesthetic. I'd rather exert a lot of control over a project and allow for input. I want to show the community the best that I can give them. At the same time, they have to live with it; if they say, 'Could you do this?' it's usually easy to do."

PHILADELPHIA ON A HALF-TANK,
PENROSE AVENUE AT PLATT BRIDGE.

NORRIS SQUARE:
WHERE ART AND NATURE
FLOURISH

NORRIS SQUARE:
FLOURISH

Each day in Philadelphia, tourists from around the globe learn about American independence by exploring the buildings and objects left behind—The Liberty Bell, Independence Hall, and the cozy brick house where Betsy Ross is believed to have sewn her famous flag. If those same tourists were to venture just two miles away, they could trace the roots of one American ethnic group without ever leaving their car.

In the twenty compact blocks of the North Philadelphia neighborhood called Norris Square, the history of Puerto Rico unfolds. It's there in the ground, in gardens kept under lock and key to protect the crisp, crunchy *lechuga*, fragrant cilantro, and pigeon peas. It's there in peaceful parks, where children swing on hammocks and run off their after-school energy on newly shorn grass. It's in the air, in the alarm calls of backyard roosters and the big brass Latin music blasting from passing car stereos. It's in the smell, in the scents of *arroz con pollo* that waft from row house kitchens, making stomachs growl.

And it's there on the walls, in the form of murals documenting the roots of a proud people: Murals of the Taino Indians, who inhabited the Caribbean island long before the Spanish; murals where the red blossoms of the *flamboya* tree bloom just like they do in Puerto Rico; murals thick with religious symbols; murals of everyday people doing everyday things to reclaim their neighborhood and maybe, just maybe, preserve a way of life.

Tending the earth, first

Of course, there was no Norris Square and no Puerto Rican immigrants when Philadelphia was founded in 1682. But there was a great outdoors, which William Penn was eager to preserve. Penn envisioned his new city as a "Greene Countrie Towne," an urban center with prominent public parks and homes with their own gardens and orchards. He knew nothing of the skyscrapers and parking garages that would one day shroud the urban landscape. He simply believed the city would be most livable if one acre was preserved as green space for every ten acres developed.

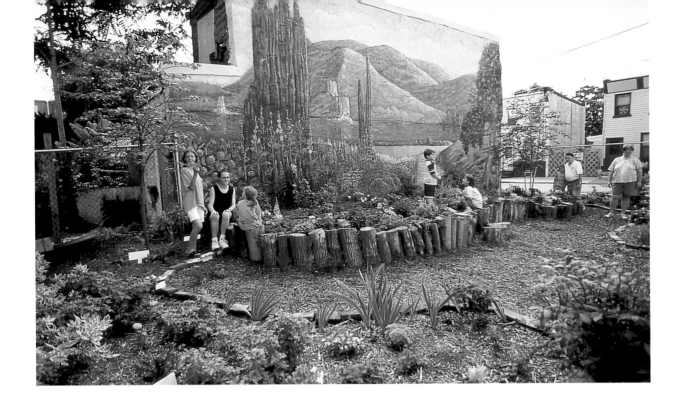

More than three hundred years later, traces of Penn's vision remain in the form of well-used parks and squares all across the city. At more than nine thousand acres, Fairmount Park is larger than some foreign countries, providing plenty of space for cyclists and joggers, rowers, and horseback riders. Many tourists and residents spend summer afternoons lounging in leafy Rittenhouse Square and Washington Square, while others play chess and dominoes in cozy pocket parks in South and North Philadelphia.

Despite the predominance of parks and squares, there are parts of the city today where it is possible to walk for blocks without seeing grass or a single green, growing tree. In 1974, the Pennsylvania Horticultural Society (PHS) staff began to explore how they could help impoverished neighborhoods hit hardest by the city's industrial decline. Using profits from its annual Philadelphia Flower Show, PHS began a new program aimed at beautifying the city's gritty core through urban gardening. They called it "Philadelphia Green" and offered residents seeds, tools, and advice on how to turn even the smallest side yard into a gem of a garden. Soon, window boxes were bursting with flowers. Old oak wine barrels became curbside planters. Street trees were planted where concrete used to be king. Across the city, residents in ravaged neighborhoods were clamoring to be a part of the program. African Americans and ethnic immigrants, in particular, were drawn to the program, which took them back to their rural roots, made them remember the farms and family of their history. "People wanted to save their neighborhoods, which they saw crumbling around them. Gardens were something they could do, something they could control," recalled Mike Groman, Philadelphia Green's longtime director.

A NEWLY PLANTED NEIGHBORHOOD GARDEN IN NORTH PHILADELPHIA, ORGANIZED BY PHILADELPHIA GREEN, SHARES SPACE WITH AN EARLY MURAL DEPICTING AN ITALIAN LANDSCAPE.

By the 1980s, hundreds of gardens emerged within the city's broad borders, convincing the PHS staff that the city was ready for an even bolder approach. Recalling William Penn's verdant visions, a series of modern-day "Greene Countrie Townes" would be cultivated: lush, leafy spaces that would bring a pastoral peace to communities torn by crime and poverty. Funding arrived in the form of a key federal community-development block grant and a three-year, $2 million promise from The Pew Charitable Trusts. A handful of neighborhoods were chosen as test sites, ranging from a 20-block portion of North Philadelphia to Point Breeze, a meandering 120-block swath of South Philadelphia.

In 1988, Norris Square became the last of PHS's seven "Greene Countrie Townes." The 20-block neighborhood runs from Front to 5th Streets and from Berks Street to Lehigh Avenue in a pocket of lower North Philadelphia that became nearly entirely Puerto Rican in the latter part of the twentieth century. The area had once been part of a thriving textile industry, but by the 1980s the factories were long gone.

On one end of the neighborhood, the construction of the Market-Frankford El brought public transit at the expense of the environment, its towering tracks casting a dreary shadow on street life below. On the other end, some of the city's busiest drug dealers flourished on desolate corners. At the center of the neighborhood, addicts haunted once-leafy Norris Square Park in a heroin haze. Children and their parents avoided the place, which came to be known as "Needle Park."

GARDEN "ACTIVISTS" TOMASITA ROMERO, LEFT, AND IRIS BROWN SPEND A QUIET MOMENT IN FRONT OF *WALL OF NEIGHBORHOOD HEROES*, ON 2ND STREET BETWEEN DAUPHIN STREET AND SUSQUEHANNA AVENUE. THIS NORRIS SQUARE MURAL HONORS LOCAL LEADERS.

Reclaiming the land

Simplistic as it sounds, activists like Tomasita Romero and Iris Brown believed that gardening, of all things, might just be the perfect weapon to fight back. If they could organize the community around something people knew and loved, they could teach a new generation of children a constructive activity. Maybe by working the land, they could reclaim it.

From PHS's standpoint, Norris Square had all the right raw materials. The neighborhood was teeming with energetic, active residents who did for themselves what City Hall and posturing politicians never could. Brown and Romero had a special hope for their "Greene Countrie Towne." They wanted to use the gardens to teach children about all the aspects of Puerto Rican life the children never learned in school.

Sit with a group of Puerto Ricans long enough, and eventually the discussion may turn to the land—working it, honoring it, reveling in the way seeds, sunlight, tenderness, and *agua* are all that is needed to bring forth food. Many in Norris Square were already growing

eggplant and cilantro, *gandules* (pigeon peas), and *aji dulce* (sweet peppers). Some were raising chickens and goats on tiny fenced-in farms behind their homes. "Norris Square," recalled J. Blaine Bonham Jr., PHS's vice president, "was a natural."

With Philadelphia Green's help, residents set about transforming the terrain. The work was not without danger. While taking photos of a project, one PHS staff member was mugged by a drug dealer. In addition, a garden at an elementary school was destroyed by vandals. It was years ago, but Brown still feels the sting of the discovery. "We didn't say anything," she recalled. "We just sat against the wall crying."

In spite of the difficulties, nearly one hundred gardens and planting projects were established in Norris Square between 1988 and 1992. During that time, the effort got a major boost in the form of a federal "Weed and Seed" grant to establish a mobile police station alongside the park. The police presence sent the dealers packing.

Painting the bow on the package

Pairing murals and gardens wasn't really planned. Jane and Tim Spencer had known Blaine Bonham and Mike Groman at the Pennsylvania Horticultural Society for years, since their work took them into many of the same troubled neighborhoods. As the Philadelphia Green program took off, PHS staffers found themselves alerting the mural program about garden projects in lots with great walls.

With all the color and vibrancy springing from the ground, Groman said it made sense to add some to the walls around the gardens, as well. "They're both an improvement to the neighborhood, a form of physical rehabilitation," he said. "We're doing the present and the box; Jane's putting the bow on the package."

As the "Greene Countrie Towne" program expanded, murals started appearing in garden lots throughout Point Breeze, Francisville, and Strawberry Mansion. Jane's mural *Mt. Kilimanjaro* (20th and Diamond Streets, 1989) and the garden in front of it were both inspired by a group of North Philadelphia women who had taken a trip to Africa and wanted local children to learn about the greatness of their motherland.

In Norris Square, the partnership between murals and gardens seemed especially appropriate, since residents there wanted both art forms to teach children about Puerto Rico. "Our history is not taught in the schools," Iris Brown explained. "We have been struggling to preserve this culture for many, many centuries. It is still very important to us; it's not a suit that you put on and take off. When I go home to my house, you see the same colors you see on the murals. The murals are an extension. The gardens are an extension. What we cook is an extension. Music is an extension."

"We have been struggling to preserve this culture for many, many centuries. It is still very important to us; it's not a suit that you put on and take off. When I go home to my house, you see the same colors you see on the murals. The murals are an extension."

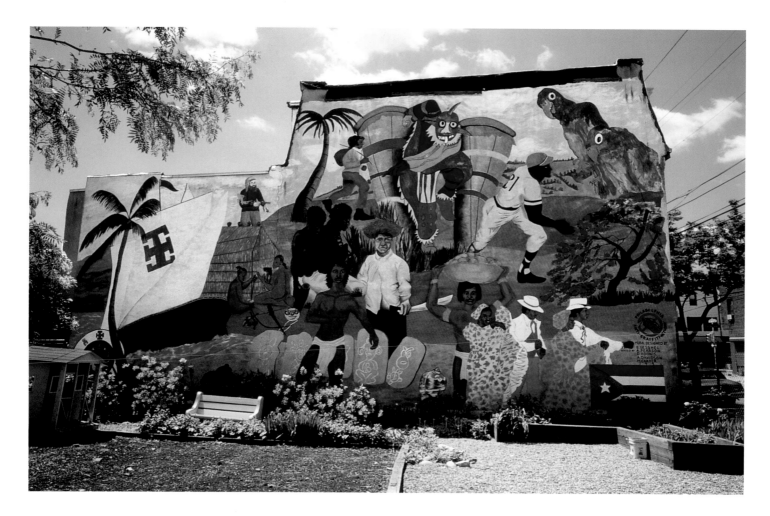

The History of Puerto Rico (2nd Street and Susquehanna Avenue, 1991; restored 2001 by Dennis Daly, shown above) was Norris Square's first major mural/garden project. The mural was painted by Barbara Gishell and designed with the help of residents who were so intent on artistic accuracy that they showed Jane and the artist books and sketches to capture what Brown called "the *real* Puerto Rico." The result is a tribute to the island's complex past, with images of Taino Indians in loin cloths, gun-toting Spanish conquerors, farm peasants, the masked Vejigante figure from island folklore, and even baseball great Roberto Clemente. Amid the people are other symbols of the island: the tiny, ubiquitous *coqui* frog, green parrots, giant conga drums, and the azure ocean washing up against the pale sandy beach.

Residents call the mural and garden *Raices* (Roots). Inside, mint, sage, and yarrow grow in one patch, while lilies and lilacs linger in another. Surrounding the plants are boldly colored picnic tables and benches, birdbaths, and a pint-sized playhouse for children.

Jane didn't travel far to paint her first major mural. The *Wall of Neighborhood Heroes* (2nd Street, between Dauphin Street and Susquehanna Avenue, 1993; restored 2000 by Kimberly Clark, see p. 68) stands just a half-block from *Raices*. Jane's mural honors the Norris Square residents' commitment to gardening. Painted as a series of snapshots with bright Afro-

Latin-inspired borders, the mural includes images of ten local residents who lent their strength and spirit to the community—from the maintenance man who cleaned up vacant lots in his free time to women like Tomasita Romero who showed young people how to garden.

Surrounding the mural are *Las Parcelas,* the award-winning community gardens that transformed a series of trash-strewn lots on both sides of the block into a living laboratory filled with figs, rhubarb, berries, and beans. On a spring day, a calico cat suns herself on one of the bright benches as children rake topsoil across ground once controlled by the drug gangs. Inside stands a cotton-candy-pink *casita* (little house) where children can learn about the wonders of their heritage—from tasting the familiar Puerto Rican *achiote* spice to listening to the poetry of Julia de Burgos. Within the garden complex are two smaller murals Jane painted, celebrating the mountains and views of Puerto Rico.

An international art center

By the late 1990s, the once-primarily Puerto Rican neighborhood began attracting a growing number of immigrants from Mexico and the Dominican Republic, people with their own stories to tell. Jane noticed the shifting demographics and thought that it might be an

VISITING MEXICAN ARTIST ALEJANDRO FLORES GAVE THE NORRIS SQUARE COMMUNITY A HIGHLY SURREAL AND SYMBOLIC DEPICTION OF ASPIRATION AND FAITH IN HIS MURAL *WINGS OF HOPE,* AT HANCOCK AND DIAMOND STREETS.

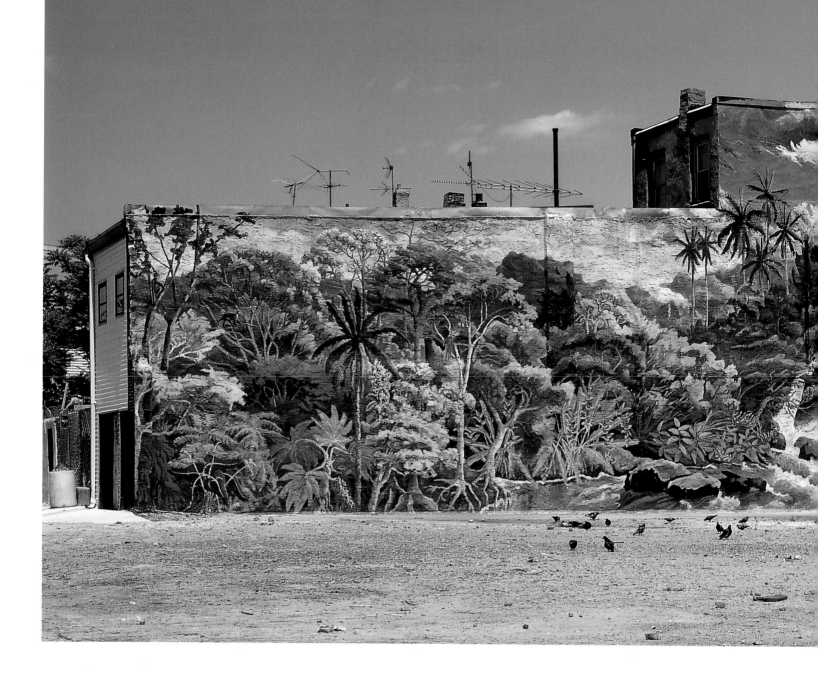

appropriate place for murals by international artists. Local muralist Meg Saligman suggested Alejandro Flores, a Mexican painter she had come to know while restoring Diego Rivera murals in Mexico City. Jane secured $8,000 in corporate funding to commission Flores to paint a fresco in Norris Square.

Residents welcomed him to a design meeting with a sumptuous ten-course meal. But their smiles faded when they saw his sketches. The Puerto Ricans were used to the bright carnival colors of the Caribbean; Flores's designs employed rusts and pale shades. Moreover, the Puerto Ricans took their religious symbols very seriously; Flores's design incorporated mystical images that could be viewed as anti-Christian, including an angel painted from behind. Some figures in the first design were naked, further offending some residents.

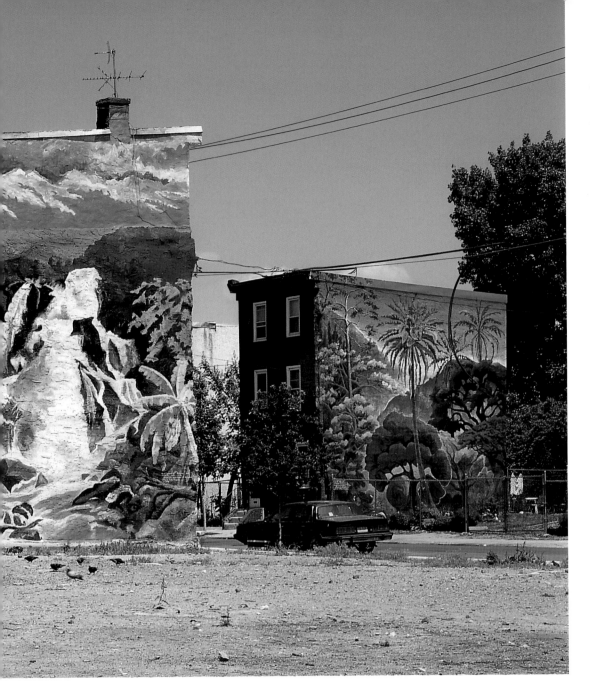

ANA URIBE'S *TROPICAL LANDSCAPE WITH WATERFALL* JUMPS ACROSS THE STREET TO CONTINUE ON A NEIGHBORING HOME IN ONE OF THE CITY'S RARE EXAMPLES OF MIRRORING MURALS.

Flores listened to their fears and, after talking with Saligman, agreed to change his design. In 1999, he created *Wings of Hope* (Hancock and Diamond Streets, see p. 71). The finished product is still heavy on puzzling symbolism: "Aspiration" is portrayed through reaching hands; "faith" through angels with flapping wings; and "connection" by a painted string that meanders through the mural, tying its two arched sections together. Interspersed throughout the mural are Dali-esque images: a chair, a man floating through the sky above a mountain, and pieces of watermelon.

Usually garrulous residents are cautiously tight-lipped about Flores's mural. "It's nice; it tells a story," Iris Brown said. "It means a lot, but people don't have a lot to say about it," adds Tomasita Romero. A local businessman once greeted a visitor to the mural with the urging to walk two blocks away to see "a better mural, a pretty mural." Even Jane

ANGEL COMING DOWN, 2000, BY HAITIAN
ARTIST FRITO BASTIEN, AT 2100 N. 4TH
STREET, OFFERS A GENTLY WHIMSICAL
TREATMENT OF A TRADITIONAL SPIRITUAL
THEME.

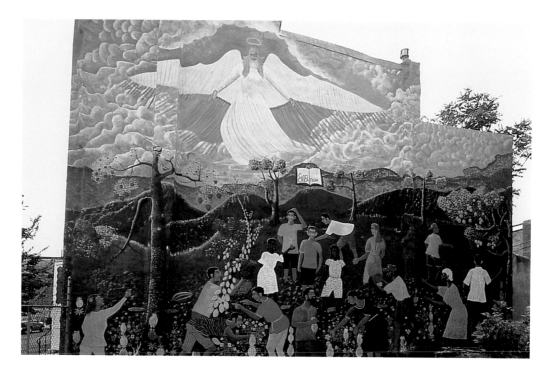

acknowledges that while artistically impressive, *Wings of Hope* is no local favorite. "It's tricky, when artistic vision collides with neighborhood desire," she said, diplomatically. The mural "remains ambiguous. People have had a hard time with it."

Despite the problems over Flores's mural, Jane still believed that Norris Square had the capacity to accept and embrace outsiders and their art. A year later, she tried again, bringing Cuban muralist Salvador Gonzalez to town. This time, the process was much more collegial between the visiting artist and residents. Perhaps it is because Cubans and Puerto Ricans feel a shared sense of struggle in their national histories. It was the residents, in fact, who suggested a butterfly as the basis for the wildly colorful tile mural. "People talked about how the neighborhood had been in a cocoon and had emerged as a butterfly through all the murals and gardens," Jane recalled.

When *Butterflies of the Caribbean* (Susquehanna Avenue, between Hancock and 2nd Streets, 2000, see p. 64) and its companion garden emerged, it was as if an ugly wall on an ugly corner had sprung transformed from its own confining cocoon. The painting is so full of color, depth, and texture that it seems almost like a giant jeweled broach pinned to a wrinkled blouse. Cars passing by the mural stop suddenly, as if their drivers' senses need a moment to recover from the sight.

But is it the wall or the ground they are gaping at? The space next to the mural is known as *El Batey* (Taino for "ceremonial center") and features a *pergola* and an *aldea*, a tiny Indian house. Residents have planted perennials in every available spot, making it exclusively a flower garden. "When they're in bloom, the colors are the same as on the mural," Romero said. "It's like magic."

Where do we go from here?

Patricia DeCarlo likes murals, and she loves how they keep her neighborhood's history alive on the walls. Whenever she starts missing Carmen Aponte, the beloved *comrade* (godmother) of the community who helped found the Norris Square Senior Center and who died in 1996, DeCarlo need only look at the mural outside the senior center to be reminded of the crusades Aponte led so selflessly.

DeCarlo, a lawyer who runs the Norris Square Civic Association, does not knock the work of artists from around the world; she just wants to see more local representation behind the paintbrush. "They've got to use neighborhood community folks," said DeCarlo, even if the murals "don't look as perfect."

DeCarlo may soon get her wish. The mural program received a $30,000 grant from the federally funded American Street Empowerment Zone to paint five murals in the area. In accepting the grants, Jane agreed to involve local artists in the projects. Still, Jane remains conflicted about putting quotas on mural art. "It's simplistic to say that you can just hire artists from the neighborhood," she says. "Doing murals is complex and dangerous. If you wind up with bad murals, everybody's upset."

Iris Brown has a wish of another kind. She wants to bring the Puerto Rican artist Samuel Lind to Philadelphia to paint a project that would help unite the people who now live in Norris Square: Latinos and African Americans. Brown envisions a series of art, music, and dance workshops for residents that would explore the Afro-Caribbean themes in Lind's work before, during, and after his arrival.

"I see his mural as a bridge between the African Americans and the Puerto Ricans," she said. "We're the same; we come from the same culture. We just don't want to talk about it."

The first time Jane hears of the idea, she is off and running, wondering which foundation she can approach for the funding and how quickly she can make it happen. There is nothing she likes more than a neighborhood coming up with its own ideas, thinking of how art and life can complement and challenge each other. "Murals are doing just what they should be in Norris Square—giving a voice to people," she explains.

The Horticultural Society's Blaine Bonham also remarks at how the Norris Square community has come to see murals and gardens as defining emblems, an elemental part of its existence. "The murals became a natural way to interpret their way of life, to show the energy of the community, the color of the community," Bonham said. "I think the real simple beauty of the Mural Arts Program and Philadelphia Green is the way both touch something within people that roots them to their essence."

It was the residents, in fact, who suggested a butterfly as the basis for the wildly colorful tile mural. "People talked about how the neighborhood had been in a cocoon and had emerged as a butterfly through all the murals and gardens," Jane recalled.

ANA URIBE

"Nobody wanted to paint there because it was such a scary place. But I come from a scary place, and I felt at home," explains Colombian-born Ana Uribe. In 1999, she received a commission for her first mural partly because other muralists, artists generally inured to painting from dawn to dusk in the city's most troubled areas, were reluctant to work in such a desolate, infamous spot, isolated by railroad tracks and abandoned buildings. "For anything you want to do bad," Uribe quips, "it was a very good address."

Tons of garbage—furniture, refrigerators, even cars—had accumulated for years on this lonely block of Indiana Avenue between 16th and 17th Streets. Then, it acquired a more sinister reputation. The corpse of Aimee Willard was discovered there by five local boys in 1996. Willard, a college lacrosse star from Brookhaven in suburban Delaware County, had been kidnapped from her car on an expressway and murdered.

The tragedy of Willard's death eventually led to the transformation of one of the city's worst blocks into what Doris Phillips, executive director of the group HERO (Helping Energize and Rebuild Ourselves), now calls "a blessing in the community." Joined by Gayle Willard, Aimee's mother, Phillips led groups of young people and other volunteers from several parts of the city in devising and implementing a plan to clear and convert the area into Hope

Park Garden, dedicated to Aimee Willard's memory. In addition to plantings, there are picnic tables, a stone entrance, a barbecue pit, a gazebo, and even a shrine to the Virgin Mary. As the new environment took form, Phillips realized that "the wall [of an adjacent building] was just bland." So she asked Mural Arts for a mural.

Willard wanted sunflowers—Aimee's favorites—and Phillips mentioned a waterfall, but Uribe told them, "Putting those two together is like mixing bananas and catsup." The compromise design for the relatively small mural, entitled *Sunflowers: A Tribute to Aimee Willard* (17th Street and Indiana Avenue, 1999) is a wind-swept field of giant sunflowers with bowed heads, next to an area of fast-moving water. Uribe, who "borrowed" two sunflowers from Van Gogh, feels, "It's a beautiful mural because the colors are vivid, but it's also very sad."

For Uribe, a mural is "just a big painting." Bypassing traditional methods of transferring a drawing to the wall, she often improvises—though this means she must paint alone. "I attach my brushes to long sticks like Matisse [did]. If I goof, I go back with the blue [background sky color]."

In addition to numerous barbecues and community meetings, movies have been shown in Hope Park Garden. A wedding was even held there. The park received the Philadelphia Horticultural Society's City Gardens Contest First Prize for the year 2000. Uribe occasionally joins other volunteer gardeners there. "I love it," she says. "Sometimes it feels very spooky, but sometimes it feels very good."

Uribe specializes in landscapes and flowers. She based her design for the exuberant *Garden of Flowers* (20th and Poplar Streets, 2000) on a bouquet given her by a friend. From above, it looked "like an explosion of flowers." As part of the project, Uribe worked with two hundred students who painted the ceramic tiles bordering the wall. Additional tiles embellish planters and park benches in the adjoining garden, creating a visually unified environment. In another landscape mural, *Tropical Landscape with Waterfall* (5th and Berks Streets, 1999, see p. 72), Uribe incorporated a parrot and two monkeys. The complex scene is partly invented and partly based on photographs and memories of her homeland.

Uribe grew up in Colombia, South America, where her family owns a ranch. Because her mother's family is American, Uribe and her siblings attended college in the United States. She graduated from Philadelphia's Moore College of Art and Design in 1977 and returned to Colombia, where she made a successful career as a landscape painter. There, she lived and worked alone in Chocó, on the Pacific side of the Andes, where the jungle meets the sea—an area accessible only by plane. It is, she says, "the most untouched place on earth, ... beautiful, like the Grand Canyon." She painted outdoors on heavy boards cut from jungle trees, and used a radio to communicate with the army: "So I was safe." Her work began to be known and sought after.

She decided to return with her young son to the United States after her mother was kidnapped, an event that is relatively common in Colombia. "They kidnapped her because I wasn't there," Uribe learned. Although her mother was ransomed and

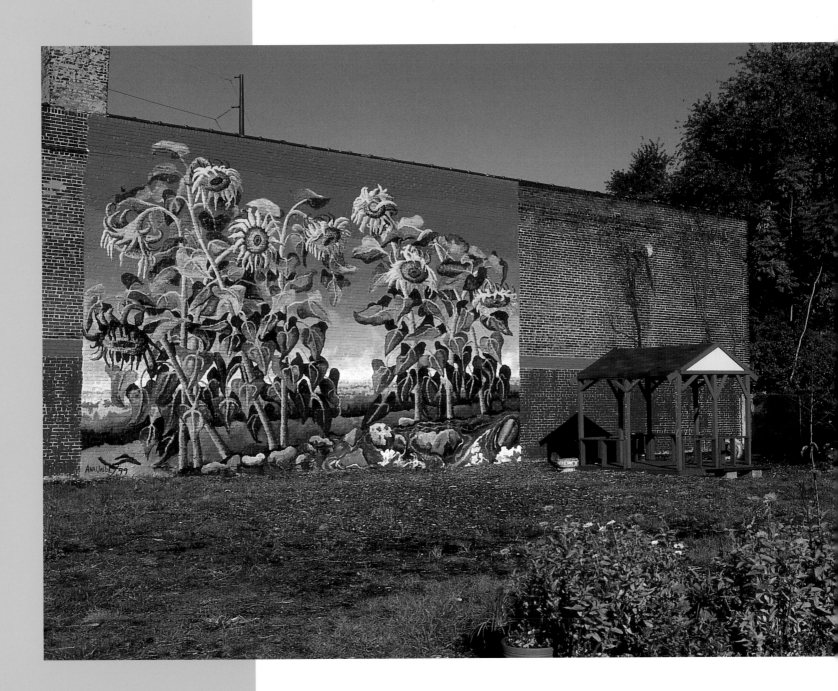

safely returned, Uribe sought a more
secure life in Philadelphia. Jane saw a
postcard of one of her landscapes and
approached her about mural painting.
Now Uribe is rehabbing a row house
in the Northern Liberties section of
Philadelphia. She has a studio and
paints outdoors even when she isn't
working on a mural. "I don't have much
of a social life," she laughs. "The best
thing is I sleep all night long. I don't
worry about anything."

*SUNFLOWERS, A TRIBUTE TO AIMEE
WILLARD*, 17TH STREET AND INDIANA
AVENUE.

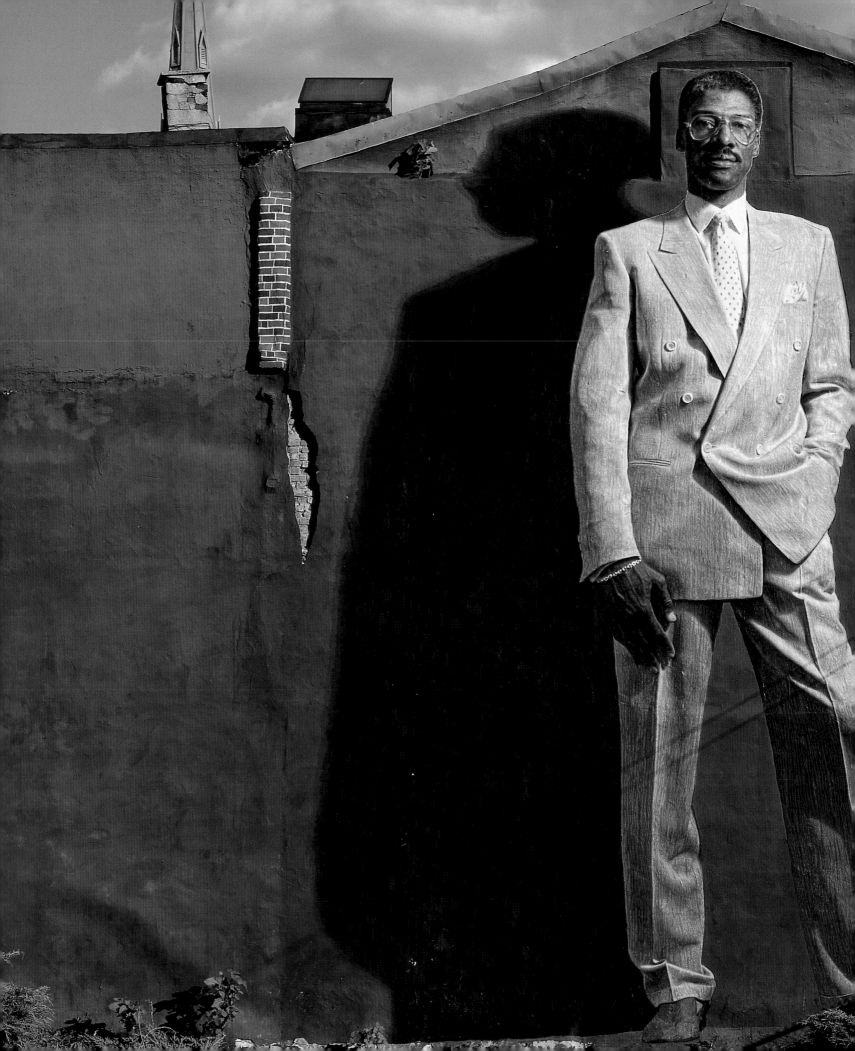

THE MURAL ARTS PROGRAM COMES OF AGE

PRECEDING PAGES *DR. J* AT 1234 RIDGE AVENUE, BY LOS ANGELES MURALIST KENT TWITCHELL, IS ONE OF PHILADELPHIA'S BEST-LOVED MURALS AS WELL AS THE FIRST TO INCORPORATE PARACHUTE CLOTH. THE ENTIRE FIGURE OF DR. J. WAS PAINTED ON LARGE CLOTH PANELS, WHICH WERE THEN ADHERED TO THE WALL WITH ACRYLIC GEL.

On May 22, 1996, a month after Tim Spencer's death, Mayor Ed Rendell's office announced "a comprehensive reorganization of the City of Philadelphia's graffiti-fighting efforts." The press release went on to explain that the Philadelphia Anti-Graffiti Network (PAGN) had been absorbed by the Mayor's Office of Community Services (MOCS). Although the *Philadelphia Weekly* reported that six field reps had been slated for pink slips, the transition was billed as an expansion.

Out of thirty paragraphs in the press release devoted to the city's renewed anti-graffiti efforts, only one mentioned the "highly acclaimed" mural program, which would now be administered by MOCS and operated out of the Department of Recreation.

Although it was the end of PAGN, it was the beginning of the Mural Arts Program. After twelve years, Jane, Adonis, and the rest of the mural crew had a new home. They were warmly received at the Department of Recreation. "I was convinced that we were the right fit for [the mural program]. I was really interested in expanding art and cultural arts," recalled Michael DiBerardinis, then the Department of Recreation commissioner and a former community activist himself. "We had a pretty one-dimensional, narrow approach in the recreation department. When I talked to Jane, it was clear that we could benefit her program and she could benefit us. It became clear that this could be a very good marriage."

DiBerardinis encouraged Jane to make the quality of the murals a priority, something she had been able to do with only moderate success in years past. In the program's infancy, inexperienced teenagers with inferior materials were usually behind the paintbrush. The murals were hardly artistically ambitious. Nevertheless, neighborhood people constantly requested the lush landscapes, waterfalls, and mountains that had become the program's calling cards. "People would have a physical response to them," Jane recalled. "We'd hear over and over, 'Oh, I feel I can touch the water. I feel like I could dive in.'"

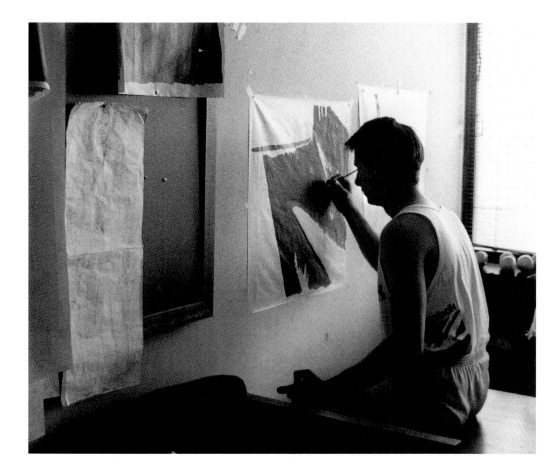

Muralist Ana Uribe believes she understands the enduring popularity of the waterfall motif. "They symbolize ablution—to cleanse your past. It's the thing Jung calls the collective memory. We all have that need. It's basically what we're doing with the mural program. We're cleansing the past."

Jane felt conflicted. As an artist, she was tired of painting the same outdoor scenes, but she was not sure her opinions should dictate what went up in the city's emerging outdoor gallery. "I was grappling with the definition of public art—what it means. I thought, 'It's the community's mural. It's their voice. If I don't like it; that's my problem.'"

Feeling restless and desperate to improve the quality and variety of the murals, Jane made a decision in 1990 that would forever change the Mural Arts Program. She raised money from private foundations to bring her old friend and mentor Kent Twitchell to Philadelphia. She wanted a "breakthrough mural," and Twitchell—a nationally acclaimed California artist—was just the man to paint it. "We knew we had to push the boundaries," she said. "The goal was to try to integrate superior artwork with a subject that touched the community in a special way."

Twitchell was known for his portraits, and he lobbied to paint basketball great Julius Erving in a business suit instead of a uniform to portray him more as a man and role

model than simply another well-known athlete. The dignified, full-length portrait (*Dr. J*, 1234 Ridge Avenue, near Spring Garden Street, 1990, see p. 78) is so tall that Erving's head just fits under the peak of the three-story building. The image was first painted on large squares of parachute cloth, which were then adhered to the wall surface with acrylic gel. The cloth's smooth surface allowed Twitchell to craft Erving with uncannily realistic detail, from the crease in his tan suit trousers to the gold bracelet on his right hand. Local residents, who maintain a small park in front of the mural, claim that the real Dr. J. had tears in his eyes when he saw the completed portrait for the first time. *Dr. J* is also the only Philadelphia mural so respected that it appears in homage in *another* mural, the student-painted panorama of urban life on the Spring Garden Street Bridge.

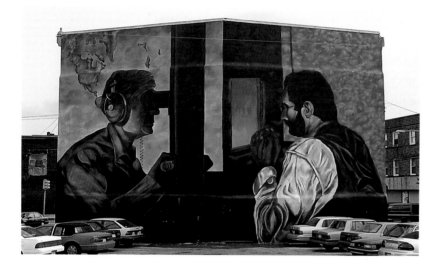

"The mural was universally applauded. It showed that murals have the potential to be great. The level of expectation was raised," Jane said. The mural helped alter public opinion about the program, too. "The art snobs, people who'd been looking down at our murals, started to change. There was a ripple effect—foundations and grants started to emerge."

A new outlook, a new vision

Dr. J marked a new era in mural making in Philadelphia. Jane began brainstorming about other well-known artists she could commission. Sidney Goodman agreed to design *Boy with Raised Arm* (40th Street and Powelton Avenue, 1990, see p. 18), based on one of his better-known paintings. The mural shows a child reaching for the sky next to the inspiring Walt Whitman quote, "I am large. I contain multitudes."

A year later, Vincent Desiderio allowed his painting *The Pathology of Devotion* to be copied in a mural painted by Jane, Adonis, and the rest of the mural crew. It was later restored by Eric Okdeh and Jason Slowik (12th and Morris Streets, 1991, see above). The surreal scene on an angled wall features a man looking through a submarine periscope into a confessional booth containing a priest listening to the military man's confession. Each day, South Philadelphians walk by the mural scratching their heads, trying to determine exactly what the image means. The mural went up just as the Gulf War broke out, an interesting coincidence given the significance of the military and religious subject matter to this largely Roman Catholic neighborhood.

In 1994, Jane and her crew tackled two immensely challenging projects. *The Ledge Wall* (Interstate 76, near Girard Avenue, 1994, see next page) was painted fifty feet above one of Philadelphia's busiest expressways. The artists worked on scaffolding perched on a ledge projecting out from the wall. The painting conditions were so dangerous that even some

hardened former graffiti writers were nervous about the job. Based on an Edward Hicks's painting called *The Peaceable Kingdom*, the mural features images of a lion, a lamb, and an exotic selection of other wildlife. The animal menagerie is appropriate, given that the mural was being painted in the neighborhood of the famous Philadelphia Zoo. The theme of a "peaceable kingdom" was also fitting, since a racially mixed group of teens helped paint the mural.

The History of Immigration (2nd and Callowhill Streets, 1994, see p. 86) took Jane, Adonis, and a crew of twenty teens an entire year to paint—understandable, since the wall was six-hundred-feet long and twenty-feet high. The painted history, from Native Americans to the modern civil rights movement, later caught Hollywood's eye; it was featured in the Academy Award-winning movie *Philadelphia,* starring Tom Hanks and Denzel Washington.

Jane also experimented with abstract murals in Center City, such as *The AIDS Quilt* (2nd and Vine Streets, 1994, see p. 86), which she painted along with Adonis and a mix of activists, neighbors, artists, and novices, ranging in age from fifteen to eighty-five. Jane was trying to push expectations and assumptions about the Mural Arts Program. "The workshops were getting better, and we were getting good press and lots of support. There was no turning back."

Reorganization and rebirth

If hiring Kent Twitchell to paint *Dr. J* was a creative watershed for the program, then the move to the Department of Recreation was the political leap Jane had been waiting for. In its new home, the Mural Arts Program reinvented itself.

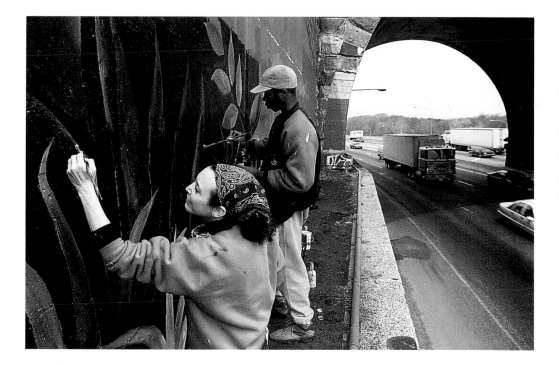

A PHYSICAL AS WELL AS ARTISTIC WONDER, *THE LEDGE WALL* MURAL WAS PAINTED USING SCAFFOLDING PERCHED ON A NARROW LEDGE ABOVE TRAFFIC HURTLING BY ON THE SCHUYLKILL EXPRESSWAY. TO CHECK THEIR PROGRESS, THE ARTISTS HAD TO GET INTO A CAR AND DRIVE TO THE OTHER SIDE OF THE RIVER.

DAVID GUINN

David Guinn is pleased when people tell him his murals look like part of the neighborhood. "What I think about when doing the design is finding something that will belong and work as part of the larger scene of buildings and trees," he explains. "One of the major considerations in working with murals in general is fitting the painting into its context through color."

While he was still in his twenties, Guinn and his mural *Crystal Snowscape* (10th and Bainbridge Streets, 1999, see next page) were featured in *Spin* magazine. "My dad is a Philadelphia painter. I studied architecture at Columbia [University in New York City], and thinking about context is definitely something I got out of architecture class." Guinn also feels that the "style of fracturing," which makes his murals so recognizable, is rooted in the conventions of architectural drawing and the analytic skills involved in model making. The grid-related lines move through space and organize the visual experience along "lines of force." Many people associate the faceted color areas in his murals with the geometric shapes and muted palette of Cubism. Although Guinn does not think of himself as a Cubist, one of his favorite artists is Lyonel Feininger, an American member of the Cubist-influenced German Expressionist movement *Der Blaue Reiter*. Guinn is also especially fond of Paul Klee, another member of the group.

In *Crystal Snowscape*, the composition's interlocking right-angled shapes juxtapose warm and cool, light and dark, and subtle variations on the complementary colors orange and blue—contrasts that simultaneously seem to suggest and resolve polarities. Squares and rectangles spring not from the dictates of a digitized image, but from the artist's imagination. "I want to be free and human, but I like the structure of a rigid grid, too," he explains.

After receiving his bachelor of arts from Columbia University in 1994 and working briefly with an architectural firm in New York, Guinn returned to Philadelphia. "The Mural Arts Program was going, and I was really excited about it and eager to get involved. I wanted to paint murals in New York, but there really isn't a program. I liked the idea of painting really big."

One of his first assignments, shared with artist Barbara Smolen, was the mural *Casa di Pazzo* (12th and Federal Streets, 1999), painted on the exterior of the Italian social club of the same name. The group portrait mural includes about twenty people "dressed like they're going to a wedding," all based on photographs from the 1950s and 1960s. "The wall is small, and I thought it would go pretty quick," Guinn recalls, "but there were so many people, it took a lot longer. I'm glad I got to know those guys. They hung out all day in this club and came out to watch me paint and give me tips. They were kind of particular about how they looked. It was hard to draw the line at who got in the mural. People who were friends would come by and want to be in it. There could have been seventy-five people."

Guinn was offered the *Crystal Snowscape* wall when another muralist's project fell through. The scaffolding was already in place, and, he says, "there was a lot of pressure to do it quickly. I did the design in one day. I found this photograph of a flood that was taken from up high. I didn't quite know where I was going [with it]. There was a lot of unconsciousness in it." Guinn transformed the flood into a shimmering, dream-like snow scene in which ambiguous lighting and altered perspectives are harmoniously resolved. "I felt that I learned about myself in that painting," he recalls. "I thought, oh, there could be a cross-country skier. The figure is taken from a photograph of a woman skiing, but, of course, it's me. It had this very specific and timely significance about my life and where I was at that time. All the houses in the foreground are really dark. The present is dark and the future is light.

"I like the idea that you can read it abstractly or representationally. Up close, it's just colors and shapes. I also like the idea of having this enormous space with figures that are life-size or smaller. What an amazing wall that people could enter —to have a world open up on the wall."

Crystal Snowscape is the first of a series of four seasonal murals in the works. "They're all stylistically linked, but I want there to be an evolution through all four seasons in style and content. I think that won't be clear until they're done."

"The murals I like best represent a moment of soulfulness in the city," Guinn observes. "I see murals as art and a person's vision that comes through. I really like Parris [Stancell]'s work. He's fully invested in his artwork, and the

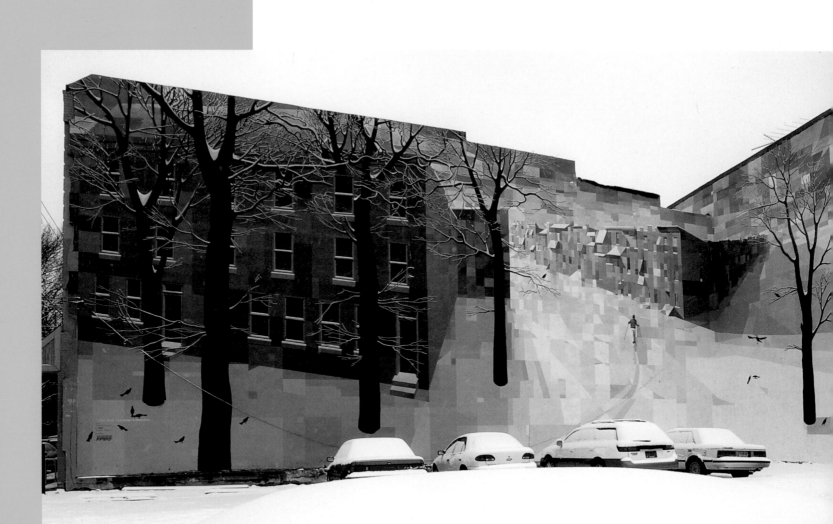

design is kind of open. I definitely want to please the community, and I like to keep the design loose so that I can absorb the experience of being in the community and put that into the mural. I don't necessarily feel like I have the role of addressing specific community problems or having a political element. I'd like to provide a subtle moment that would be fulfilling to the spirit—uplifting in that way."

CRYSTAL SNOWSCAPE, 10TH AND BAINBRIDGE STREETS.

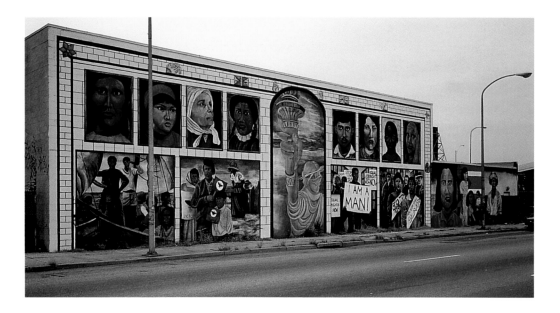

"We had to start thinking about how we define community. How do we do murals with lasting impact? How do we figure out where to work with a waiting list of several thousand people?" Jane recalled. Under DiBerardinis's guidance, the program began making smarter decisions. "We started asking, 'Are you organized? Will you pull the weeds in front of the mural? Is this mural significant to your community in a larger way? Are there kids who will work with us?'"

The typical process of designing a mural might be described as triangular. On one side are the local residents—people who request a mural and are nearly always invited to be intimately involved in approving the subject matter. On another side are the foundations—nonprofit agencies or corporations that give money to sponsor murals. On the third is the city—Jane and her representatives. Smack in the middle of the triangle is the muralist whose job is to pull all the ideas together and create a memorable piece of art.

Of the hundred or so murals the program now paints a year, only a dozen are financed exclusively by the city. Most of the rest are financed by philanthropies (such as The William Penn Foundation and the Independence Foundation) or corporations (such as GlaxoSmithKline, a pharmaceutical company; CIGNA, the insurance conglomerate; or KPMG, a consulting giant). Sometimes, small businesses, community organizations, and churches will sponsor murals as a way to beautify their surroundings and keep graffiti at bay. Although the Mural Arts Program is a city agency, it may accept private contributions to supplement its limited public resources. Nearly two-thirds of its budget is raised from private sources, which enables the program to pursue an ambitious agenda.

Uniting and dividing

Murals are prized and commissioned because of their ability to unite communities and express core values. But the power of public art can also work against itself, with murals providing a focus for community conflicts and division.

Sometimes, neighbors who have come together behind the idea of a mural can wind up sparring over themes and locations. Residents may argue over who should appear in the mural and how they should be represented. Sometimes they find fault with the finished product, even if it is just what they requested. After Diane Keller finished *Frank Sinatra* (Broad and Wharton Streets, 1999, see p. 107), some fans complained that the crooner looked too brooding and world-weary; they wanted his face repainted. It was not an unprecedented request. After Walter Edmonds painted a portrait of *Father Paul Washington* (3364 Ridge Avenue, 1990, shown at right)—a beloved local religious leader and important social activist— neighbors were not satisfied with the likeness. So, Washington's face was repainted by another artist, Stuart Yankell.

At one planning meeting in the drug and violence-plagued Mill Creek section of West Philadelphia, a half-dozen residents still reeling from a recent mass murder agreed they wanted a mural that promoted peace and healing. But how were they to achieve it? Some residents wanted a mural featuring animals getting along in nature; others wanted a more literal interpretation with images of prisons and cellblocks to scare children into toeing the line. Parris Stancell, the artist in charge, sat in the audience taking notes and puzzling over how to turn their wishes into a painting.

"It's almost dangerous, aesthetically, to open up the theme to so many people," Jane admits. "But I'm not sure how you do it otherwise." Artists frequently create several designs and let the community choose one, even though the community may be represented by only a handful of active residents. When Jane is present at the design meetings, she can often help residents realize that what they want may not make good art.

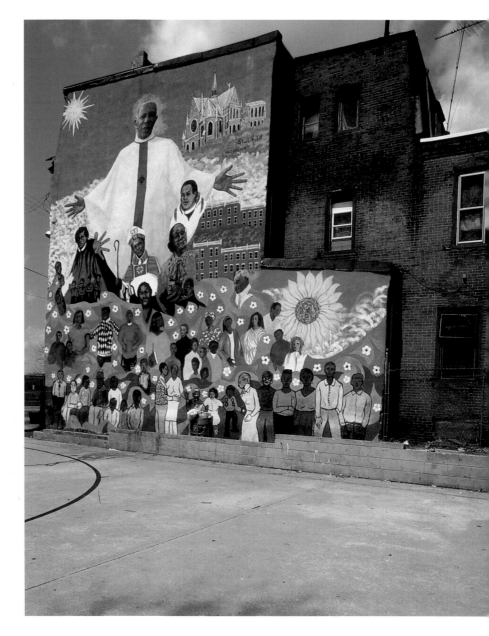

THIS MURAL OVERLOOKING A PLAYGROUND HONORS *FATHER PAUL WASHINGTON*, A BELOVED LOCAL RELIGIOUS LEADER AND SOCIAL ACTIVIST. WASHINGTON'S FACE, WHOSE ORIGINAL RENDERING WAS NOT TO NEIGHBORS' LIKING, WAS REPAINTED BY STUART YANKELL.

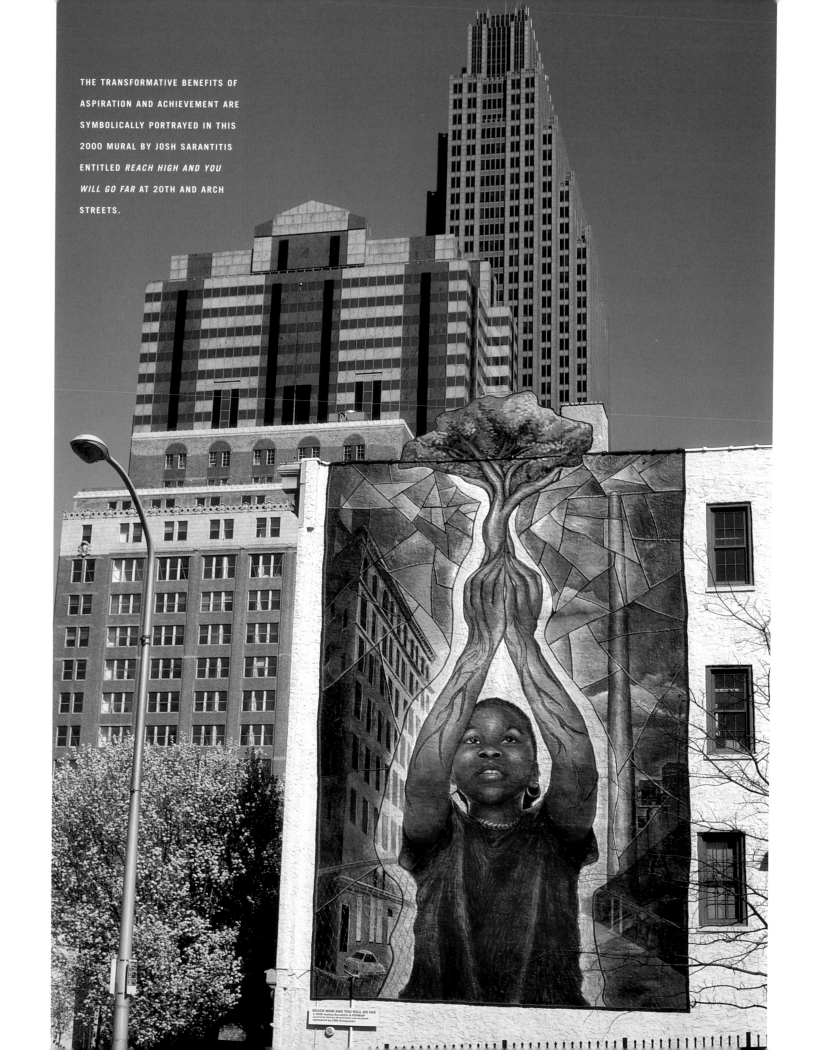

THE TRANSFORMATIVE BENEFITS OF ASPIRATION AND ACHIEVEMENT ARE SYMBOLICALLY PORTRAYED IN THIS 2000 MURAL BY JOSH SARANTITIS ENTITLED *REACH HIGH AND YOU WILL GO FAR* AT 20TH AND ARCH STREETS.

Murals can become targets of racial and ethnic tensions in communities. In 1998, a six-by-fourteen-foot mural painted at the Jardel Recreation Center in the Burholme section of Northeast Philadelphia was destroyed—a first in the program's history. Artist Andrea Lyons told reporters at the time she suspected the vandalism was the work of local residents who objected to the mixed complexions of the eight swimmers she had designed and painted on the wall. She said a group of teens saw her at work and told her to "whiten" the mural. Within weeks of its completion, the mural was obliterated by a coat of beige paint. Michael DiBerardinis was outraged. "That was a disgrace. People gave up on that mural and the dialogue and just painted over it. It was a crime," he said.

Center City has also been home to conflict. Despite the program's prominence, some people still equate murals with urban blight and argue that murals don't belong in thriving Center City. Sometimes, racial and ethnic undertones emerge in the opposition, with residents suggesting that murals featuring people of color do not belong in predominantly white parts of the city. That artistic segregation is bolstered by reality: It is indeed uncommon to find murals with white faces in mostly black, Hispanic, or Asian neighborhoods.

RESTORED IN 2000, THIS COLORFUL MURAL ON THE SIDE OF TALLER PUERTORRIQUEÑO, A CULTURAL CENTER AT 5TH STREET AND LEHIGH AVENUE, RE-CREATES THE BRILLIANT COSTUMES AND LIVELY STREET SCENES OF LATIN CARNIVALS.

Consider the case of *Reach High and You Will Go Far* at 20th and Arch Streets, painted by Josh Sarantitis in the summer of 2000 (see left page). It is in an odd stretch of the city—semi-residential, semicorporate—an area without a strong or unified community identity. The mural was commissioned by a local business whose employees are active in literacy programs. The mural, on the company's own external wall, features an African American girl reaching for the sky, a towering tree sprouting from her up-stretched hands. The girl has roots—instead of veins—running through her arms. In the bottom left corner looms a small collection of more ominous images, including an abandoned car and boarded-up buildings.

Symbolically, the painting is a testament to the value of human aspiration, a visual homage to the notion of dreaming it and achieving it. The tableau at the bottom seems to represent both the negative forces that can get in the way of one's goals and the unpleasantness that can be left behind after achieving success.

The corporate sponsors were thrilled with the bright and deeply meaningful mural. One local community group was not, however. Its members deemed the painting inappropriate, repeatedly reminding Jane that Logan Square is a "prosperous" neighborhood. Some also made reference to the girl's skin color. Although dissenters demanded that the mural be repainted, the opposition was not universal or widespread enough to warrant a change.

The experience was both troubling and depressing for Jane. It caused her to rethink some of her long-held beliefs about how best to gain community approval for murals, and, for that matter, even whom to ask. "What defines a community?" she pondered. "Is it the people who wait for the bus? Is it the people who bicycle or walk by the wall? Or those who live in skyscrapers? Is it everybody?"

Jane also started wondering whether the program should be operating in all areas of the city, especially when some communities clearly crave murals while others shun them. "Certain areas of the city will always be difficult," she said, mentioning affluent neighborhoods around the Philadelphia Museum of Art, Rittenhouse Square, and Chestnut Hill. Given the likelihood of opposition, Jane wonders if she should be so intent on trying to win over all the naysayers. "It's not worth it," she has decided. "I'd rather spend my energy in the neighborhoods and communities where murals are wanted."

At least one powerful mural fan hopes that Jane won't let criticism cause her to doubt the lasting power of public art. "I completely and absolutely reject that [murals] are a sign of something negative," said City Councilman Michael Nutter, an enthusiastic supporter of the program. "It's outdoor public art. Just like statues, murals are landmarks.

Taking it to the next level

Michael DiBerardinis, the former commissioner of the Department of Recreation, is among those who worry about saturation and the emerging trend of invoking pop culture with murals. Already, the city has walls featuring singers Patti LaBelle, Mario Lanza, Frank Sinatra, and Marian Anderson, not to mention athletes such as Dr. J. and Wilt Chamberlain.

DiBerardinis worries about all the "pop icons." It is easy for him to see the program going too far—from Frank Sinatra to the Flintstones. "Where's your next stop? Do you do Joey Bishop? Do you do Frankie Avalon? Will Smith? Allen Iverson?" DiBerardinis thinks the program should establish guidelines about whom to paint, but knows it is a slippery slope. In many Philadelphia neighborhoods, Philadelphia 76ers basketball star Allen Iverson is a hero worthy of the same adoration as Mario Lanza, whose portrait mural on South Broad Street by Diane Keller is beloved by that area's community.

IN *SECRET BOOK*, 1999, BY JOSH SARANTITIS, AT 19TH AND WOOD STREETS, THE POWER OF READING TO INSPIRE A YOUNG PERSON'S IMAGINATION IS EXPRESSED THROUGH IMAGES OF FLIGHT AND FANTASY.

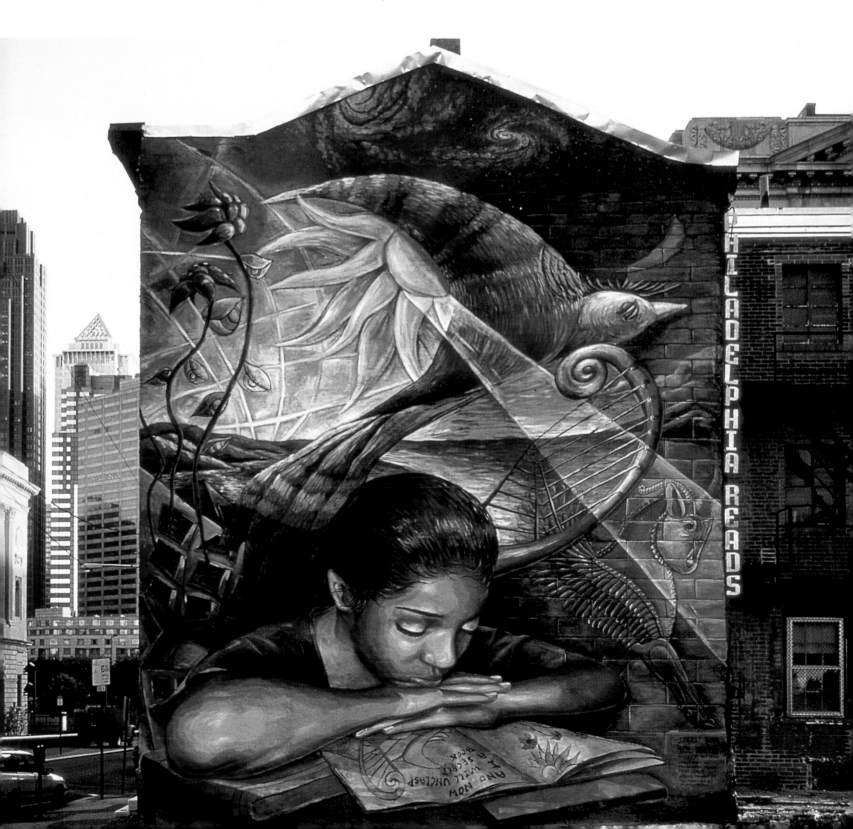

UNDERGROUND RAILROAD, 2000, BY
SAM DONOVAN, WAS LOST WHEN ITS
BUILDING AT 908 CHESTNUT STREET
WAS DEMOLISHED IN 2002. THE MURAL
CELEBRATES THE COURAGEOUS WORK OF
HARRIET TUBMAN AND PHILADELPHIA-
AREA ABOLITIONISTS WHO HELPED MAKE
FREEDOM A REALITY FOR HUNDREDS OF
SLAVES ESCAPING NORTH.

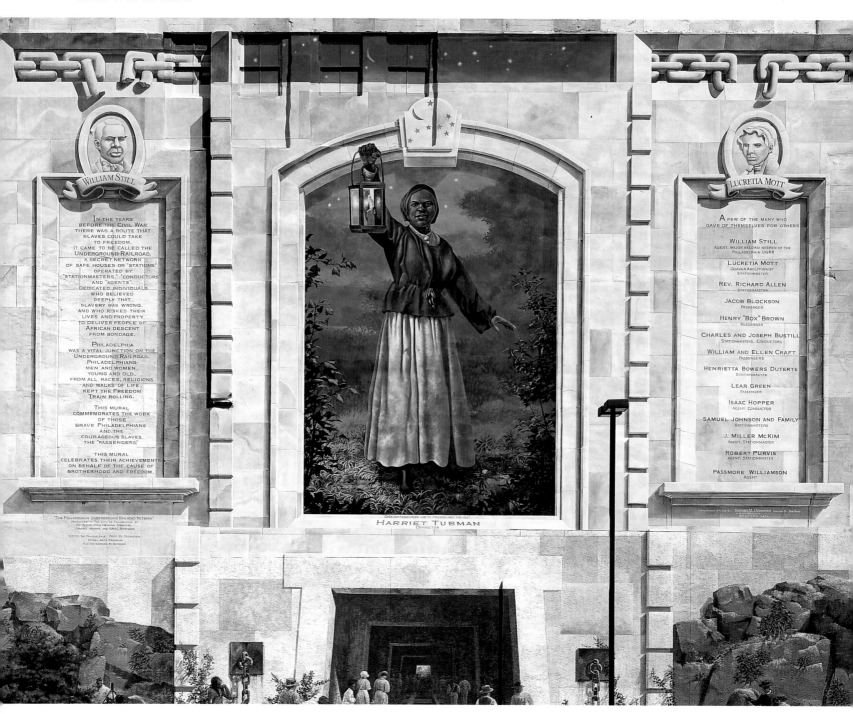

Jane said that requests for "people murals" jumped after the murals of former mayors W. Wilson Goode and Frank Rizzo were completed. She has had appeals to do famous Philadelphians such as Chubby Checker and Fabian. One of the most frequently requested celebrities is Will Smith—the movie star and rapper from the city's Overbrook section. While there are lingering questions about just how many celebrities to paint, Jane thinks the idea of a Will Smith mural near his former high school is perfectly appropriate. "He is a role model for a lot of kids; he's inspiring. If that's what the community wants, if it's a true reflection of their desire, then why shouldn't we?"

DiBerardinis, like Jane, believes that the time has come for restoring the best of Philadelphia's murals. In 2000, Mural Arts launched a program to restore at least ten murals a year, starting with *Patti LaBelle* (Sam Byrd, 34th Street and Mantua Avenue, 1991); *Frank Rizzo* (Diane Keller, 9th and Montrose Streets, 1995, see p. 99); *Tuscan Landscape* (Tish Ingersoll, 32nd and Spring Garden Streets, 1994, see p. 24); *The Pathology of Devotion* (12th and Morris Streets, 1991, see p. 82); and one of the first major murals in the city, Parris Stancell's *Taller Puertorriqueno* (5th Street and Lehigh Avenue, 1986, see p. 89). Keith Haring's mural *We the Youth: City Kids of Philadelphia and NYC* (22nd and Ellsworth Streets, 1987, see p. 90) was restored by Eric Okdeh with the assistance of young people in the Big Picture program in 2000. That same year, Jane's *Wall of Neighborhood Heroes* (2nd Street and Susquehanna Avenue, 1991, see p. 68) also got a facelift.

"How do you have what you do around art resonate deeper and longer?" DiBerardinis rhetorically asks. "You have to shift your resources into preservation. If you think [murals] are art, you've got an imperative. Real art is preserved."

To DiBerardinis, the program's future rests squarely on Jane's belief in the magic of murals. "She has genuine faith in people and belief in community and the integrity of this kind of art and its power," he said. "She exudes creative energy that is sort of like a communicable disease. It spreads. It's inspiring. It taps not just the best part of your spirit, but the best part of your intellect. It's a gift. That's her gift to me, and that's her gift to the people around her."

PARRIS CRAIG STANCELL

Pure color radiates from a Germantown Avenue wall in a struggling North Philadelphia neighborhood. At first glance, the lemon, indigo, emerald, violet, and crimson, all outlined in black, could be borrowed from a stained glass window, an acknowledged spiritual reference point for Parris Stancell, the mural's artist, who was assisted by Gail Lloyd. A second look reveals that *Education: A Key to the Future* (3814 Germantown Avenue at McPherson Street, 1997, see next page) was influenced by late Cubism, perhaps Picasso. But Picasso's hues were muted compared to those in this mural, whose energy and pervasive patterning strongly suggest African *kente* cloth.

Aesthetically, it is a sophisticated synthesis of influences, but the message is straightforward: Family and spirituality are the essence of a good life, and education is central to both. In flat shapes that disguise the uneven surface of the wall, the slender figure of a teacher rises, her long hands opening a book into the light of a spiraling orange and red sun. Below, in lively urban surroundings, a family group stands united in front of the teacher. Separated by an undulating yellow bridge, one child reads to younger ones.

Education was a high-profile project, one of five murals painted in conjunction with a major 1997 summit in which four U.S. presidents—Gerald Ford, Jimmy Carter, George Bush Sr., and Bill Clinton—came to Philadelphia to focus the world's

attention on volunteerism, at-risk children, and America's future.

Stancell welcomes challenging subject matter. He made his first mural for a Salvation Army chapel in Roxborough in April 1991, and his second, *Stop the Violence* (7th Street and Susquehanna Avenue), in the same year for Anti-Graffiti. He addresses serious issues in the communities where his murals are located and hopes his paintings are "provocative" to the larger audience passing through the neighborhood. Stancell remembers being disappointed when he first met with residents of the drug-blighted neighborhood where he painted *The Three Graces* (52nd and Master Streets, 1998). Seeking a sense of relief from poverty, some residents wanted upbeat subjects like "kids playing with sheep or a rainbow."

Because the project was sponsored by the Drug Enforcement Agency and the Bibleway Baptist Church, he saw it as the "perfect opportunity to make a statement about drugs devastating the community." Fortunately, when he presented his design to the group, "they loved it." The composition is divided into three arched sections. "Community" (families in an identifiable Philadelphia environment) and "Spirituality" (people looking at stained glass windows suggesting both Islam and Christianity) flank the central section— "Tragedy," which depicts the cycle of drug and alcohol addiction. In one of Tragedy's vignettes, a drug addict offers a crack pipe to a young woman who has never tried it. "The bowl of the pipe glows gold and the woman is mesmerized. Behind her is a man waiting to pounce … like a vulture." Despite the grim message of its centerpiece, the overriding beauty of the painting honors the neighborhood.

"One reason it's my favorite mural is because it speaks directly to the problems in the neighborhood, and I feel that the message comes across," the artist explains. "I remember how my generation was devastated by heroin when GIs were coming back from Vietnam." After heroin, Stancell adds, "crack came through," leaving deeper wounds.

Stancell has experienced some of these problems firsthand. As a somewhat directionless teenager, he was drafted and served stateside in the 82nd Airborne where he was introduced to drugs by troops returning from Vietnam. For twenty-seven years, he struggled with addiction. During this time, he returned to Philadelphia from New York, and, partly inspired by memories of his youthful studies at the Fleisher Art Memorial, he began to take Sunday classes with noted African American painter Ellen Tiburino. Tiburino's children, today successful artists themselves, often posed. The entire family, including Ellen's artist husband Joe Tiburino, energized Stancell's developing understanding of art and politics. They introduced him to galleries, other artists and poets. They "helped me get in touch with my voice," he asserts. He continued his studies at the Pennsylvania Academy of the Fine Arts and the University of the Arts, painted the Salvation Army chapel mural in the early years of his recovery, and altogether has worked on over fifteen murals for the city.

Though his early work was strongly representational, today Stancell is more concerned with spiritual meaning. He strives for the emotional intensity and the sincerity of self-taught or "outsider" artists. He particularly admires the work of community activist Lily Yeh, whose Village of Arts and Humanities has

transformed an entire neighborhood on Germantown Avenue.

Stancell cherishes an encounter he had while painting in a neighborhood he knows well. "I'm standing there looking at my mural, and a friend comes up and says, 'See that alley back there? I used to go in there to get high. To see this mural across from where I used to live makes me feel really good.'

"That's the kind of point that I want to be heard. I want my experience to say, 'There's tragedy, but there's a way out of the tragedy. Spirituality and community are the way out.'"

EDUCATION: A KEY TO THE FUTURE,
3814 GERMANTOWN AVENUE.

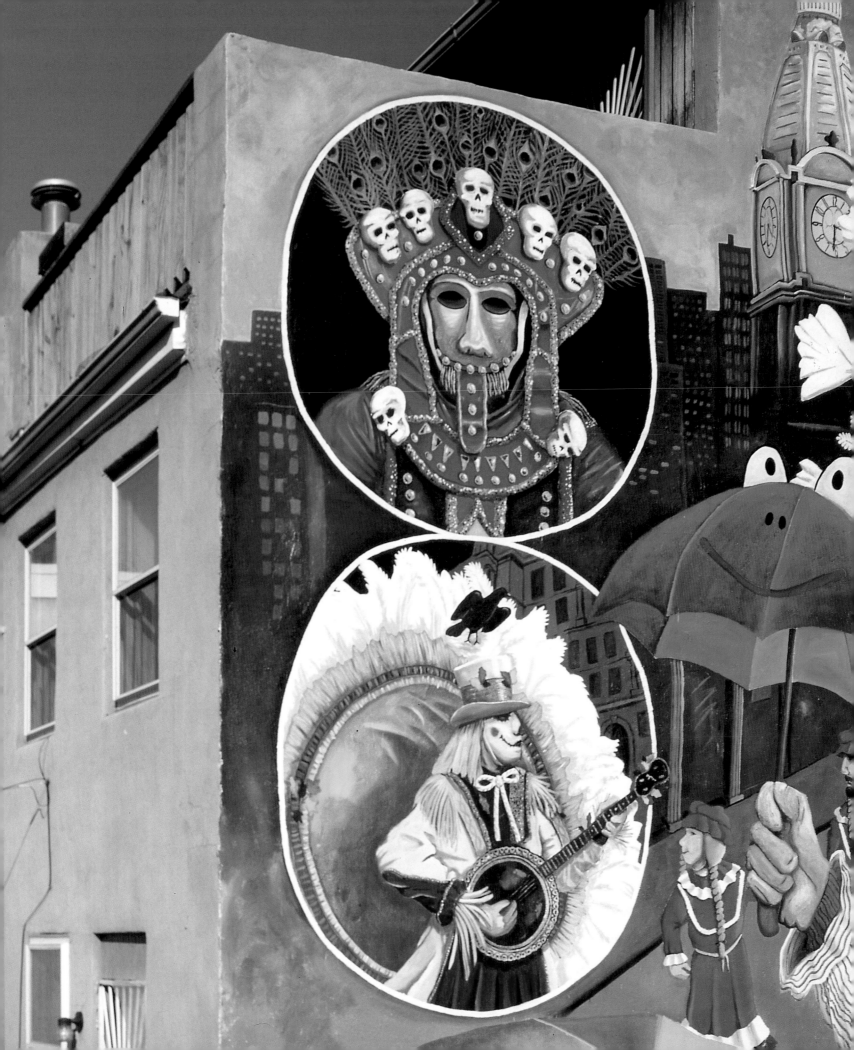

© 1999
PHILA. DEPT.
of REC. MURAL
ARTS PROGRAM
ARTIST:
ROBERT BULLOCK

YE OLDE
2
STREET

MUMMERS MUSEUM

A SHIFT IN CONSCIOUSNESS, SOUTH PHILLY STYLE

South Philadelphia is part of America's pop culture lexicon. Rocky ran through its neighborhoods, Chubby Checker sang harmony on its street corners, and Frankie Avalon got his start playing trumpet in one of its restaurants. And what baby boomer doesn't know where "all the hippies meet"? South Philly is also the birthplace of the artery-clogging, waistline-stretching cheesesteak, along with all matters of debate over toppings (Cheez Whiz or provolone?), onions (grilled, raw, or none at all?), and how to properly, respectfully order one. A neighborhood that takes its heartthrobs and hoagies this seriously does not tread on symbols lightly.

Three of the most talked-about icons in this largely Italian community are men who left large legacies in their wake: former Mayor Frank Rizzo; opera maestro Mario Lanza; and honorary native son Frank Sinatra. In the latter half of the 1990s, Diane Keller painted murals of all three. The portraitist-professor went from being a novice mural painter to the reigning Wall Queen of South Philly, the woman entrusted with Frank's deep blue eyes, Mario's musical mouth, and Rizzo's stern glance.

As a teenager, Keller painted pictures of her hunks and heroes—The Beatles, John F. Kennedy, Jimmy Stewart, and Steve McQueen. "Paintings are fantasies. I can relate to that," Keller said. "I know how exciting it is to have someone you love to see, to listen to. I'm a middle-aged groupie. In some ways, I'm the perfect person to do these jobs."

That she is a South Philadelphia resident only increased the pressure. "They're the Three Bambinos," Keller joked of her most famous subjects. "They're cult figures around here. Each had their own following—a very intense following."

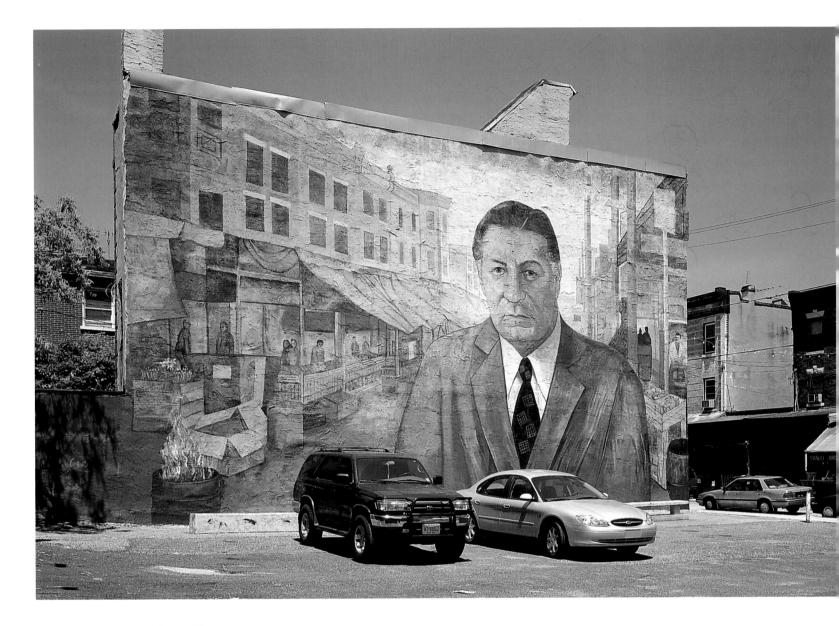

A big man on a big wall

For a first-time muralist, learning on the job in South Philadelphia wasn't the wisest idea. Even riskier was Keller debuting with a mural of Frank Rizzo. The larger-than-life former police commissioner-turned-mayor is beloved by many in the neighborhood. He is the native son who made them proud, the city's first Italian-American mayor. But to others, especially African Americans, Rizzo is a reminder of some of the most troubling chapters in Philadelphia history. He was an aggressive cop who became an aggressive commissioner. The way to deal with criminals, he once said in Italian, is *spacco il capo* (break their heads). He ran the police department with that philosophy during a period of great social and racial unrest. Indeed, one of the most famous images of Rizzo is a 1969 photograph of him arriving at a racial disturbance after attending a formal event, his billy club tucked into his tuxedo cummerbund, ready for action. When Rizzo died in 1991, even the obituaries acknowledged that he was a man either loved or despised, a legend who had divided the city in life and would probably continue to do so in death.

THE *FRANK RIZZO* MURAL ON 9TH STREET, IN THE ITALIAN MARKET, LIKE THE FORMER MAYOR, ATTRACTS BOTH FANS AND DETRACTORS. MORE THAN ANY OTHER MURAL IN THE CITY, IT HAS BEEN THE TARGET OF GRAFFITI, MOSTLY POLITICALLY MOTIVATED.

The mural program was still part of the Anti-Graffiti Network when Jane asked Keller to get involved. It was the first time the program seriously considered shifting its attention outside North and West Philadelphia. At the time, the only murals in South Philadelphia were the whimsical *We the Youth: City Kids of Philadelphia and NYC* (22nd and Ellsworth Streets, 1987, see p. 90) by pop artist Keith Haring, and the mysterious *The Pathology of Devotion* (a copy of the Vincent Desiderio painting, 12th and Morris Streets, 1991, see p. 82).

After the success of *Dr. J*, Kent Twitchell's lanky portrait of the basketball great (1234 Ridge Avenue, 1990, see p. 78), the mural program began receiving more and more requests for portraits. And when they finished the mural of the city's first African American mayor, *W. Wilson Goode* (Beau Bartlett, 18th Street and Cecil B. Moore Avenue, 1991), the petitions began pouring in for Rizzo.

More than just equal opportunity artwork, the Rizzo project would come to symbolize a monumental transition for the mural effort. For years, the anti-graffiti program had been viewed as a do-gooder operation aiming its brushes at impoverished neighborhoods and troubled teens. The earliest murals provided an alternative vista to the landscape of desperation and despondency in neighborhoods where residents ached for something beautiful. By the time murals arrived in South Philadelphia, the program was functioning in almost every stretch of the city. In the 1990s, murals were as much about celebrating life as they were about covering up graffiti or masking a sense of abandonment and neglect. In South Philadelphia, in particular, murals would come to symbolize cultural reminiscing, self-pride, and hero worship.

"Here, they represent what people want to be, what people aspire to," said Joe DiBella, a South Philadelphia artist who assisted Keller on several projects. "It's the immigrant spirit, the triumph of turning what you have into something more. The murals show what this neighborhood is all about. They show what Philadelphia is all about."

The giant lives on

Agnes Viso didn't blink when she was asked to donate her wall at 9th and Montrose Streets, in the heart of the Italian Market. Viso knew Rizzo cut a controversial figure in the city, but she wasn't concerned. Her only worry was what her deceased father might have thought of her decision. "The old Italian people wanted things just the way they were. Would my father be happy to see the side of his wall painted with a mural … with any mural?"

Given the subject matter, Viso thought her father would approve. She remembers Rizzo walking the beat as a street cop in the Italian Market when she was a child. Once, years later when he was campaigning, Rizzo left a luncheon nearby to visit her father, who was ill. Rizzo "was really a part of the neighborhood. He was very important to the street," she said. "He really did protect us."

Viso has spent her whole life in the same row house. Her father ran a meat market in front, providing choice cuts to area restaurants and discriminating housewives. Her family has deep roots in the Italian Market. Her grandfather, Pietro Giunta, had one of the first meat markets in South Philadelphia. Her aunt, Nancy Amoroso, is part of the city's famous baking clan.

Keller began work in December of 1994, an awful time to paint an outdoor mural. The weather was so bad she couldn't get on the thirty-foot-high scaffolding until March of 1995. Working from a photograph chosen by Rizzo's family members—they wanted the mural to feature his face just as it appeared in his official mayoral portrait—she sketched a design that placed his head and broad shoulders alongside muted images of life in the market. She was surprised to discover that the process did not differ much from working in the studio. Outdoors, of course, her canvas was thirty-three by fifty-five feet; Rizzo's head alone was thirteen feet high.

One day on the job, Keller met Joe DiBella, a graphic artist, antiques dealer, and all-around neighborhood character. DiBella had worked with Andy Warhol in New York in the late 1960s and was living just a few steps away from the Rizzo mural site. He wanted to learn mural painting and volunteered to help. An apprenticeship was born. They would paint every day from 9 A.M. to 5 P.M., taking a break to eat lunch donated by local shops.

The dedication proved to be an emotional unveiling for Rizzo's family, friends, fans, and the artists who had accomplished their first mural. "The people who love him were thrilled," Keller recalled. "It was the altar they'd hoped it would be."

Indeed, the mural became such a meeting place that Rizzo's son, Frank Jr., used it as a backdrop when he made his announcement to run for City Council. Tourists pose for pictures beneath it. And protesters use it to make political points: In 1999, supporters of convicted cop killer Mumia Abu-Jamal splattered gray paint and sprayed FREE MUMIA on the work just days after Pennsylvania Governor Tom Ridge signed Abu-Jamal's death warrant. Keller was not entirely surprised by the attack. "The people who don't like [Rizzo] see the mural as a symbol of his aggressive, larger-than-life imposing figure."

Viso loves the mural, but worries about the persistent threat of vandalism. She never expected the mural to become such a political statement. Maybe it was inevitable. On the wall, and in the history books, Rizzo is a giant. "I think," Viso said, "people actually feel he's still looking over us."

The Great Caruso, onstage again

Step into the Mario Lanza Museum, and you will get a taste of pure passion. The opera virtuoso's films are shown on a continuous loop. His birth certificate is on display. So is a bust of Lanza's head that a fan smuggled out of Communist Hungary.

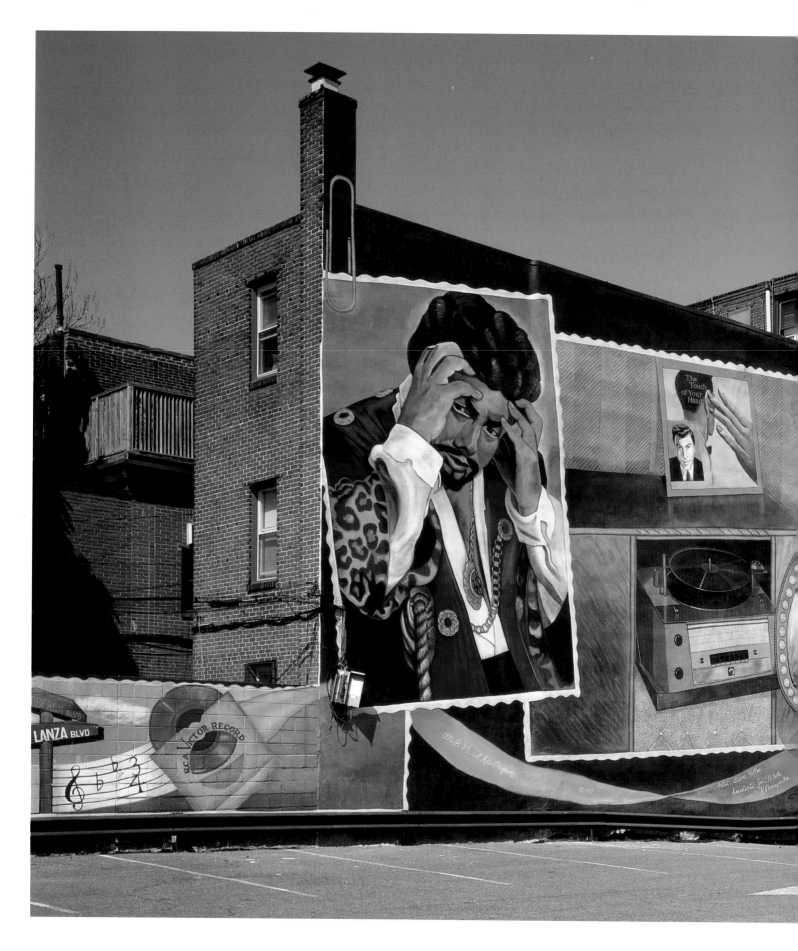

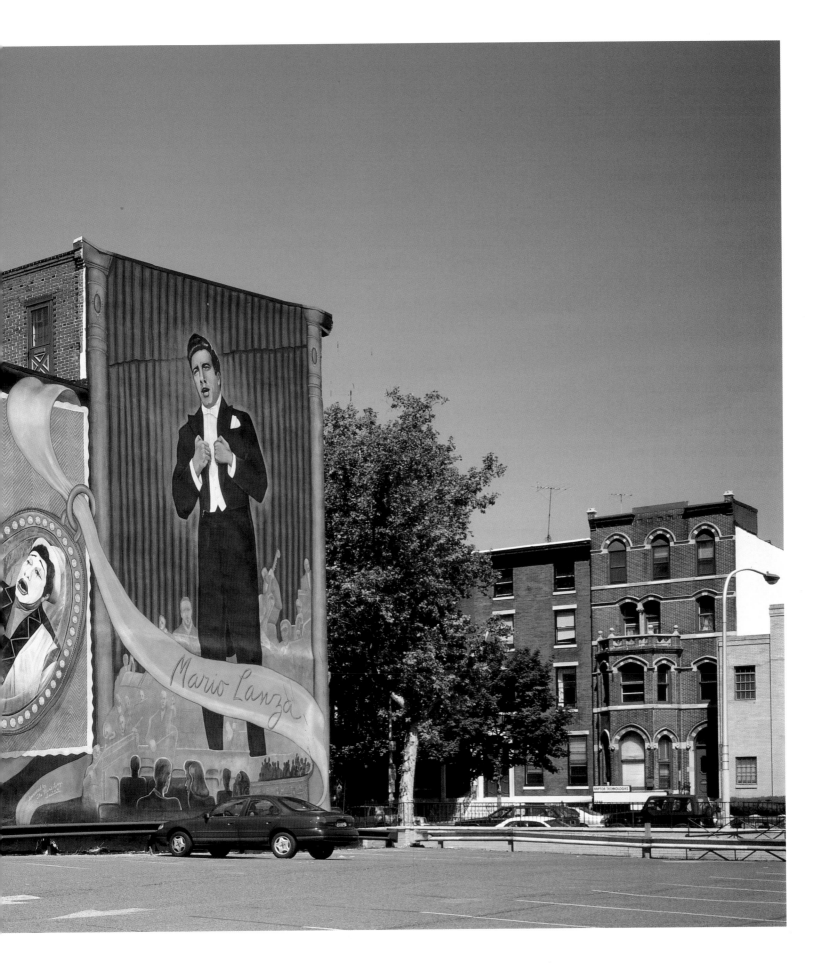

PRECEDING PAGES SUGGESTING A PAGE
IN A FAN'S SCRAPBOOK, THE *MARIO
LANZA* MURAL AT BROAD AND REED
STREETS FUSES A VARIETY OF IMAGES
AND ARTIFACTS TO CAPTURE THIS SOUTH
PHILADELPHIA NATIVE'S VERSATILE
CAREER AS SINGER, MOVIE IDOL, AND
CLASSICAL PERFORMER.

The museum is housed on the third floor of the Settlement Music School at 4th and Queen Streets in South Philadelphia, just a few blocks from where Lanza grew up. Most days, tour buses unload fans coming to mourn and schoolchildren coming to learn about the velvety voice and tragic life of a star who faded too fast.

There is a good chance their guide is Mary Galanti Papola, a retiree with a head full of Lanza lore. She points to pictures of Lanza at his Vare Junior High School graduation. Lanza is smiling with a group of classmates, including a certain future mayor named Rizzo. Papola revels in talking about the biggest of Lanza's three funerals in 1959; fifteen thousand people grieved for him at his boyhood parish, St. Mary Magdalen de Pazzi. Papola even knows about Lanza's military career. He toured Army camps as an entertainer, she explains, because "they felt he could better serve the morale of the servicemen with his music." He also battled with the bulge. "Some of it was due to emotional conflict, and some of it, I guess, because he liked to eat," she said.

MARY GALANTI PAPOLA, A VOLUNTEER
AT THE MARIO LANZA MUSEUM IN THE
SETTLEMENT MUSIC SCHOOL AT 4TH
AND QUEEN STREETS, GIVES VISITORS
AN ENTHUSIASTIC TOUR OF LANZA
MEMORABILIA.

After the *Frank Rizzo* mural, Jane was besieged with requests for portrait murals. Of all the suggestions, she was most drawn to the notion of putting local opera stars Marian Anderson and Mario Lanza on a wall, maybe even together. When fans balked, she decided to do separate Anderson and Lanza murals. Lanza's was painted first. In 1998, Anderson was painted alongside the musical Heath Brothers and community activist Mamie Nichols on David McShane's mural celebrating South Philadelphia heroes, *People of Point Breeze* (1541 S. 22nd Street, 1998, see p. 26).

For Lanza, Jane found a large wall outside Jacovini's Funeral Home on busy Broad Street. Papola got to work raising money through the Mario Lanza Institute, which gives annual scholarships to local music students. From a mailing list that spans the globe, $10,000 poured in. A woman from Italy sent $1,500; fans in Germany, England, and elsewhere played a part with smaller donations, some as little as five dollars each.

Jamming with the "Mario Lanzaheads"

Keller felt an intense pressure to get Lanza right— even more than she did with Rizzo. Papola and others at the Mario Lanza Institute were explicit in their expectations and nearly fanatical in their devotion. "They wanted him as a role player, so

it's a total fantasy," Keller recalled. "The only image of him as himself is on the record album. His real life—the checkered past, the womanizing, the nasty side—was not to be in evidence anywhere."

Keller's design for the *Mario Lanza* mural (Broad and Reed Streets, see p. 102) was approved by the Lanza Institute in August 1997, and she quickly got to work. On the scaffolding, she set up a boom box and blasted Lanza music while she painted. It helped draw attention to the project, not that she needed it. "These girls, sixty-year-old girls, would wheel up in their cars and just go nuts," she remembered, laughing. "They had the Mario Lanza watch, Mario Lanza T-shirts. They're like Deadheads. They're Mario Lanzaheads."

The adoration, and the music, proved inspirational. Keller finished the hundred-foot-long painting by Halloween, 1997: There is a mustachioed Mario clutching his head in thought in the 1956 Warner Brothers movie *Serenade*; an old-fashioned Victrola record player; a cover from one of his albums, *The Touch of Your Hand*; an orchestra hall with a mesmerized audience and a blue satin ribbon encircling the mural with the names of each person who donated five hundred dollars or more to the project.

Although the mural emphasizes his big screen roles as Pagliacci and Othello, Papola is partial to the four-story image from his most famous movie, *The Great Caruso*. Lanza is wearing a tuxedo, clutching his lapels as he belts out a note. "He's probably singing 'Laugh, Clown. Laugh,'" said the woman who knows every line in the movie. "He's so full of emotion. The emotion comes right out of the picture."

Old Blue Eyes casts a dark shadow
The warm glow of the *Mario Lanza* experience could not possibly have prepared Keller for the backlash she would receive after depicting "The Chairman of the Board." Following Frank Sinatra's death from a heart attack in 1998, Jane Golden and Joe DiBella thought a mural might be a good way to give local fans a way to pay their respects. Keller seemed like the obvious artistic choice.

From the start, the project was rife with arbitrary deadlines and pressure. After the scrappy tabloid *Philadelphia Daily News* agreed to sponsor the mural, Keller had just two weeks to come up with a design. Then, the newspaper led a fund-raising campaign and sent out invitations to Sinatra's family to attend the dedication, causing Keller to feel rushed. And since the sixty-three-by-forty-eight-foot wall needed to be restuccoed before she could paint, she wound up having just two months to work.

After pouring over photos of the vocal legend, she decided to portray Sinatra in his prime: not too old and washed-up, nor too young and green, but just at the moment of greatness. "Not just him," she said, "but his position in society."

Initially, the drawing she submitted generated little controversy. It was only after she put the painting on the wall at Broad and Wharton Streets that Keller began to feel fans' wrath. The design featured Sinatra in the 1950s, when he was soaring professionally, yet personally miserable over his relationship with Ava Gardner (whom Sinatra married in Philadelphia in 1951). Biographers have often said the brief, tumultuous pairing provided the inspiration for some of his saddest songs. Keller wanted the mural to echo the mood of his 1955 album *In the Wee Small Hours,* which Sinatra recorded shortly after the couple separated.

A chimney in the center of the wall was supposed to be removed but was not, forcing Keller to alter her design. She shifted the image of the singer to the left and put stars in the sky to create a "midnight, romantic-looking" backdrop that would envelop the crooner. For a minimalist approach, she painted him against a background of grays, blues, and blacks, tucking legions of smiling fans into this smoky night. She put the singer in a brown suit and fedora, since, at that time in his career, he had yet to adopt the tuxedoed Las Vegas look.

"I wanted the images of the fans to be almost dreamlike, to be a memory. So they weren't realistic, and they weren't there. I wanted it to look like a dream, like some other time and space," she said. "I think I caught him at one of his darkest moments. It's a rough, raw image of him—I think that's the core of him; that controversial spirit is something he may not have wanted to have, but he did."

Singing a sour note

The fans were not as agreeable. During the painting, some drove by hollering at Keller to fix his mouth, soften his lips, make his nose smaller, his face happier. "They don't like it. They think he looks too exaggerated, too dark, too coarse, and not like a photograph," Keller admits. "They wanted a lovable Frank Sinatra they could keep in their wallet."

Even casual observers like Agnes Viso have something to say about Sinatra. "He needs a little more life to him," she said. "He was a very handsome man. I don't feel the painting does justice to him. His face is too dark. He had such beautiful, fine features. I'm not impressed."

Frederick Vidi is both a fan and a benefactor. His South Philadelphia restaurant, Frederick's, held a massive dinner/fund raiser for the *Frank Sinatra* mural (Broad and Wharton Streets, 1999, see next page), attended by such pop culture luminaries as Bobby Rydell, Jimmy Darren, Red Buttons, and one of the members of the group Boyz II Men. The event raised $25,000 and put Vidi squarely in the middle of the sad-or-smiling Sinatra controversy.

"I think I caught him at one of his darkest moments. It's a rough, raw image of him—I think that's the core of him; that controversial spirit is something he may not have wanted to have, but he did."

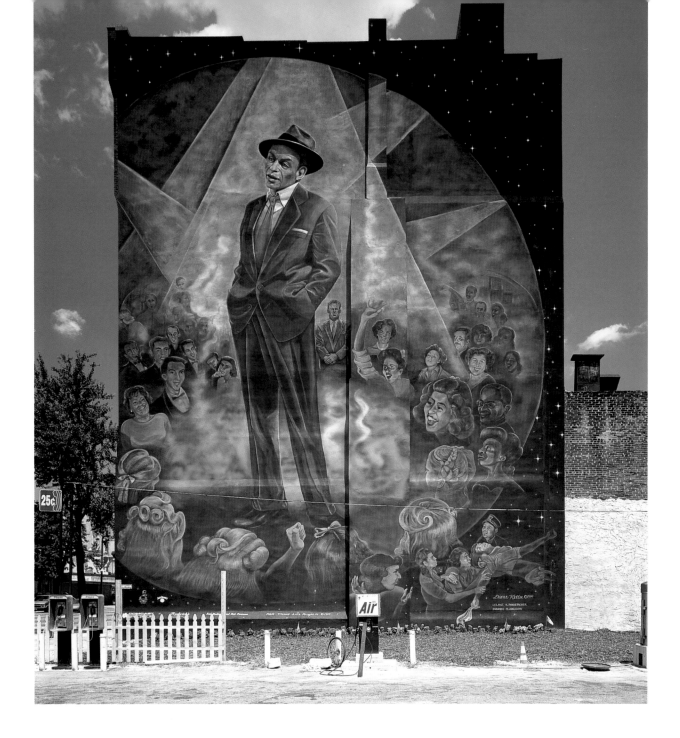

Vidi said he supports Keller's portrayal of the singer but understands the fuss. "In South Philadelphia, everyone at some point in their life has associated with Sinatra music. When they're pregnant, when they get a job promotion, when they get married, happy times or sad times. Everybody has some memory, and every memory is different. People are bound to want to see him as they saw him."

More than any other mural, the Sinatra painting prompted calls to Jane's office demanding that the artist get back up on the scaffolding and do it again. Some people who donated money demanded a refund. It did not matter. As an artist, Keller put her brush down and refused. "I told Jane, 'There's no way I'm going up there and fixing that face.' Because, when do you stop? Whom do you please?"

FRANK SINATRA FREQUENTLY PERFORMED IN PHILADELPHIA AND WAS EMBRACED BY ITS CITIZENS AS A NATIVE SON. THIS DREAMLIKE BUT RAW PORTRAIT, CAPTURING HIM AT A TIME WHEN HE WAS SOARING PROFESSIONALLY BUT SUFFERING PERSONALLY, HAS WON BOTH PRAISE AND CRITICISM FROM FANS.

Jane stood by Keller's decision not to repaint because she feared setting a precedent that would allow anyone who spoke out against a mural to dictate aesthetic changes. Yet when she examined the situation as an artist, not an administrator, Jane came to a different conclusion, which illustrates the dilemmas of running a citywide mural program. "If I were the muralist, I would change the face," she said. "This mural, unlike other murals, was funded by donations from the people of South Philly, and I would personally feel a tremendous responsibility to those folks. The success of our program relies, in a large part, on our ability to build consensus. This program is really not about an artist's vision. I am sensitive to the artist's needs, but I am also an advocate for the community. I guess one could say that I am in the unfortunate position of trying to please everyone."

Remembering May days, ditch diggers, and grandma

In 1998, Carol and Anthony Spina bought a building on 8th Street near Montrose Street, close enough to the famous Italian Market to smell the bread baking at Sarcone's and the

steel-drum fires that keep vegetable vendors warm on winter mornings. The Spinas planned to renovate the three-story, 120-year-old building that once housed an eye doctor's office, but had no idea when they would move into the place. They were certain of one thing: They wanted a mural on the side of the house as quickly as possible.

Both are lifelong South Philadelphians. Anthony grew up at 7th and Morris Streets. His father was a barber who cut Fabian's hair. Carol grew up near the market. As a child, she soared on the swings at Sunshine Playground to the sounds of Mario Lanza and Chubby Checker. Like many deeply loyal South Philadelphians of Italian descent, the Spinas have not strayed far. After they married in 1970, the young couple bought their first house next door to Carol's mother. Thirty years later, they still reside in the same zip code. Anthony Spina teaches fifth grade at Meredith Elementary School, in the neighborhood, while his wife works in real estate.

The Spinas had many reasons for wanting a mural. The parking lot next to their wall had been a dumping ground for old refrigerators and mattresses, and they figured a mural keeping an eye on things from above might be a deterrent to unsavory activity. And though some critics equate murals with blight, Carol Spina's work in real estate told her that in South Philadelphia, murals enhance curb appeal and property values.

The Spinas knew what they wanted on the wall, too. The couple felt inspired—almost obligated—to present the neighborhood with a painting to celebrate the stories of the Italian immigrants who came before them. People like Carol's grandmother, who came from Italy and got off the boat where the Delaware River meets Washington Avenue in 1917. She was fifteen, arriving for an arranged marriage to a seventeen-year-old boy already in town. People like Anthony's grandfather, who arrived in 1905 from Sicily and dug ditches for the city's fledgling transit system.

In recent years, younger generations of Italian Americans have moved out of the city to New Jersey and the suburbs, and South Philadelphia has become a magnet to a new wave of immigrants, from Asia. Now, there are Chinese and Cambodian produce stands next to Italian butchers in the market. Vietnamese jewelers and bakers have set up shop alongside Italian delis. The children roaming the halls of Meredith Elementary where Anthony teaches are a more multicultural mix than ever before.

"I remember the old Italian women with the babushkas on their heads in the cold weather, the men with the stogie pipes, the clang of the trolley coming up 9th Street," says Agnes Viso, the butcher's daughter who donated her wall for the *Frank Rizzo* mural. "Now, the older people have died off, and while some of the children took over the businesses—the Espositos, the Giuntas, the Capuccios, the Savios—another class went away to college. They have desk jobs; they're bankers, doctors, lawyers. They're not really here anymore."

Carol Spina's work in real estate told her that in South Philadelphia, murals enhance curb appeal and property values.

Sensing that their Italian legacies might fade forever after the next generation leaves the neighborhood, the Spinas sprung to action with art. As Carol put it: "We just wanted to preserve our memories, to save them."

Once again, Keller was a logical selection. She suggested an Italian fresco incorporating old photographs from neighborhood residents—specifically, images of the May procession at St. Mary Magdalen de Pazzi Roman Catholic Church, the first Italian parish in the United States.

Carol Spina had attended the church, which was founded in 1852 and closed in 2000. Heritage was such a big part of St. Mary Magdalen's that in the old days families had to be pure Italian to become members. Back when she was still Carol Martin, Spina had to be baptized at another parish because her father was part German.

St. Mary Magdalen was locally famous for its May procession, an annual rite in which members professed their faith by marching through the streets with candles, ribbons, trinkets, coins, and cash to give to a statue of Mary. Each spring, the devoted walked from the church down 7th Street to Fitzwater, up 8th Street, then back into the church. Both Carol and her daughter were May Queens.

The stories about the church inspired Keller, but she still faced a number of logistical challenges in painting the mural the Spinas wanted. She had to paint around and incorporate two windows and an air conditioner jutting out from the wall. The solution came straight from the heavens: She designed and commissioned real stained-glass windows to be installed—authentically recreating the look of the church.

Keller started painting in July 2000. She put down the outline, but discovered the paint she had ordered had not arrived. So for two weeks, she worked on "tonal under-painting," fleshing out the drawing with sepia tones, and then covering the whole wall with a transparent glaze. The result resembles hand-tinted black-and-white photos.

From pictures and stories, Keller found the theme for her mural: a tribute to the strength of the Italian woman. There is Frederick Vidi's great-aunt Rosalie Cardinelli in a purple housedress and apron with her grandson Joey in her arms and the church behind them. There is the Spinas' daughter, Carol Ann, in her white dress as a seven-year-old May Queen in 1986. There are the local women carrying the statue of Mary, their images captured from a snapshot taken in the mid-1980s.

And on the far left of the mural is Carol Spina at age two, wearing a two-piece bathing suit and a pair of white Mary Jane's. Holding a blue parasol and perched on a towel to keep cool on the concrete, the youngster is clearly enjoying another blissful summer day on Montrose Street in South Philadelphia.

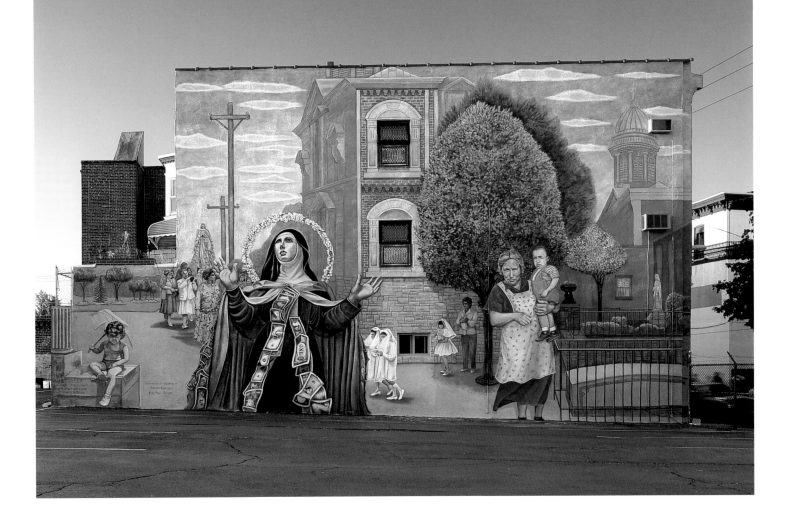

At the dedication in May 2001, Jane was struck by two things: The *Procession of St. Mary Magdalen de Pazzi* mural (915 S. 8th Street, 2001, see above) had been virtually hassle-free from idea to unveiling; and both the finished product and the ease of getting it on the wall were signs that the Mural Arts Program had built a special relationship with the people of South Philadelphia.

That relationship grew, she said, because artists, MAP staff, and community members opened their minds to different ways of looking at murals. Some neighborhoods want political statements urging peace and tranquility, anti-drug themes, or spiritual healing. Others seek murals that tell their story, like Norris Square with its lush tropical island images and its Indian history, which helps young people connect with a paradise they have never known. South Philadelphians love their history, too. But the wall art in this neighborhood depicts legends and controversies, memories and magic.

"What we do in South Philly is absolutely different than in any other part of the city," Jane explains. "The murals there are so much a part of neighborhood history. People have been able to get murals that are clearly an extension of the culture, the life, and the community. When you speak about murals as autobiography, there's no place that is a better example than South Philadelphia."

MEMORIALIZING AN ANNUAL NEIGHBOR-
HOOD TRADITION, THE *PROCESSION OF
ST. MARY MAGDALEN DE PAZZI* AT 915
S. 8TH STREET INCORPORATES IMAGES
OF LOCAL RESIDENTS, AS WELL AS
TWO STAINED-GLASS WINDOWS MADE
ESPECIALLY FOR THE MURAL.

SARAH McENEANEY

A 1993 grant from the Pew Fellowships in the Arts gave Sarah McEneaney the opportunity to paint her first mural. The fellowship includes a generous stipend, which frees artists to concentrate on their own projects. In addition, they are encouraged to find opportunities to interact with the public around their work. For McEneaney, a mural seemed a good way to accomplish both goals simultaneously.

Her first mural was an untitled sequence of ten seasonal panels, which includes portraits of local kids (8th Street and Fairmount Avenue, 1996). Although it took a long time to organize and complete and has recently been partly obscured by construction, McEneaney is committed to making murals.

"My work is all about personal narrative, but I think that it becomes universal because it's so personal," she says. McEneaney's third mural, *Inside Outside* (12th and Hamilton Streets, 2000, see next page), located near her home in Chinatown, is her favorite. It is based on "a painting done in my studio of the studio, and the mural is right in my neighborhood." The original painting, a thirty-six by forty-eight-inch egg tempera panel called *Studio Winter '98–'99,* is now owned by the Philadelphia Museum of Art and displayed in its Twentieth Century galleries.

Inside Outside, like the panel painting on which it is based, meticulously documents the artist's studio and its contents, from McEneaney's pets playing near a toy skunk on the cracked, paint-stained floor, to an assortment of paintings on walls with individually painted bricks. McEneaney's seemingly naive approach emphasizes outlines and countless specific details. Areas of color are flat so that no distinctive edges are lost in shadow. This rigorous specificity also relates to time—not so much the time of day as the artist's sense of what was happening when—or immediately before—the painting was made. The original painting is about McEneaney's work as an artist. In it, her computer is dark and the studio is arranged so she can begin painting on a white primed panel, which is proportioned exactly like the panel on which it is painted. In fact, it is that same panel.

Inside Outside, the mural version of the artist's studio, adds a veritable album of neighborhood scenes depicted as paintings and drawings displayed on the walls. "It's somewhat of a history of the neighborhood during the twenty-two years I've been living here and painting here, as well as a history of myself within the community," McEneaney explains. Next to the worktable in the mural, instead of a blank panel, she included a painting of horse and carriage near the intersection of 12th and Hamilton Streets, directly across from the mural. She executed this scene from observation, by turning on the scaffolding and looking at the corner. "[The mural] is near the horse carriage stables at 13th and Buttonwood," she says. "The carriages go by every day, so I had to put one in." Five other paintings on the studio walls are copies of actual paintings McEneaney made in her studio. One of these, *My House, Summer '98,* is a garden scene—the artist's own backyard

with her in it. Above the garden painting are two small square paintings. The one on the left depicts a nearby vacant lot with a lot of trash in it. "I've painted that lot a number of times," McEneaney reminisces, "It's always been a thorn in my side because it was unkempt. But now the owner has given us permission to turn it into a community garden." she exults, pleased that the mural records a vanished eyesore.

Also, part of the mural is a group of sketches, studies for the mural itself and a drawing of helicopters, which were a feature of the 2000 Republican Convention. On the screen of the artist's iMac computer, we see a Website opposing the proposed location of a new stadium in Chinatown, a hotly debated issue at the time McEneaney painted the mural. The residents of Chinatown felt a stadium would destroy the unique character of their community. "When the mural was dedicated, we hadn't won yet," she remembers. Since that day, the proposed stadium has been relocated, and the mural reminds the community of its ability to organize and influence city government.

To adapt her original *Studio Winter* painting to the *Inside Outside* wall, McEneaney marked off a piece of paper in the proportions of the wall, with one inch representing two feet. She then projected a slide of the painting onto the paper and traced it. After gridding off the wall, McEneaney used the scale drawing to guide her direct graphite drawing. "I work on the whole mural at the same time, just as I do a studio painting," she says. "I cover up my initial drawing with big areas of color. I don't draw in the details—the flowers or the vegetables. I have to keep getting back off the scaffolding and checking it. I get a lot of exercise."

McEneaney still thinks of herself as primarily a studio painter, but she believes in the mural process. "I like the opportunity to make my work really big and have it be really public. Although it's scary, it's really exciting. I like art being out in the world."

INSIDE OUTSIDE, 12TH AND HAMILTON STREETS.

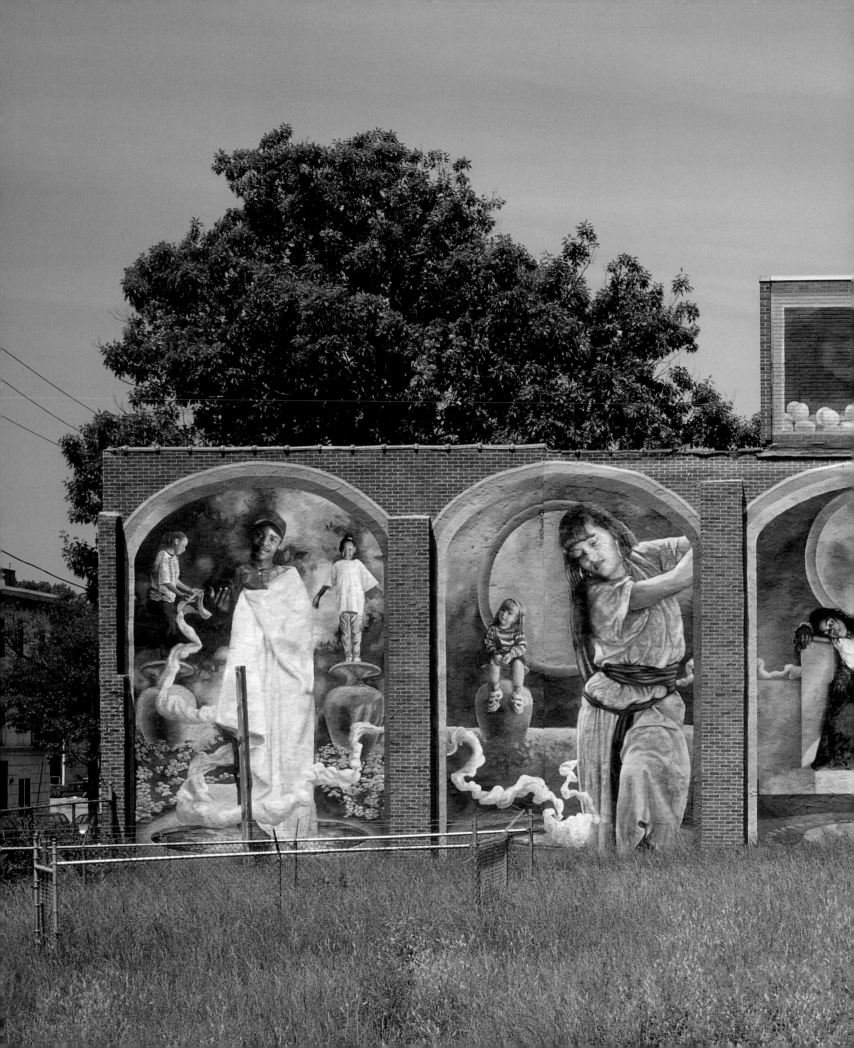

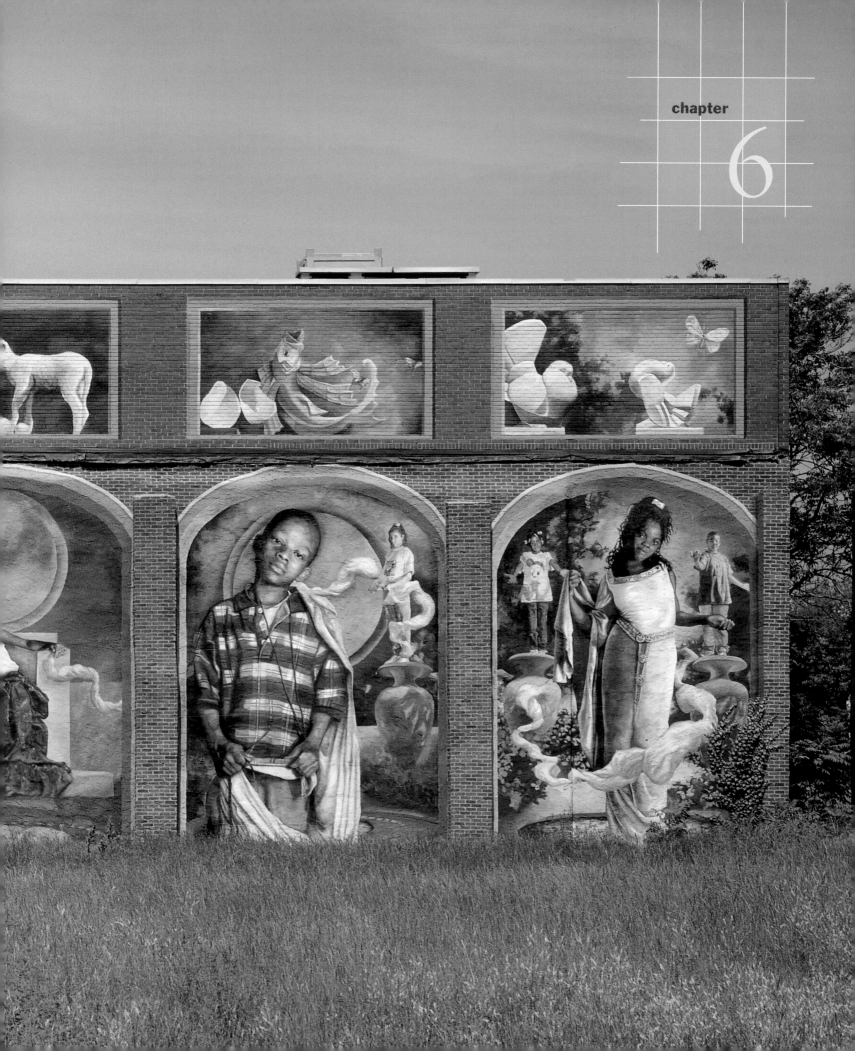

MEG SALIGMAN
THINKS BIG

I have a vision that, after painting for many years, I will have a body of work that documents different urban communities during different decades in cities throughout the country. It will be a record of people—their time, styles, attitudes and hopes. I feel there is a great potential for change and empowerment through quality, innovative mural art.

Meg Saligman

PRECEDING PAGES PAINTED ON THE SIDE OF THE CHILDREN'S CRISIS CENTER AT 18TH AND CALLOWHILL STREETS, *JOURNEY*'S PANELS, WHICH MOVE OUTWARD FROM THE CENTER, TRACE A CHILD'S PROGRESS BACK TO EMOTIONAL HEALTH.

OPPOSITE TOWERING EIGHT STORIES ABOVE THE BUSY INTERSECTION OF BROAD AND SPRING GARDEN STREETS, *COMMON THREADS* IS PHILADELPHIA'S TALLEST MURAL.

I n some ways, Philadelphia's most prominent mural, Meg Saligman's *Common Threads*, is a mural about murals. Unquestionably, it is about perception and representation. Even passers-by who are familiar with the mural cannot help but pause in respect and wonder at its huge scale, its rich assortment of strong resonant colors, and its dramatic, convincing chiaroscuro.

Rising eight stories from the corner of a busy downtown intersection, *Common Threads* (Broad and Spring Garden Streets, 1998, see next page) is visible from blocks away, its striking composition and massive figures beckoning drivers and walkers alike to venture closer. In structure and coloration, the mural is reminiscent of an altarpiece, with formal figures painted in different scales and grouped throughout the composition. The design uses elements of the building's distinctive architecture. Symmetrical trompe l'oeil balconies, ornamental tile work, columns, and alcoves help to organize the thirty-one figures, consisting of fifteen antique statuettes and sixteen contemporary teenagers. Through virtuoso illusionistic painting, *Common Threads* unites allegory and portraiture in a broad commentary about the things that connect us across generations and across cultures. "*Common Threads* represents, for me, everything that is wonderful about murals," said Jane. "We see Meg's uncanny ability to create a mural that is evocative, that stirs our senses, and that brings alive contemporary issues in a way that is both aesthetically appealing and compelling."

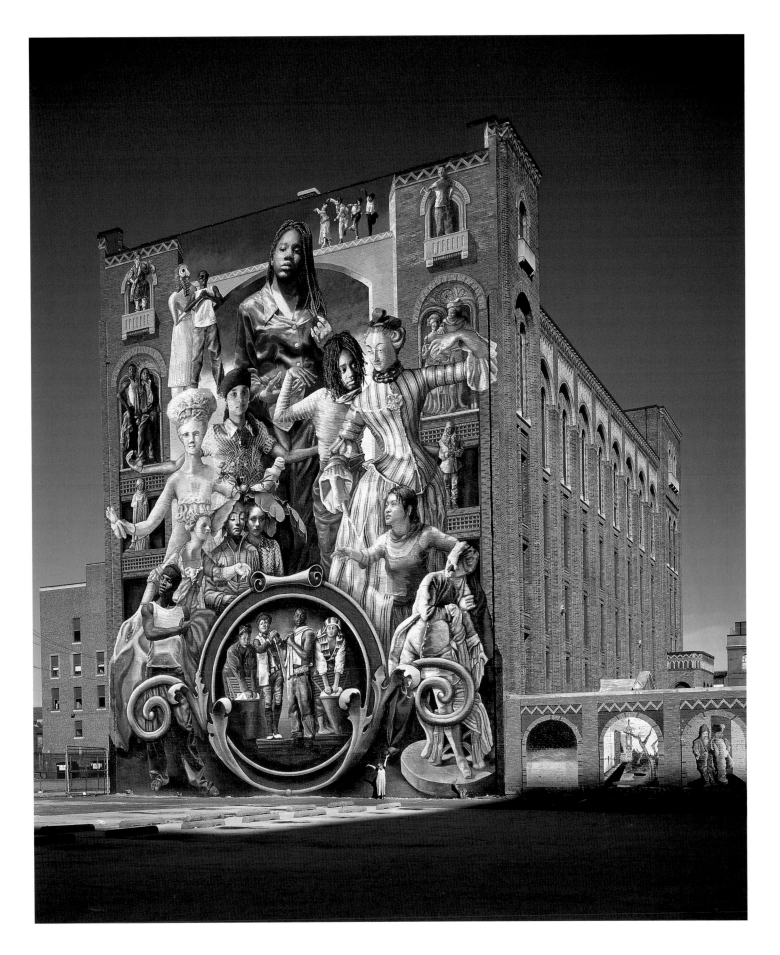

A few moments' study unravels the mural's visual metaphor. With the exception of one iconic central figure, *Common Threads* depicts real, contemporary young people imitating the postures of historical figurines. Each pair—human and figurine—is painted in the same scale. Some are dozens of feet tall, while others are only twice as large as life. Some pairings mirror each other from opposing sides of the composition; others stand side-by-side. For example, a painted alcove on the right near the top shelters a formal porcelain couple in European court dress. From the left side of the building, in a matching alcove, two young African American teens, casually dressed in denim, stare out with the same cool demeanor.

At the bottom of the composition, four figures stand in an elaborate gold cartouche. The two outside figures—one a contemporary American woman, the other an ancient Egyptian statuette—lean over large basins of water scrubbing clothes on washboards. The two laundresses are separated by a second matched pair: a young man in stylish baggy jeans and boxers, hands clasping the sleeves of a shirt draped over his shoulders, and next to him, in a similar pose, a young musician figurine, raising a horn to his mouth.

Somewhat isolated, though at the center of all this activity, stands the meditative figure of a young African American woman, Tameka Jones, who was a student at the Philadelphia High School for the Creative and Performing Arts when the mural was painted. Dressed in a deep pink blouse, she plays abstractedly with the end of one of her long braids and gazes down on the street below, as if pondering something beyond the mural. Her pose is not imitated by any other figure. She stands alone, with an authority and inner composure that transform her into a timeless icon of beauty and grace.

THE ARTIST'S FINAL SKETCH FOR THE MURAL.

"The strength of *Common Threads* is that it has a content that is true to me," Saligman said. The concept for the mural came to her as she noted the resemblance between the elaborate braided hairstyles of today's African American teenagers and those on the figurines she used to admire at her grandmother's house. She began to muse on the differences and similarities of fashion through the ages. The word "threads" in the mural's title might even be considered a pun on the slang term for clothing. Although European china figurines are prominent in the composition, there are also a few ancient and non-Western prototypes as well. Near the top of the mural, the figure of a bearded Sumerian king, hands clasped in a gesture of respect, stands behind a young contemporary student in a similar pose. The boy is wearing sunglasses to simulate the dark holes on the statue where jeweled eyes were once inset. Midway up the left side of the mural, in an alcove, a coweled medieval figure clasps her hands at her waist. Her pose is mirrored by that of a modern Muslim girl in a conservative head covering. Throughout the mural, Saligman plays symmetry against

asymmetry: pale marble or porcelain against a warm range of flesh tones; and the unvaried texture of sculpture against brilliantly rendered metal, hair, satin, and gauze. It is a baroque counterpoint that engages the eye and the mind in an almost musical way.

Saligman regards *Common Threads* as her finest achievement so far. Attempting a mural of such size and complexity would have been inconceivable in the early days of the mural program. Though perhaps technically possible, neither Saligman nor Jane, nor any other artist in Philadelphia at that time, had the experience or credibility to pilot such an ambitious public project from conception to completion. Even later, when plans for *Common Threads* began to take shape in 1996, Saligman and her partners in the mural program were challenged. Fortunately for Philadelphia, years of community mural experience had given both the program and the artist the tools to meet the challenge.

Reach for the stars

Saligman grew up in upstate New York. After a year at Parsons School of Design in New York City, she earned her bachelor of fine arts in painting at Washington University in St. Louis, Missouri, in 1987. Next, she decided to relocate to Philadelphia because she could live rent free in her uncle's houseboat, which was moored at Penn's Landing on the Delaware River, not far from downtown. Then she heard about the mural program. She contacted Jane and was hired to teach before she got a chance at a mural.

"I'm obsessed with painting large. It's what gives me my kick," Saligman explained. "I was never one for holing up in a studio. It made me depressed. I did my first mural for Anti-Graffiti in 1989 and just knew that this was what I wanted to do with the rest of my life. How many people can say they fell in love like that? It's everything I love to do."

That mural, on a recreation center wall at 18th and Wallace Streets, was based on Raphael's challenging figure composition *The School of Athens* (1988). Saligman substituted famous athletes for the Renaissance artist's poets, philosophers, and scientists. Even in this early work, major aspects of her mature style were already in place: the dense, dream-like groupings of figures, convincing manipulations of space, and rich color harmonies.

Although Saligman loved planning and painting her first mural, she was not so pleased with her first trip up the scaffolding. "I didn't know that scaffolding swayed," she remembers with chagrin. "I got stuck up there all day. I did have a fear of heights, but I got over it."

Saligman stayed with the Philadelphia Anti-Graffiti Network (PAGN) for about a year and did a handful of murals. Of these, the most important is *Reach for the Stars*, executed on the exterior of Pennsylvania State Representative Dwight Evans's office at 72nd Street and Ogontz Avenue (1991). The theatrical scene depicts young people in a stage-like space based on a photograph of a Broadway production. The students slouch in casual poses in front of fragmented leaping shadow silhouettes. To depict the teenagers in the mural,

Saligman looked up photographs in the library. "I pulled random shots of kids and worked them into the design. It just looked right for the neighborhood. The funny thing is that they were actually from that neighborhood." To the artist's astonishment, local residents recognized the young people in her mural. "It was an amazing coincidence," Saligman said. "At that time, it was not so typical to incorporate people from the community in murals," she remembered, but the response showed her "how rewarding it is."

As a result, Saligman determined that: "In all my public work, the content would come from the community. I would not intentionally paint anybody who is known in their own right. I just don't think they need to be up on the wall. Everybody is always asking, 'Who is that person? What did they do?' I like the idea that every individual is just as heroic as a person who has fame. I like to make an everyday person rise above their environment. My only requirement is to have a variety of people. Sometimes you find someone who you get a sense just needs to be on the wall."

Following *Reach for the Stars*, Saligman broke away from PAGN as a regular employee. "At the time, it seemed like a good thing for me to be actually doing murals that I had designed. I did a lot of interiors: nurseries and ceilings, restaurants and bars. I probably made the best money per man-hour to date, but it was incredibly boring." Her first private commission, on a sweater factory that no longer exists, came from the person who is now her husband. During this period, she often worked for corporations with graffiti problems. A simple but effective strategy was to take Polaroid photographs of neighborhood children and make a big grid of portraits, almost like yearbook photos, on the side of a wall. What wall writer would have the effrontery to deface oversize images of local youngsters?

Saligman received national and state grants. She went to Mexico City on a National Endowment for the Arts exchange program to execute a fresco. There, she continued her practice of painting local people into the mural. Contrary to Mexican custom, instead of tributes to political figures, Saligman depicted homeless people who lived in the park. She made them heroic, as if they were the leaders of society instead of its rejects.

"I'm hoping that the longer I paint, the more I will be able to get away with," she explains. "You can get away with a lot more if something is very aesthetically beautiful—whether it's beautifully rendered or beautiful color or just pleases people's eyes. I try to push as much as I possibly can and still retain a design with mass appeal to make it a successful and powerful piece of public art. If people dig it, they're not going to question it."

At 3,200 square feet, the *Gateway* mural on the Charles Building (125 N. 8th Street, see next page) was a major project and Saligman's most ambitious at that time (1993). Its location near the Vine Street Expressway, the Pennsylvania Convention Center, and Philadelphia's historic district guaranteed a large and continuous audience.

"I'm hoping that the longer I paint, the more I will be able to get away with. You can get away with a lot more if something is very aesthetically beautiful—whether it's beautifully rendered or beautiful color or just pleases people's eyes. I try to push as much as I possibly can and still retain a design with mass appeal to make it a successful and powerful piece of public art."

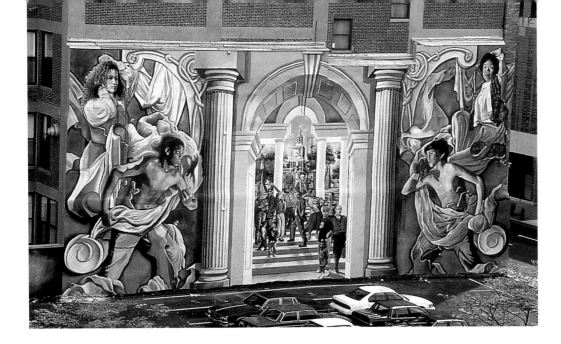

IN THE *GATEWAY* MURAL AT 125 N. 8TH
STREET, SALIGMAN TREATS THE THEME
OF FREEDOM BOTH LITERALLY, THROUGH
A DEPICTION OF NEARBY INDEPENDENCE
HALL, AND SYMBOLICALLY, BY THE
FIGURES BREAKING OUT OF THEIR
STONE BONDS.

Using what was by then a well-honed approach, Saligman photographed people who frequented the area of the mural. Because the spot is essentially commercial, the twenty individuals in the mural were mostly students and people who passed the site in the course of their workday. She placed them in a brilliantly convincing painted architectural setting, which frames a view of Independence Hall with visitors coming and going. The central historical vista, however, is dwarfed by gigantic statues on either side of the composition, which appear to be transforming from stone into human flesh, breaking free of the inflexible bonds of the past. Visually there is a relationship to Michelangelo's unfinished sculptures of bound slaves, in which the human figures have only partially emerged from their stone prisons. Saligman's metaphor specifically suggests in contemporary terms the powerful transformation wrought by an abstract theoretical document like the Declaration of Independence.

"The thing that I'm proud of is that I did *everything* for that mural," she said gleefully. "I washed and primed the wall. I gridded it. I would tape the chalk line [a string heavily coated with chalk dust] at the top, pull it down to the bottom, and pop it [snap it against the wall leaving a clean straight line of chalk] and then climb back up to the top of the scaffolding. It was all grit and muscle—straight draw and paint." The artist's next big Philadelphia mural would be even more demanding.

An uncommon mural

On a typical weekday, 5,800 people pass through the SEPTA stop at Broad and Spring Garden Streets. A nearby high school and community college attract hundreds of young people to the area, and a large parking lot also draws workers and shoppers to this bustling Center City corner. Towering over the intersection, *Common Threads* is impossible to ignore, as is the towering central figure of Tameka Jones, who muses silently from her place on the wall.

"Knowing there's a picture of you up twenty-four hours a day, seven days a week, 365 days a year—it's almost eerie," the multitalented young woman reflects, several years after the mural was painted.

Jones was seventeen when Saligman, who had obtained permission to photograph students at Benjamin Franklin High School and the School for Creative and Performing Arts (CAPA), approached her. "Basically," Jones recalled, "I was walking down the hallway of CAPA, and she came up to me and told me she was doing a mural." Saligman met with groups of students she had selected—more than one hundred from the two high schools. "She showed us murals she had done around the city and country and made appointments to photograph us," Jones recalled. At the photography sessions, Saligman showed the students pictures of figurines from several historical periods and asked them to mimic their gestures. Through a sequence of three photography sessions, Saligman selected the final fifteen people who would be in the mural and followed up with detail shots. At the end of one session with Jones, Saligman asked her, "What would you like to do?" They "played around with different poses." Ultimately Jones was selected for the central figure.

Jones, of course, is the only contemporary person in *Common Threads* who is not imitating someone from the past. "Tameka is the timeless figure," Saligman explained. "When I asked her what she would do if she were a figurine, she did that [pose]. I thought she looked kind of classic."

"It was just unbelievable," Jones recalled. "I thought Meg was going to change her mind. I thought, this is just the beginning. This is an omen of what you are going to become— the beginning of what I believe I'm going to accomplish." In a more mundane moment, when the mural was completed, she also wished she had worn lipstick for that photograph.

In the four years since *Common Threads* was painted, Jones has completed high school, become a prestigious Presidential Scholar, one of two from the state of Pennsylvania, and finished two years in the drama school at New York University in New York City. She is currently seeking scholarship money to continue college. Although she recognizes herself in the mural, she also sees the public portrait as something apart with a life of its own.

"Basically, you use a big, wide brush . . . "

The artist already had the concept for the mural and some grant money when she began "wall hunting." With its intriguing architecture, immense windowless brick wall, and eight-block viewing range, the Stevens Administrative Building, which Saligman described as "asbestos ridden and two-thirds vacant," looked like the perfect mural location. "Everything came together" for Saligman. She felt the building "just had a good spirit."

TAMEKA JONES, THE HIGH SCHOOL STUDENT WHO POSED FOR THE MURAL'S CENTRAL FIGURE, STANDS NEXT TO HER FINISHED PORTRAIT, A MERE EIGHTY FEET TALL.

Saligman was particularly engaged by the ornamental stonework and tile patterns above the windows, which she could copy in paint and use to organize her design. "It's very important that any mural that I do be integral with its architecture and surrounding environment," she explained. In *Common Threads,* painted tiles and architectural motifs unite the design and add to the overall richness of the visual experience.

When Jane, who happened to be scouting the wall at the same time, learned of Saligman's plans, she committed the program to the mural, eventually dedicating around $20,000, a substantial part of her mural budget. The total budget for the project was approximately $40,000. "The intelligence and creativity of this particular mural stirred my imagination," Jane recalled. "I think it is brilliant."

"Jane is willing to give artists a chance to do something big," Saligman said in another context. "She's willing to put her faith in the artist's [ability] to be bigger and better, willing to believe with you that your project can really be great. If it is, she'll find a way to support it, which is why it's a good thing to be a mural artist in Philadelphia."

During the time Saligman was photographing students for the mural, Adam Phillips, from CAPA, asked her to look at his paintings. Phillips, a senior in high school, had already been painting for around six years. He makes big, realistic paintings. Saligman was sufficiently impressed with his work to offer him "an apprenticeship of a sort." During his senior year and through the following summer, Phillips worked on *Common Threads.* "I got to cut my teeth on one of the greatest murals in Philadelphia," he said. "It was great being in high school and having a really prominent piece, [which] I can still, four years later, show to people."

Phillips was surprised by the amount of studio work involved in preparing for the mural. "For the detailed parts," he explained, "we projected pictures on pieces of plastic up on the studio walls and traced them with Sharpie markers." The full-scale drawings on clear vinyl were then traced on the Stevens building wall. "We went through a lot of pens doing that."

The fair-haired young man in the upper-right-hand corner of the mural is Phillips. "Meg thought it would be fun to have me paint my part," he said. She had already taken the photograph and selected the location in the mural.

"It was neat. Actually that was one of the first things I did. That part—right where my head is—is where I was learning very quickly to paint a mural. Even with the large six-by-nine-foot [easel] paintings I was doing, [I was] still able to get a lot of detail in and step back. At that [mural] scale, you can't put any detail in. The more detail you put in, the messier it looks when you step back. You've got to think very abstractly when you're right up at the wall. Basically, you use a big, wide brush and block in all the parts."

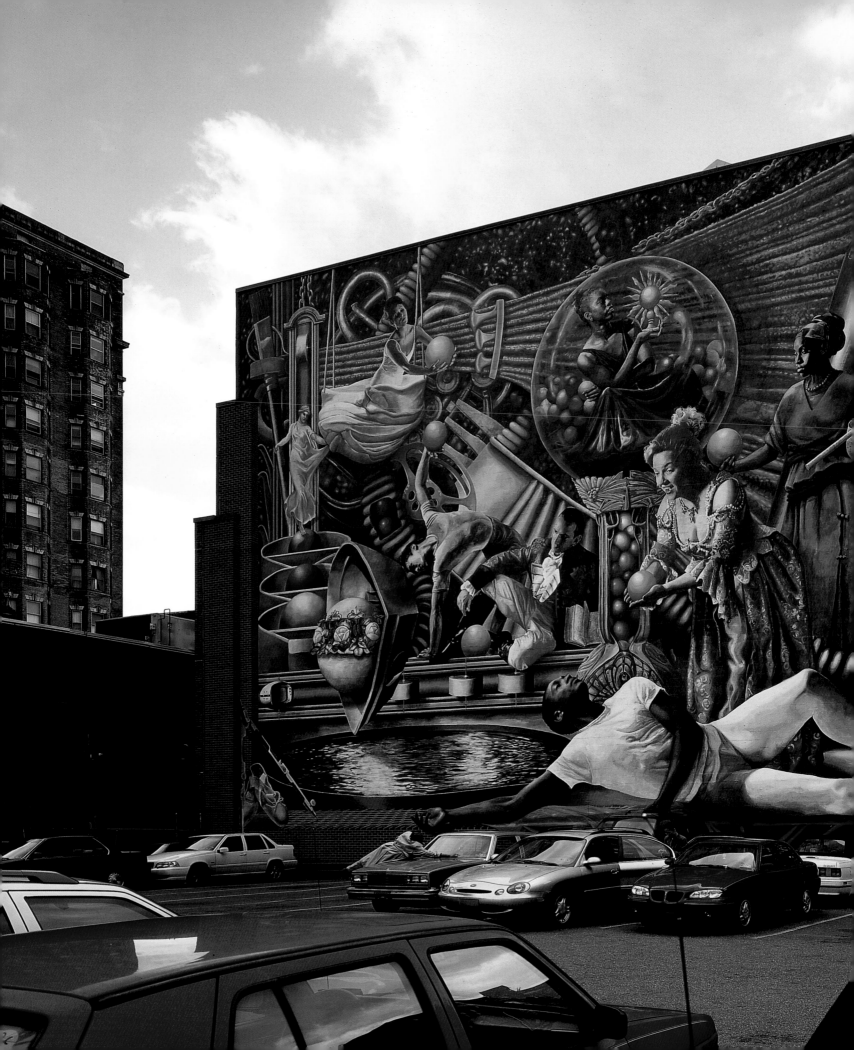

OFFERING A CONTEMPORARY INTERPRE-
TATION OF THE ANCIENT GODDESSES
WHO PRESIDED OVER THE ARTS AND
SCIENCES, *PHILADELPHIA MUSES*, AT
13TH AND LOCUST STREETS, HONORS
THE ARTS COMMUNITY OF PHILADELPHIA,
SEVERAL OF WHOSE MEMBERS POSED
FOR THE MURAL.

"I got to work on Tameka's face," he remembered. "That was an endeavor. Her face is about ten feet tall. It's a great example of how working on a mural is so different from regular painting. You're squashed up about three inches away from the painting. You can only see this tiny little square [traced from the acetate]. You can't climb down the scaffolding to see it from far away, and you can't freehand something like that."

Phillips was also surprised to learn that the wall would have to be completely primed and then repainted to look like brick. "Actually, if you left the brick unpainted, the painting would look very strange. It's paradoxical, but it looks more natural than the original." In addition, he explained, "we skewed the scale slightly as we went down." The bricks near the bottom are larger than the ones near the top, exaggerating the sense of height.

Saligman has explained that for a mural to become a convincing space for the viewer, the horizon line must be raised, or "switched up. To effectively fool the eye, it has got to maintain the perspective of the person on the street." Phillips added, "To make it flow, you have to distort it a little."

He was disappointed when he had to quit working on the mural about two-thirds of the way down the wall to begin his freshman year at Bard College in New York. Another high school student, Jason Slowik (who still works with Mural Arts), and then Cesar Viveros (who has also continued to work on murals with Saligman and the program), took over as primary—often sole—assistant.

Phillips shifted his major from painting after two years at Bard College and is now a student at the University of Pennsylvania majoring in politics, philosophy, and economics, though he continues to paint on his own. He also spent a second summer working with the mural program. That year, he painted with several muralists, including Paul Santoleri, but he has decided that although he likes "the whole aesthetic of murals," he is more interested in pursuing his own painting.

"There's a whole side of mural painting that is not painting," he explained. "It's politics. You have to put something in a space that a broad selection of people are going to like— something that they're not going to get tired of in a year. The politics is off-putting for me."

Saligman agreed that the political side of murals could be daunting. "You can never be adversarial, or it's not going to get you what you want. But if you feel like you're compromising, you might be compromising the artistic integrity of the work. You have to figure out a solution that allows you to rise above the problems." Even then, she acknowledged, "it's never a sealed deal until the mural's up. You have control that it's going to be a powerful piece, but you can't control everything." She paused thoughtfully. "In *hindsight*, they're all fun," she concluded with a hint of humor.

Mural musings

Since *Common Threads*, Saligman has continued to paint murals in Philadelphia, including the *Philadelphia Muses* (13th and Locust Streets, 2000, see p. 124), a composition for which she abandoned her rule of painting ordinary folk to represent some of the city's better-known performers, writers, and artists. The figures surround a giant art-making machine (reminiscent of a large gumball dispenser) that generates spheres—"the perfect form." Each figure holds a sphere, helping to unify the composition.

For the millennium, she painted a huge 25,000-square-foot mural in Shreveport, Louisiana. For that mural, as well as for *Philadelphia Muses*, she adopted California muralist Kent Twitchell's technique of projecting digitized images onto a very thin fabric, which is then painted and later applied directly to the wall with acrylic gel. Twitchell told Saligman that he stumbled upon this technique when one of his own sketches covered with this gel got stuck to his car. "When he wanted to get his car detailed, he couldn't get it off," Saligman said. Originally, Twitchell's technique incorporated paper and, later, parachute cloth. Now he and Saligman use a more high-tech material called nonwoven media, similar to Bounce, the laundry product, which is more absorbent than parachute cloth and does not distort when wet. Both materials are incredibly durable. "If you look at [Twitchell's] *Dr. J*," Saligman pointed out, "the areas that are deteriorating don't have [parachute] cloth on them."

Saligman says that often mechanically digitized images need to be corrected slightly to read properly; however, once the drawing on the cloth is complete and the areas numbered to signify which color of paint to use, anyone can fill it in. In Shreveport, two thousand people participated in painting the mural. The Shreveport work was composed entirely of nonwoven media, a technique that can be effectively combined with direct painting, as with *Philadelphia Muses*. Saligman feels ambivalent about doing all her painting in the studio. "I like the opportunity to stand up on the scaffolding and paint on a sunny day," she observed, adding that for representing faces and certain textures, computer digitization is supreme, while free painting is more effective with some fabrics and water.

Her plans for the future include making portable murals on vinyl—huge images in several sections—which can be moved from town to town and displayed for a few months to a year. "I'm getting slower," she said. "The longer I paint, the more time I spend on the design. I have the luxury of taking longer because I get paid more."

Most of all, she believes, "the important thing is to bring art to people who might not otherwise encounter it. I get the sense that for mural art, Philadelphia is really happening, and I think it's due to Jane's work. Without her, we would have a few nice murals, but not the consistent dedication and quantity of mural art that we have. We are in the front. This is an exciting time. The quality of the work grows and grows, and it's just coming into its own now."

"There's a whole side of mural painting that is not painting," he explained. "It's politics. You have to put something in a space that a broad selection of people are going to like—something that they're not going to get tired of in a year. The politics is off-putting for me."

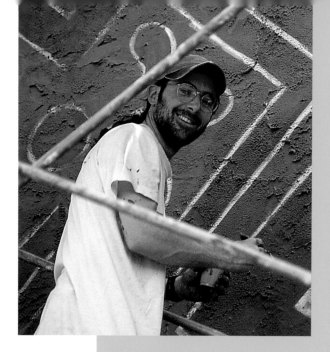

DAVID McSHANE

David McShane combined vintage photographs from several print sources for his tribute to Jackie Robinson on a North Philadelphia wall. "My initial idea was to have Robinson stealing home, which is hardly done today and hard to pull off, but he did it twenty-two times in his career," McShane explains. "This was the gutsy style of the Negro Leagues, and I liked the metaphorical idea of 'stealing home' because Robinson was already home, in that he was the first black player in the major league. He stole home in the World Series, and it was the turning point of the series. But in the most famous photo of this historic event, his hat was on and his hand was down. I merged that one with a synthesis of other photographs of his upper body in motion. I wanted a facial expression showing the intensity of the action—not an artificial baseball card pose."

Jackie Robinson (North Broad Street near Somerset Street, 1997, see next page) is one of the city's iconic murals, frequently chosen to illustrate articles on the Mural Arts Program and "the one I'm most known for," McShane says. The wall is painted entirely in black, greys, and white, reminiscent of newspaper photographs, but McShane chose the colors as a reminder of the black and white divisions that Robinson helped to overcome when he joined the Dodgers in 1947. As a role model of courage and grace, Robinson set a standard for the future civil rights movement.

"The subject seemed to fit the community," McShane says. "The site is just six blocks from the old Connie Mack Stadium (Shibe Park, at Lehigh Avenue between 20th and 21st Streets). From what I read, Philadelphia was one of the worst—if not the worst—city for black athletes." Encouraged by their manager, "players from the Phillies would yell racial slurs from the dugout throughout the game, and the audience joined in," McShane learned. Robinson acknowledged that this harassment almost drove him to the breaking point. By placing a border around the picture, McShane allows the figure of the great player to break out of the black-and-white background into the future.

McShane got a degree in biology before completing a certificate program and a master's degree at the Pennsylvania Academy of the Fine Arts (PAFA) in 1995. As an art student, he came to realize his passion for larger work and social issues. "I'm not so interested in work in museums and galleries or work that is owned by wealthier or more educated people. I'm from a working-class family and never went to museums or galleries when I was young. I want to demystify art, to make work that is accessible to general society.

"I like figurative murals. That's where my strength is. When I first started, the design of the mural was most important to me. Now I'm more concerned with what is right for the community. I'm still concerned with my aesthetic sensibilities, but also a good fit."

McShane admires the figurative distortions of German Expressionist Egon Schiele ("I really love when somebody takes a figure and claims ownership of it."). He, like many muralists, also admires Diego Rivera. "He really embraced the poor and working class. His workers are squat, solid, and thick armed and legged: they really support the weight of the world on their shoulders."

McShane builds his painting from shapes of flat color, like those used in poster art from the 1930s and 1940s in which compositions would be built out of specially mixed pigments rather than the standard four-color-process printing used today. For *Jackie Robinson,* he chose seven distinctive shades of gray in addition to black and white.

Although primarily a muralist, McShane also teaches at PAFA and LaSalle University and pursues his own work on the side. "I personally push my own aesthetic sensibilities in my studio when I am between murals," he says. "With public art you are less free because you are working with the community, as well as with politicians, the city, and others, such as funders."

McShane likes to work in disadvantaged neighborhoods, including those in North Philadelphia. "The feeling for family and community seems to be more cherished. It seems to me that class is often a bigger divide than race, but it's hard to prove. When I first started painting murals, I just wanted to paint bigger and have it be seen," he said. "Now I believe if there is more community involvement, if the city is investing in a neighborhood by working with kids in connection with a mural, it validates their voice.

"Most people are grateful, but you can't please everyone. In the poorer neighborhoods, there's a lot more interaction. I get really nice words of thanks in North Philly."

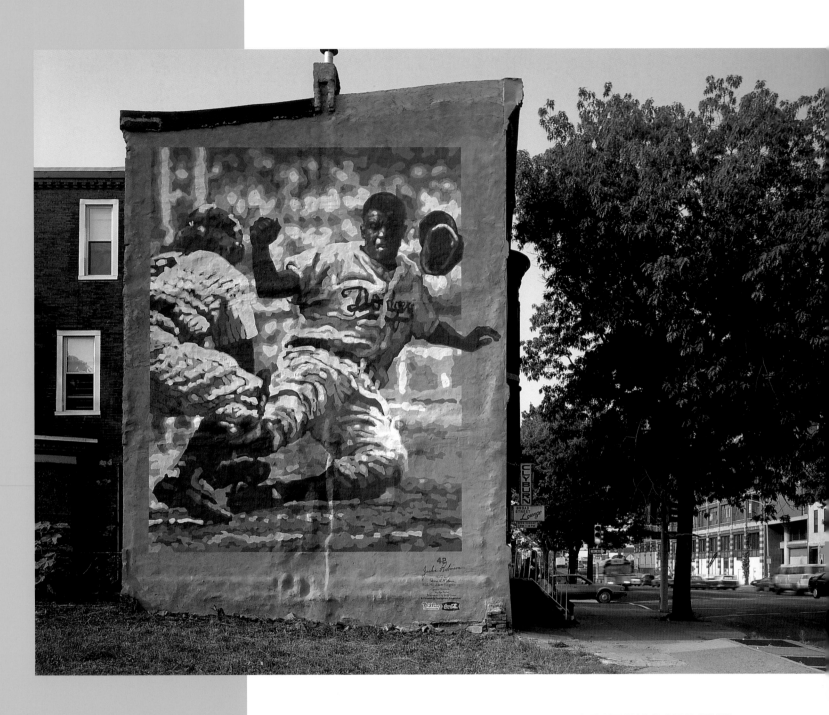

McShane has completed nine murals for the program, several for other organizations, and has four more scheduled for Mural Arts. "No mural is forever, he acknowledges. "The property owner may repaint the wall or tear the house down. A mural may be around when the kids that helped on it grow up, but it may not be there for their kids. That's okay.

"If my work was in a gallery, chances are the show would be a month long. *Here,* if conditions are good, the audience is large for fifteen to twenty years."

JACKIE ROBINSON, N. BROAD STREET
NEAR SOMERSET STREET.

THE COALITION FOR THE RIGHT TO LIVE IN PEACE
Sponsored by KEYSTONE MERCY HEALTH PLAN
FOR MURAL ARTS PROGRAM

A WALL OF
NEIGHBORHOOD
HEROES

I t is a Saturday afternoon in mid-September 2000, an hour into an emotional mural dedication ceremony in north central Philadelphia. Gray rain clouds have crept over the outdoor party, threatening to disrupt the touching testimonials about a little old lady and one big man, both of whom changed lives in this sagging stretch of the city.

One after another, friends and family members take the microphone to recall the lives of Rachel Bagby and Lloyd Logan. The two are neighborhood legends—she for creating community gardens and providing housing for senior citizens; he for watching over area children, steering them away from gangs and into sports.

Rosa Logan, Lloyd's widow, walks slowly to the podium leaning on her cane and her son Marcel. Speaking just above a whisper, she credits her husband for being a role model to a generation of children, showing them how to be "constructive, not destructive."

The Reverend Ellis Louden of Jones Tabernacle AME Church, tells the crowd how the beloved "Miss Bagby" watched over him as a child, and what a privilege it was to grow up to pastor a woman who gave him so much spiritual guidance. He talks about Miss Bagby's perseverance and bottomless faith, about her belief in people and a place that others simply gave up on years ago. Then, as if on cue from the good reverend, the clouds part ever so slightly, creating a hole just big enough for a patch of sun to poke through, bathing the mural in warmth and light.

Craving beauty

The mural commemorating the lives of Lloyd Logan and Rachel Bagby at 21st and Dauphin Streets is not the biggest or boldest in the city. Located in the heart of an inner-city neighborhood, it is not likely to be on many tourist itineraries. Spend an afternoon on the corner, though, and you would think it was the *Mona Lisa* painted right there on the side of an ordinary row house, steps away from a busy bus stop. To residents more accustomed to

open-air drug dealing than public art, the mural is magnificent. It's a life-size eulogy
to fallen heroes, a way to preserve a piece of local history that would almost surely be
forgotten as children grow up and families move away. On this corner, on this street, it is
not surprising that Lloyd Logan and Rachel Bagby were chosen to be profiled. All across
Philadelphia, there are people like them—folks toiling in quiet, deliberative ways to make
their communities safer, more secure.

Rachel Bagby was one of the first people Jane
Golden met in her career as a Philadelphia muralist.
It was the late 1980s, when the program was still a
fledging fight against graffiti, which seemed to be
spreading through the city like a cancer. Much of
the effort focused on reforming "taggers" and
encouraging them to express themselves in more
traditional art forms. So it made sense to Jane to have
them create murals in the very same neighborhoods
where the graffiti gangs were doing the most damage.

From Mantua in West Philadelphia, to North
Philadelphia's Strawberry Mansion neighborhood,
Jane spent the early days of the program trying to
explain the magic of murals to people struggling for
survival in urban war zones. Over and over, she got
the same response: People liked the idea of outdoor
art, but they did not want anything overly political or
pointed. They needed no reminders that they lived
in drug-and poverty-infested neighborhoods. Rather,
they needed serene waterfalls and lush landscapes,
something to take their minds off the misery.

"They wanted what they didn't have—nature, beauty,"
Jane recalled. "It was really about craving beauty."

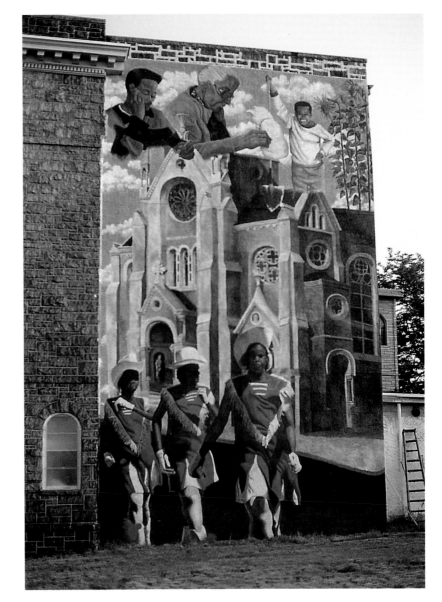

One of those people who was not at all shy about
telling Jane exactly what she wanted was a feisty
woman everyone called "Miss Bagby." She was born and raised on a farm in Orangeburg,
South Carolina. After college, she moved to Philadelphia and became a kindergarten teacher.
In 1950, she married a roofer and jazz drummer named William Bagby. The young couple
then bought a row house at 22nd and Woodstock Streets in north central Philadelphia.
Miss Bagby later told a newspaper reporter that when she arrived, the community was "the
prettiest neighborhood in Philadelphia." By the 1970s, after the city's industrial collapse,

ENTITLED *STEPPERS* TO CELEBRATE A
POPULAR LOCAL DRILL TEAM, THIS MURAL
BY CAVIN JONES AT 23RD AND BERKS
STREETS, 1996, CELEBRATES COMMUNITY
LIFE AGAINST THE BACKDROP OF A
CHURCH THAT ONCE STOOD IN THE LOT
IN FRONT OF THE MURAL.

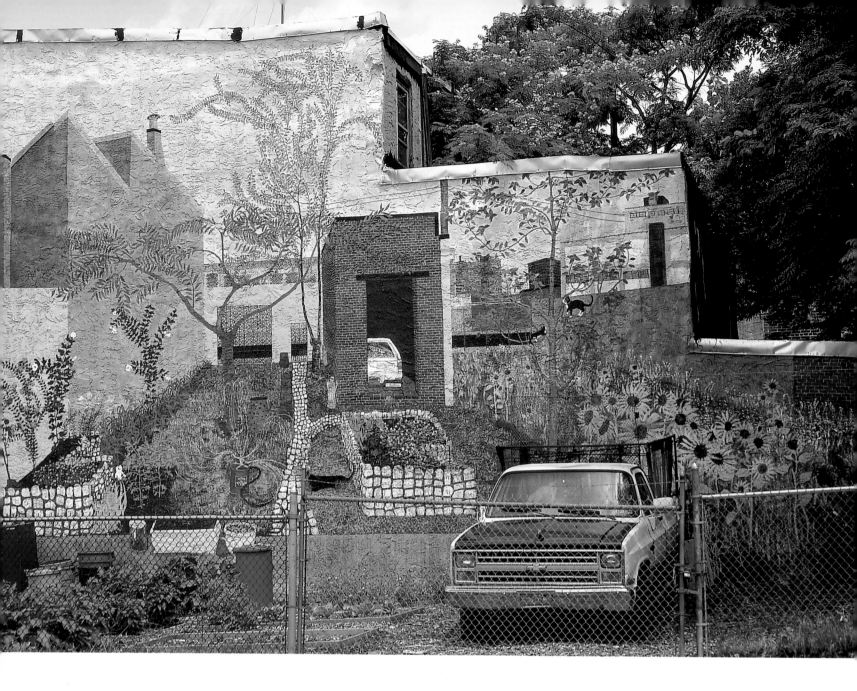

PAINTED IN PARTNERSHIP WITH
PHILADELPHIA GREEN, THIS WHIMSICAL
LANDSCAPE, ENTITLED *SUMMER GARDEN*,
1999, BY SARAH MCENEANEY, AT
FRANKLIN AND DIAMOND STREETS, WAS
PAINTED TO GO WITH A GARDEN THAT
HAS SINCE BEEN PLANTED IN FRONT OF
THE MURAL.

her haven had become overrun with abandoned houses, crime, and desolation. "This whole neighborhood is like an abused person," Miss Bagby would later recall.

After retiring from teaching and raising her family, Bagby began a crusade to do what she could to make the area whole again. She invited friends and neighbors to her dining room table to talk about what they could do to make a difference. In the late 1970s, they came up with a plan and named it: the Philadelphia Community Rehabilitation Corporation. The group's chief interest was promoting homeownership in the neighborhood. Perhaps, Bagby said, if the group could "re-people" the community and restore a sense of pride, family values would reemerge and reclaim the neighborhood she so cherished.

The nonprofit group applied for every available grant. Bagby used the money to buy and renovate vacant homes, holding first-time homebuyers' hands at each step in the process. She taught them home maintenance skills and counseled the new owners on how to apply for loans to improve their properties. She motivated her peers to keep fighting, creating a mighty band of senior activists. In the process, the organization bought, renovated, and opened the Rachel Bagby Shared House, a unique twelve-bedroom group home providing safe, affordable housing for senior citizens.

"She believed this is what the Lord wanted her to do," recalled William Bagby, her husband. "She had a way about her, that when she went to people to ask for something, she was seldom refused. She was like a mother figure. People loved her, and she loved them."

In the 1980s, the former farm girl began working with the Pennsylvania Horticultural Society's Philadelphia Green program, a partnership that would bring community gardening, and eventually murals, to her neighborhood. Bagby's neighborhood was chosen by the Pennsylvania Horticultural Society as one of the program's "Greene Countrie Townes," where gardens would come alive over a three-to-five-year period as part of an effort to organize residents and revitalize an urban environment through the time-honored practice of working the land. The Horticultural Society's president, Blaine Bonham, remembers watching Miss Bagby in action. "Her approach was tough and insistent," he recalled. "She was the benevolent dictator in the neighborhood. As long as she was vibrant and alive, that neighborhood was a gem, [even] with the whole area around it falling down."

Bagby saw gardening and murals with rural themes as a way to teach children about their ancestral past, since many of the elders in the neighborhood were Southern transplants like her. She also wanted to use gardening to teach kids about nutrition, about America's rich rural traditions. She thought the young children of north central Philadelphia—many of whom had unstable home lives—could learn discipline and self-respect through working the land.

"A lot of children here have never seen a farm," she once said. "They have no idea where anything they eat comes from."

Painting the neighborhood

As the gardens began to grow, Miss Bagby set her sights on bringing murals into the area, because until then the only visual stimulation for the neighborhood was billboards advertising cigarettes and malt liquor.

"She felt the weight of the poverty of the neighborhood on her shoulders," Jane recalled. Together, they nourished the neighborhood with murals. Between 1988 and 1990, a flurry of painting took place under Miss Bagby's watchful eye and Jane's brush. Two murals went up around 22nd and Dauphin Streets. One depicted an African American family working

"A lot of children here have never seen a farm," she once said. "They have no idea where anything they eat comes from."

QIMIN LIU

"I waited two years to do this mural, and [during that time] I was thinking about what I was going to do. I think a mural is more interesting when it coordinates with the surrounding environment and contributes to the neighborhood," explains Qimin Liu. His *Song of the Kites* (Mt. Vernon Street near 11th Street, 2000, see next page), in which exuberant children frolic against a flat background of gold-painted squares, has antecedents in traditional Chinese painting. But Liu thought beyond painting to include the entire environment: He designed and arranged elements for the simple community garden in front of the mural (Jane found money to finance it). "I considered the bench, the trees, and the walk, so that from different angles and positions, the painting on the wall becomes a different picture," the artist explains. "I wanted to think not only about space but about time. The light will change with the seasons. For example, winter snow and bare trees will be different from spring. My [painted] background is empty, with only small apple trees to give some color and meaning. In summer the [real] trees will cover some images, but that's okay. In fall the yellow leaves of the trees will let you see more and that's okay." Neighbors have volunteered to keep the trees trimmed in a way that will enhance the mural.

Liu came to the United States from China in 1991 to join his wife who was studying at Boston University. He studied art at Iowa State University and the Pennsylvania Academy of the Fine Arts, but before that, in China, he received the equivalent of a bachelor of fine arts in set design at the Institute of Chinese Traditional Opera in Beijing and worked for a short time in the Beijing Theatre. His sensitivity to the importance of lighting and movement through an environment in real time reflects this experience, though Liu cites 1990s theories of environmental or installation art as another important influence.

When Liu first met with the neighbors, "Some wanted flowers and trees, but I explained that 'you have flowers and trees already, why do you want them painted? We have this wall where we can create something more meaningful than just beautiful.' When I explained this project to them, they changed their minds."

Liu based the individual children in *Song of the Kites* on his own photographs of neighborhood children. "I asked the parents to bring the children on a certain day. They had a picnic on the block, and there were so many children!" The ten portraits include "Caucasian European, Hispanic, black, and Asian children. I chose those children to represent the immigrant stream. As an immigrant coming to the United States, I hope to be part of this society. I find greater opportunity in this democracy. If you work hard, you will fulfill your American Dream —that's part of the theme of the mural."

The mural's background of gold squares simulates the gold leafing traditionally used in Chinese and Japanese painting. "You can think of it as decorative color or as sky. The gold is symbolic, meant to represent prosperity, hope, and the richness of the culture." The patterned kites—two dragons, two phoenixes, and a sun kite—also represent hopes or dreams. Liu added a Superman kite as an American icon linked to the value of work.

Liu estimates that he painted the entire wall in one month and ten days, working from 8:30 A.M. to 8 P.M., taking time off only when it rained. He had to finish in time for the fall semester at the University of Connecticut, where he is now on the faculty. Though this was his first Philadelphia mural, he had considerable experience with large-scale work in China and Iowa. He had assistants, but he painted each figure himself. After gridding off the wall, he did a loose sketch of each child from a photograph and finished it in a high-key Impressionist palette. "I had to finish each one in two days because I had so little time."

An admirer of Goya, Manet, and Philadelphia realist painter Sidney Goodman (see *Boy with Raised Arm,* p. 18), Liu came to Philadelphia to study figurative art at PAFA. He believes that "the great masters still have the whole thing. Abstraction is highly developed now, and figurative work may be the future." He received an Independence Foundation grant for his ongoing series of paintings of Philadelphia's homeless people, a subject that has a complex meaning for him. He calls homelessness "the negative side of capitalism or of 'brotherly love.' Spiritually, the homeless have lost a lot," he acknowledges, but he feels a personal affinity with them. "This is part of my search for my goal as an artist. As an immigrant, I have lost my home and am trying to locate myself in this society. I'm a little bit tired and searching for a place to rest my soul." On the other hand, he says, "When I do public art, such as murals, I want to speak positively. We need to heal this society in some way."

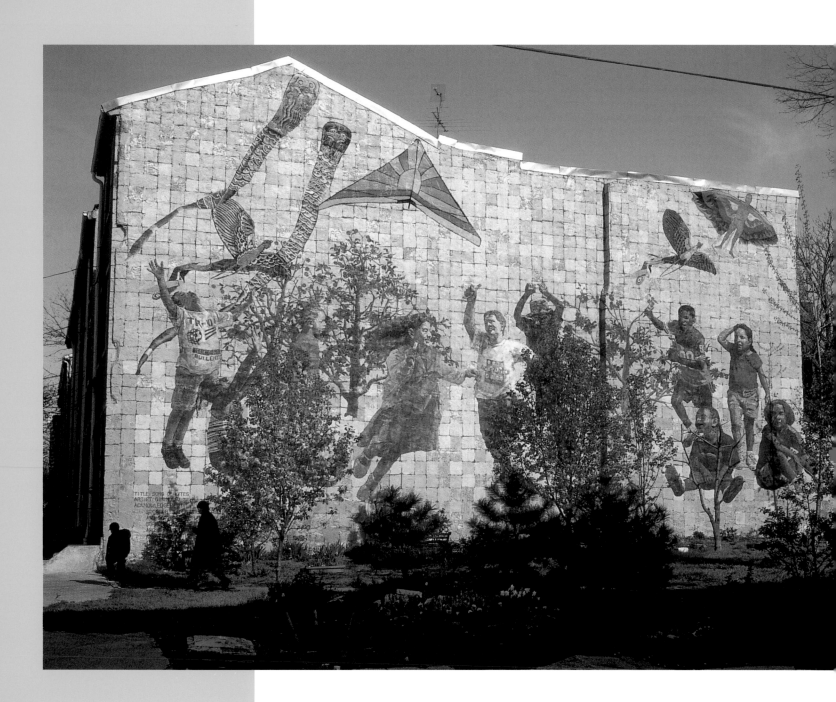

together planting a tree and picking apples. The other featured a farmhouse set in a valley below rolling hills, with an image of a weathered African American farmer wearing a white shirt, suspenders, and hat, leaning against a fence next to his daughter who was in a red dress. Miss Bagby hoped the images would inspire men in the neighborhood to think more seriously about their relationships with their children.

Around the corner, another farm scene was painted on a small wall at Dauphin and Woodstock Streets. This mural was filled with images from Miss Bagby's own photo albums—pictures of her aunt, an uncle, and people working the family farm. Nearby, two other murals featured images of neighborhood residents—especially children—working in gardens.

Miss Bagby coveted each new splash of color and energy in her neighborhood. She loved bringing art to the children, knowing full well most of the disadvantaged youngsters would never have access to Center City galleries and museums. She loved the murals' educational value, the way the visual stories taught lessons about life and love. She also reveled in the way outdoor exhibits sent drug dealers and graffiti gangs packing. "The beauty and the attention," she once marveled, "drives them away."

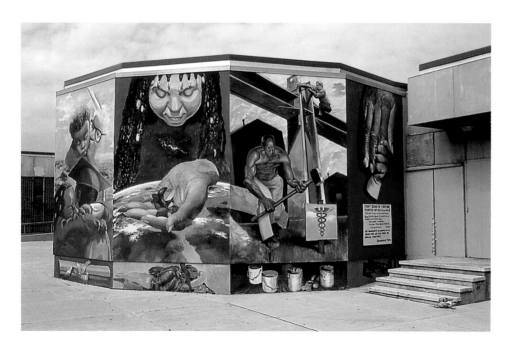

After years of trying to save her neighborhood one house at a time, Miss Bagby began to tire. She suffered a stroke in 1997 and died in the summer of 2000, a few months shy of her eighty-fourth birthday. She left behind her husband of forty-nine years, three grown children, fourteen grandchildren, two great-grandchildren, and a neighborhood of surrogate family members.

Little did the petite, modest woman with such welcoming eyes know she would one day wind up emblazoned larger than life on a wall herself. Had she been alive at the time, she probably would have tried to talk Jane out of the idea. "You don't just put anything on a wall," Miss Bagby once said. "You have to do something outstanding in order to get there."

A surrogate father

Lloyd Logan came to Philadelphia in 1926, by way of Halifax, Virginia. He was ten years old. He grew up in the East Falls section of the city and attended Simon Gratz High School. In 1939, he met Rosa V. Hall, whom he married two years later. The couple had

five children and settled in north central Philadelphia a decade before Rachel and William Bagby moved there.

A truck driver by trade, Logan played semiprofessional baseball in his day. It was only fitting that he started a youth baseball league in the late 1960s. He hoped to give neighborhood children something to do besides joining gangs or playing handball in the street. His son, Marcel, too young to play, was the team's batboy.

A year later, Logan retired from truck driving. Then the man who answered to a host of nicknames—Sol, Banjo, Rabbit, and Frog among them—really went to work, devoting all his time to area children. Logan's dreams, like Miss Bagby's, were hatched inside his family's row house: first baseball, then football and basketball teams. "They wore out three sofas," his wife Rosa recalled of the early days, when all the planning, programming, and rough-housing took place under the Logans' roof.

The players may have been poor, but Logan would not let them look or act it. He sold Pepsi out of the back of his station wagon to raise money for proper uniforms. "He never short-changed us," Marcel recalled. "We always had the best."

In the late 1970s when Logan could have been living a restful retirement, he was, instead, starting a new life as a community leader. He received city financing to buy and renovate the former Osteopathic Children's Hospital on the corner of 20th and Dauphin Streets. In 1981, the Colorado Community Center opened its doors.

Logan's work was not all for athletes or just for boys. Once he had space to spread out, he added GED classes and sponsored neighborhood clean-ups. For girls, he offered charm classes and majorette training. The athletic teams began traveling, competing across the city and into New Jersey. Once, the Colorado crew even played baseball inside Veterans Stadium.

Logan's obsession with helping young people grew out of his concern about the bleak futures ahead for children in mostly single-parent families, especially boys with no father figures to guide them. "He remembered back when an older man took him under his wing," Rosa Logan recalled. "He wanted to do the same for these kids. A lot of the parents were good parents; they just didn't have the time."

Jewell Williams, a Pennsylvania state representative with deep roots in the neighborhood, remembers Logan as a surrogate father who took him to his first Phillies game and taught him about manners and respect. "He always addressed people as 'Mister,'" Williams recalled. "He was such a gentleman."

Logan had a twenty-four-hour job. While the days brought fun and games to neighborhood street corners, the nights were rife with gang warfare. To reach troubled boys, Logan knew

BLACK AMERICAN GOTHIC, 21ST AND YORK STREETS, HONORS THE RURAL ORIGINS OF MANY RESIDENTS IN THIS MOSTLY AFRICAN AMERICAN COMMUNITY.

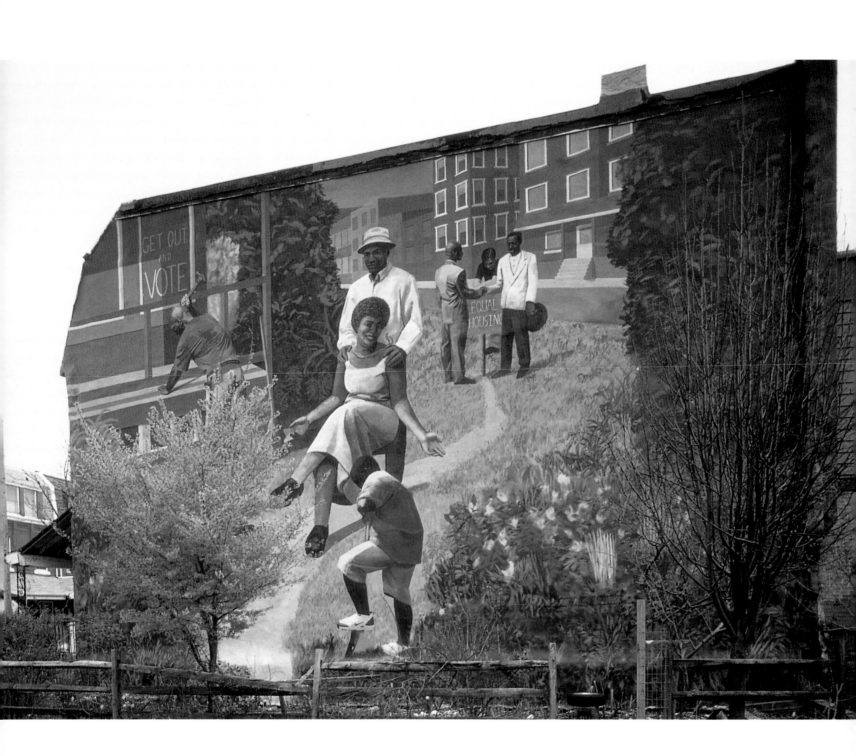

REQUESTED BY THE COMMUNITY TO
HONOR TIRELESS NEIGHBORHOOD LEADER
AND ACTIVIST *FLORIE DOTSON,* THIS
MURAL AT 3220 W. TURNER STREET
BY KARL YODER, 2000, CELEBRATES
DOTSON'S MANY CONTRIBUTIONS.

PORTRAIT OF AN ANONYMOUS BOY, 1999,
BY DAVID MCSHANE AT 3041 N. BROAD
STREET, REFLECTS THE POSITIVE CAREER
OPTIONS AND LIFE CHOICES AVAILABLE
TO YOUNG PEOPLE IF THEY PURSUE THEIR
INNATE TALENTS AND INTELLIGENCE,
SYMBOLIZED BY THE LIGHTBULB ON
THE BOY'S T-SHIRT.

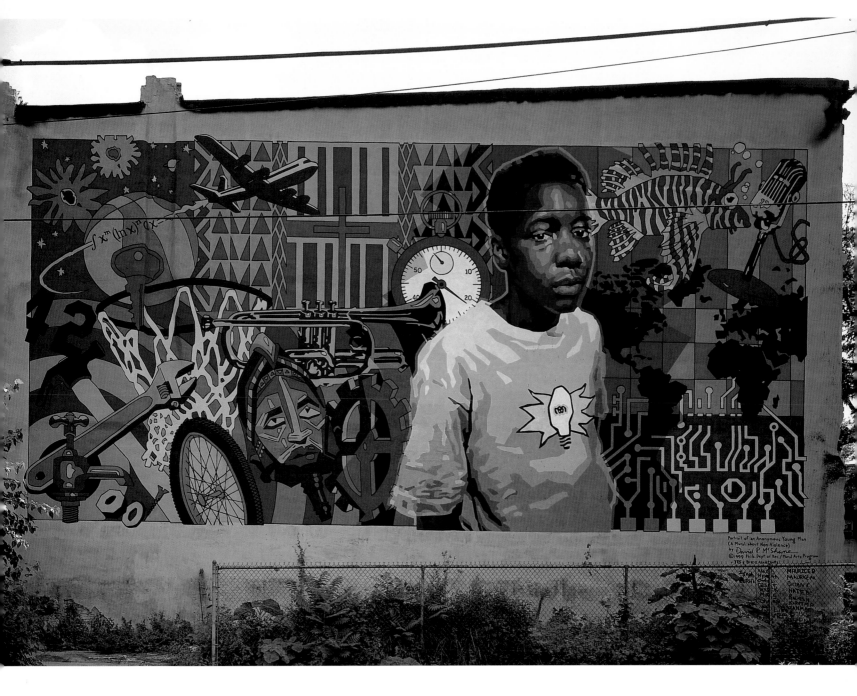

he had to confront them. Night after night, he went outside to stand up to the negative influences on north central Philadelphia's most notorious corners. In the dark, he tried to reason with young thugs, hoping to stop fights and steer kids in a more positive direction.

Watching his father, Marcel learned how to be a strong and compassionate man. "When you stand up to these kids, they respect you," Marcel said. "Some of them just want discipline."

Logan—the disciplinarian with the big heart—was something of an anomaly at the time, when it seemed like most of the community crusaders were women. After just one meeting with Logan, Jane realized she had met the male equivalent of Rachel Bagby. "He was the most welcoming man," she recalled of Logan, who offered space in his community center for Jane to teach art classes. "He had a twinkle in his eye. He was exceptionally, exceptionally kind."

For years, whenever anyone would ask Logan how he was, he uttered the same response: "One day at a time." It was his mantra, the phrase that summed up the marathon approach to battles that could not be won in a sprint. On his final day—Thursday, October 24, 1996—eighty-year-old Lloyd Logan was hard at work at the Colorado Community Center when he suffered a fatal heart attack. He died doing what he loved, in the place that was his second home.

So many people wanted to come to Logan's funeral that the family held two services. Streams of family and friends eulogized the former Teamster and team leader as a pioneer, a man "blessed with a special gift, the greatest gift he could give—himself." Someone dubbed him "a buffer, a bridger, a builder."

There were hymns and tears and a poem from Logan's grandchildren, thanking their beloved "Pop-Pop" for his attention and support. And then, in the end, someone read a simple Bible verse from the Book of Timothy that seemed to sum up Lloyd Logan in three lines:

I have fought a good fight.
I have finished my course.
I have kept the faith.

Honoring the past

In the fall of 1999, the Mural Arts Program inaugurated a new program to teach the history and technique of mural painting to children in some of Philadelphia's roughest neighborhoods. Dubbed the "Big Picture," the program gives youngsters serious art instruction and real-life work experience painting murals. Unlike many art programs that only work with students for a few weekends or a summer, the goal of the Big Picture is to have impact through staying power—to build real relationships with children, helping and watching them grow.

"The whole issue of sustainability is a big one for us, one we're struggling with right now. It's important to go back to neighborhoods and see what worked, what didn't."

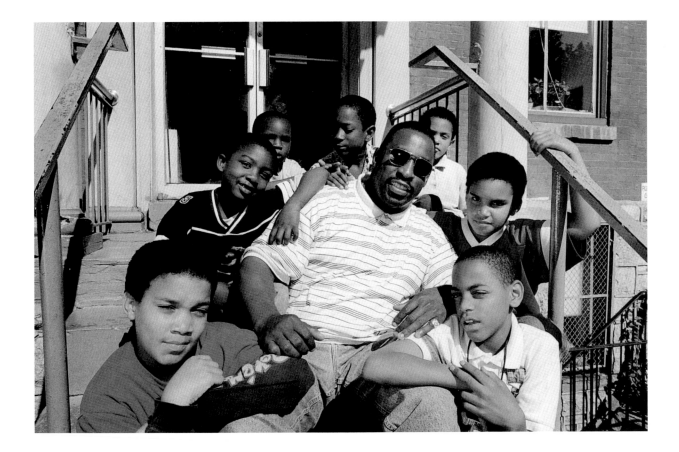

As Jane was deciding where to launch the Big Picture, she recalled her experiences in north central Philadelphia at the Colorado Community Center. She liked the idea of coming back to the neighborhood where the program had learned to fly a decade earlier, when it was a fledgling anti-graffiti initiative. She wanted to revisit the program's past while launching its future.

"When we talk about the power of murals, the real questions are: What can they *do* in communities? How do we not make it a superficial experience? How do we make the impact really profound? How do we make it last?" Jane explained, "The whole issue of sustainability is a big one for us, one we're struggling with right now. It's important to go back to neighborhoods and see what worked, what didn't."

Much had changed in the neighborhood since Jane had painted up a storm with Miss Bagby and Lloyd Logan by her side. After his father's death, Marcel Logan took over responsibility for running the community center—an unpaid job he tackles in the mornings before going to work at Temple University Hospital. By 1999, Miss Bagby had suffered a stroke and was in poor health, leaving her husband and a spirited band of senior citizens to continue her work as best they could.

As part of the Big Picture program's commitment to the neighborhood, Jane promised that the area would get a handful of new murals. As always, she needed walls and ideas.

MARCEL LOGAN, CENTER, IN FRONT OF THE COLORADO COMMUNITY CENTER FOUNDED BY HIS FATHER. MARCEL CONTINUES HIS FATHER'S LEGACY OF COMMUNITY ACTIVISM, WORKING TO PROVIDE POSITIVE ALTERNATIVES FOR THE NEIGHBORHOOD'S YOUNG PEOPLE.

Marcel Logan already had both in mind. Logan found a wall on the corner of 21st and Dauphin Streets, next to a vacant lot where gangs used to gather before residents reclaimed the block. He thought it would be a perfect setting for a mural, a permanent reminder to drug dealers and other criminals in the area that their presence would not be tolerated. What better way to show them, Marcel thought, than a mural honoring the exalted examples set by his father and Miss Bagby?

On a warm evening in the first week of July 2000, Jane left the office and hopped into her city-issued Jeep Cherokee. She drove north on 16th Street and turned left on Diamond Street, then right onto 20th Street. At Dauphin Street, she parked at the corner. There, Jane met Marcel Logan; Jewell Williams, the recently elected state representative; McGarrett Whitney, twelve, a bubbly, aspiring artist involved in the Mural Arts' growing Big Picture program; and Cavin Jones, a well-respected muralist whose work graces walls across Philadelphia.

They had come to determine just how to turn the blank wall into artful inspiration. A few neighbors and volunteers from the community center stopped by, intrigued by what was taking place.

Jane explained that neighborhood children would be integral to the mural making, news that got McGarrett Whitney grinning. Jones showed rough sketches of his design: a rich mosaic, resembling stained glass, would form the background, a symbol of both Logan and Bagby's faith. The images of Logan would show his serious and playful sides, while below bold letters would proclaim his favorite saying, "One day at a time." In the center of the mural, Jones would paint a warm portrait of Bagby, because she was "a mother figure, a nurturer of the neighborhood." On the far left portion of the wall, he envisioned painting ivy and greens "as a symbol of rebirth."

As Jones unveiled his plans, Jane looked nervously at the small group of men standing on the sidewalk. In a decade of these meetings, she had come to expect dissent and divisiveness when talk finally turns to what exactly a community mural will look like. Despite the unity that brings neighbors together behind the idea of a mural, passion often pulls them apart when it is time to settle on an image.

But that night, Jane was pleasantly surprised. The handful of locals who gathered for Jones's pitch liked it. Marcel Logan stared at the sketches, nodding fondly. So did Williams, the politician, who said that without the mural, leaders like Bagby and Logan "would be forgotten." Within fifteen minutes, Jones had a green light. Then, the real work began.

Painting for an audience

On July 10, the scaffolding was erected. The next day, Jones began priming and gridding the wall. Like many muralists, he creates his massive works using a grid system, transposing the work from half-inch squares on paper to one-foot squares on the wall. This method allows him to fill in each square individually while keeping the enlarged elements in proportion to his original design. "It's not paint by numbers," Jones explained. "I work it out in my head."

Initially, just two children in the Big Picture program, McGarrett Whitney and another boy, showed up at the work site during the priming, which had Cavin Jones worried. He had looked forward to shepherding a group of young artists on this project and hoped he would not be let down. McGarrett could not wait to get started. The time commitment for being part of the program—three days a week during the school year; all day during the summer—was no problem for a youngster who had been drawing passionately since he was seven years old. A sweet, round boy with a glorious singing voice, McGarrett has spent much of his twelve years battling kidney ailments. It was during one of his many hospital stays that his mother, Lucy Whitney, discovered his gift for art.

He thought it would be a perfect setting for a mural, a permanent reminder to drug dealers and other criminals in the area that their presence would not be tolerated.

Fortunately, more children from the Big Picture program eventually joined the mural effort, painting small icons symbolizing characteristics and interests of Bagby and Logan—tools, baseball gloves, basketballs, insects, flowers. McGarrett quickly mastered the rose and a frog. His baseball glove needed a little work, but Jones wasn't worried. Already, he saw that this boy had a gift. "I've never seen anybody his age as good," Jones raved.

Although Jones is one of Mural Arts' fastest painters, the soggy summer of 2000 threw off his rhythm. July was a gray, wet month with few days of sun in between each rainfall. The wet weather would later be blamed for a series of sixty buildings—many were long-abandoned and neglected row houses—collapsing across the city. The soggy soil gave Jones pause, as he worried whether the scaffolding was firmly rooted in the ground each time he climbed up into the air to work. Working on a community mural is as raw and real an experience an artist can have. High above the ground on the scaffolding, Jones is the subject of praise, scorn, and lawn-chair criticism. This time, the response was mostly favorable, although residents often stopped to ask him questions. "I don't think most people knew them," Jones said, referring to Miss Bagby and Lloyd Logan, a sign of just how much the neighborhood had changed since the duo were alive.

Others in the neighborhood seemed puzzled by why he was painting three images of Logan but just one of Miss Bagby. Jones knows it looks odd, but swears there was no conspiracy. "It's really a mundane reason," Jones explained one day at the mural site. "I had more pictures of Mr. Logan to work with."

Initially, Jones planned to paint a garden behind Miss Bagby to link her to the earth she so lovingly tended. Once he started executing the design, however, he realized the stained glass effect needed to be carried out throughout the background. So he changed plans midstream—a first for the artist.

Despite the weather and time constraints—Jones was working on two projects simultaneously that summer—he completed the mural in eight weeks. Once the scaffolding was removed, he could analyze his work. Maybe Miss Bagby's nose could have been a little straighter, but he was painting from an old photo. The children's work came out nicely, too, especially McGarrett Whitney's. "It looks even better," Jones said a month after he finished the project, "than I remembered."

A sacred space

The dedication was scheduled for mid-September, on a weekend to accommodate out-of-town family members. Despite the fact that Jane has been to hundreds of them, there's something about a mural dedication that always lifts her spirits. They are soaring events, full of praise and positive vibes. Each community celebrates murals differently. Each has its own way of embracing and experiencing art.

The corner was transformed: No broken beer bottles, no crumpled potato chip bags, not a hint of litter. Fresh cedar chips were scattered on the ground of the miniature park, which was quickly taking shape with benches and seedling trees—carefully planted, of course, so as not to obscure the mural when full-grown.

Elderly friends of Bagby's walked slowly to the party from the nearby senior center. McGarrett Whitney's Boy Scout troop had come, proud and in uniform, to serve refreshments under a tent. A borrowed sound system got the crowd swaying to old rhythm and blues.

COMMUNITY LEADERS, AT 21ST AND DAUPHIN STREETS, CELEBRATES THE LIVES OF RACHEL BAGBY AND WILLIAM LOGAN, NEIGHBORHOOD LEADERS WHO DEVOTED THEMSELVES TO IMPROVING THEIR COMMUNITY.

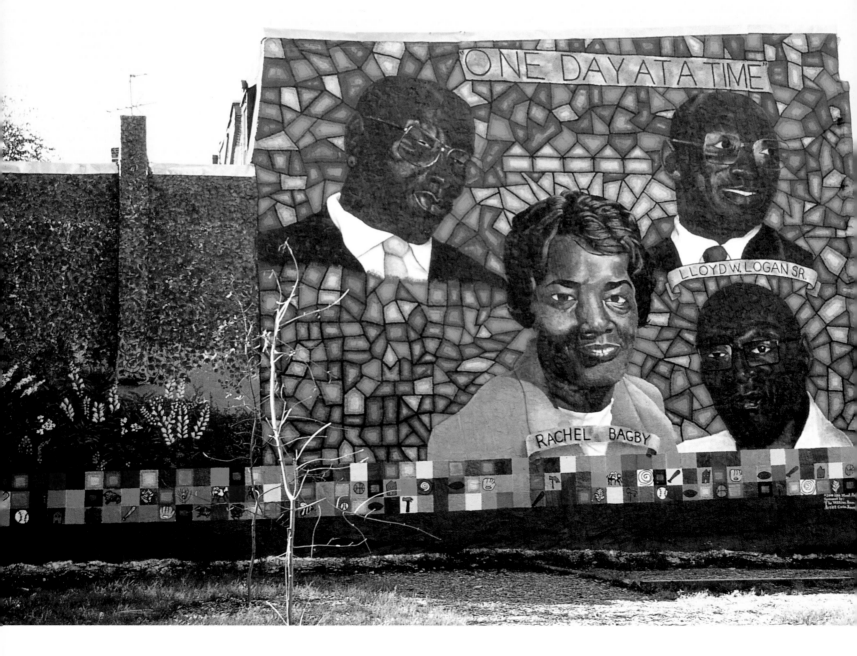

A string of friends and family members took the microphone. One remembered Bagby as a "pioneer." Bagby's daughter Rachel read a stirring poem, describing her mother as a woman with "spirit larger than she was tall." Jane told the group about how she first met the dynamic duo of Logan and Bagby while painting her first mural in the neighborhood in the 1980s: "They saw me eating my pathetic peanut butter sandwich and took me into their homes and fed me. They inspired me. Their words stayed with me for years and years."

Jane launched into one of her oft-repeated speeches about the power of murals: "Art shouldn't be locked away in galleries and museums." She reminded the audience, "This wall belongs to the community." She praised the finished product, made possible with "the magic of Cavin's hand," and talked about plans to add park benches and more trees.

Representative Williams offered thanks and gifts to the young artists who worked on the mural, reserving special praise for McGarrett Whitney. "This young man will be a real role model," Williams said, as McGarrett blushed, then thanked Jones for taking him under his wing.

An unexpected development of the mural painting is the budding friendship between Cavin Jones, the muralist, and McGarrett Whitney, the young aspiring artist. Jones was so taken with McGarrett's abilities and ambition that he offered to mentor the boy on weekends. "He's better than I was at that age," Jones tells McGarrett's mother, Lucy. "He's a special little guy."

Residents say they had no idea how quickly the mural would become a familiar part of their visual landscape. Andrew Dixon lives across the street from the painting. "I like to take walks. This four-block radius is a horrible place. In any direction, there's a lot of sadness," he explained. Now, he has the mural to brighten up that horizon. "This beautiful picture makes it a little better."

Dianna Sheffield has been working with Dixon and other neighbors on a project called "Operation Eyesore: Changing Our Community One Day at a Time." They are developing the little park beneath the mural and plan to turn another lot nearby into a baseball field for the kids. In just a few weeks, Sheffield said, the mural's presence forced drug dealers to take their business elsewhere. "They know our boundaries," she said, proudly. "This is *our* corner."

To Donita Dixon, Andrew's wife, the victory is especially sweet. "This corner is important. Most people use it to either come into our neighborhood or to leave," she said. "Already, there's a whole different feeling here. You see all this urban blight around here, and then you see this," she said, pausing to gaze at the mural.

"You take that home with you. You take it to work. It lasts."

"This corner is important. Most people use it to either come into our neighborhood or to leave. Already, there's a whole different feeling here. You see all this urban blight around here, and then you see this."

CLIFF
EUBANKS JR.

"I heard somebody say once that the first job of a painting is to keep people from going by," Cliff Eubanks notes. His murals do this and more: They reward extended contemplation, often by incorporating interrelated vignettes and framing motifs reminiscent of historic European architectural decoration.

Born Again (Dickinson and Bouvier Streets, 2000, see next page) is a majestic vision of a contemporary mother and child within a frame of religious images painted to resemble stained-glass windows based on the life of Christ. The contrast of the familiar human scene, one that is both ordinary and iconic, with the spiritually charged events in the surrounding frames is characteristic of the art of the Renaissance. Eubanks believes it is "the most successful marriage of form and content" of his six murals, all painted since 1997. "The child," he explains, "is reaching toward the mother's face, the way babies are focused on the face." A ruddy yellowish evening sky with a lavender cloud throws the figures into silhouette and gives definition to their shadowed features. Eubanks says the sunset was inspired by one he saw outside of Nairobi against Mt. Kilimanjaro.

"I wanted the mural to be satisfying if you roll by in the car, but if you can stop, you get the details in the various panels." Eubanks based most of the compositions of the twelve "stained-glass" windows, each four feet wide, on real historical

windows and organized them so that the scene of the crucifixion in the upper-right corner would be larger than the others. In subtle detail, Christ's mother looks down from the upper-left corner on the modern-day mother and child.

Born Again really was born again. With many requests for murals pending, this particular North Philadelphia block received its mural through an unusual stroke of fortune. Eubanks was originally asked to make a mural for a nearby group, but the supposedly approved wall turned out to be on a condemned building. He quickly located a suitable wall nearby, but it was under the jurisdiction of a different block organization. Though the new group's wishes were surprisingly similar to those of the first group, Eubanks thought it would be problematic to use exactly the same design in the new location. He met with the disappointed members of the first group. "I used diplomacy. I showed them that my original design [for them] included flowers and trees. They were good natured about it, but they haven't gotten a mural yet," he says regretfully.

The second community requested positive images reflecting care for children and hope for the future. They wanted the theme to be Christian. In response, Jane suggested images of stained glass, which evolved into the idea of depicting events from the *New Testament*. The central image came easily to Eubanks, who estimates that he's made over three thousand portraits since 1981 and specializes in newborn babies. "Frequently, the parents keep in touch and ask me to do follow-up portraits."

From his own childhood, Eubanks "can't remember not doing art: By the time I started kindergarten, I was drawing at the kitchen table." His mother believes he

was almost four when he drew "a nude lady. I told her, 'I'm gonna put clothes on her,' and she said, 'You better.'" His father, whose posthumous portrait as a muscular seventy-eight year old is included in his mural *Eight Signs of Fortune* (District 5 Health Center, 20th and Berks Streets, 1999, see p. 138), was an inspiration, a man profoundly dedicated to the Bible and education.

After studying at the Pennsylvania Academy of the Fine Arts and the University of Pennsylvania, and receiving a master of fine arts at Yale, Eubanks spent a summer in Oxford, England, and traveled through Europe. He later completed another master's degree at Hahnemann University so he could work as coordinating director of arts therapies with Presbyterian Medical Center, Westhaven Division. He did this for three years before returning to his first love, painting.

In spite of an old shoulder injury, Eubanks completes about two murals a season. "When I first went up on scaffolding, I was really scared and more or less lay on my stomach to paint," he laughs, "but now I'm a complete monkey. With *Born Again,* I had someone helping me for a couple weeks, but he left and I had to finish alone. I invented this lift with a grappling hook and a long cord to haul cans of paint up the scaffolding." Adapting creatively to the situation at hand, Eubanks mixes his colors in cardboard boxes and tries them out on his clothes and shoe tops. "After work I stop in the supermarket, and I get some looks!" Other tricky situations include weather. He has even had to shovel snow away from a wall he was painting and rig plastic sheeting to keep his brushes from freezing in the paint pan.

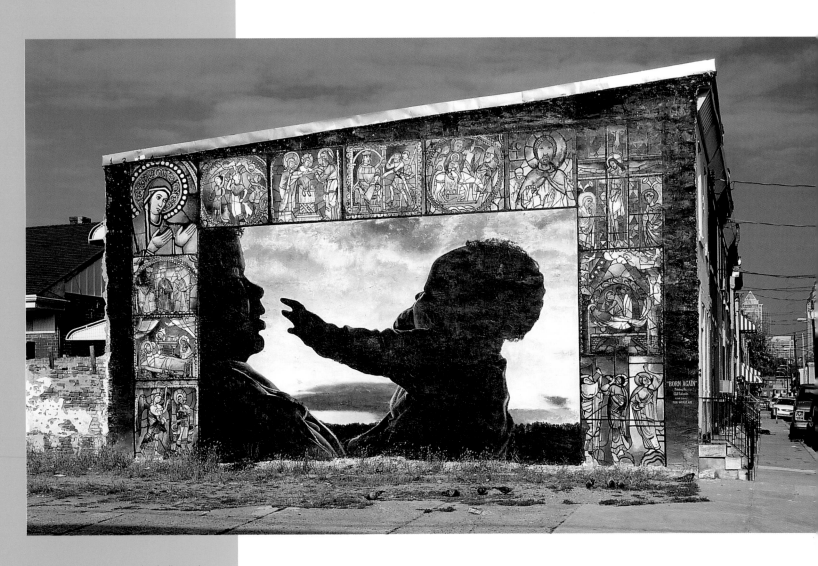

But weather is not the only challenge he has faced while painting a mural. While working on *Born Again,* "I was up on the scaffold, and I heard shots ring out. I thought, I'd better paint faster," he jokes. In reality, he decided he would be safer on the ground. A witness to the shooting came by and said, "'They shot three guys, and a little girl got injured.' Later, a kid came up and asked if I was going to do another memorial wall," he recalls, disturbed that children are now familiar with violent death.

The title *Born Again* suggests, first, the expectation of Christian resurrection; second, the possibility of renewal and rebuilding for the community and its residents; and third, the opportunities that are born anew with each generation. "It's about hope," Eubanks explains simply. "The Mural Arts Program embodies that as much as the mural itself."

mural map

1 *Born Again*, 2000, Cliff Eubanks; 1450 Bouvier Street at Dickinson

2 *Butterflies of the Caribbean*, 2000, Salvador Gonzalez; 163 W. Susquehanna Avenue

3 *Common Threads,* 1998, Meg Saligman; 1335 Spring Garden Street at Broad

4 *Community Leaders*, 2000, Cavin Jones; 2253 N. 21st Street at Dauphin

5 *Crystal Snowscape*, 1999, David Guinn; 623 S. 10th Street at Bainbridge

6 *Dr. J*, 1990 (res. 2002), Kent Twitchell; 1234 Ridge Avenue

7 *Eight Signs of Fortune,* 1999, Cliff Eubanks; 1900 N. 20th Street at Berks

8 *Spring*, 2001, David Guinn; 1315 Pine Street

9 *Frank Rizzo*, 1995, Diane Keller; 910 S. 9th Street at Montrose

10 *Frank Sinatra*, 1999, Diane Keller; 1231 S. Broad Street at Wharton

11 *History of Gray's Ferry*, 2001, Josh Sarantitis; 3405 Wharton Street and 1234 S. 34th Street

12 *History of Immigration*, 1993 (res. 2001-2002), Jane Golden and mural staff; 404 N. 2nd Street at Callowhill

13 *History of Puerto Rico (Raices)*, 1994, Barbara Gishell and mural staff; 2211 N. 2nd Street near Susquehanna

14 *Inside Outside*, 2000, Sarah McEneaney; 1123 Hamilton Street

15 *Journey*, 1999, Meg Saligman; 1831 Callowhill Street

16 *Mario Lanza*, 1997, Diane Keller; 1336 S. Broad Street at Reed

17 *Paul Robeson*, 1999, Peter Pagast; 4502 Chestnut Street

18 *Peace Wall*, 1998, Jane Golden and Peter Pagast; 1308 S. 29th Street at Wharton

19 *People of Point Breeze*, 1998, David McShane; 1541 S. 22nd Street

20 *Philadelphia on a Half-Tank*, 1999, Paul Santoleri; Penrose Avenue at the George C. Platt Bridge

21 *Philadelphia Muses*, 1999, Meg Saligman; 1235 Locust Street

22 *Seasons*, 2000, Ras Malik; 1417 N. Howard Street near Master

23 *Secret Book*, 1999, Josh Sarantitis; 312 N. 19th Street at Wood

24 *Song of the Kites*, 2000, Qimin Liu; 1136 Mt. Vernon Street

25 *Taller Puertorriqueno*, 1986 (res. 1999), Parris Stancell and mural staff; 2721 N. 5th Street at Lehigh Avenue

26 *Through Cracks in the Pavement*, 2001, Paul Santoleri; 717 N. 5th Street at Olive

27 *Tropical Landscape with Waterfall*, 1999, Ana Uribe; 1920 N. 5th Street at Berks

28 *Tuscan Landscape*, 1994 (res. 1999), Tish Ingersoll; 439 N. 32nd Street at Spring Garden

29 *We the Youth: City Kids of Phila. and NYC*, 1987 (res. 2000), Keith Haring; 2147 Ellsworth Street

30 *Welcome to Mummerland*, 1999, Robert Bullock; 1110 S. Front Street at Manton

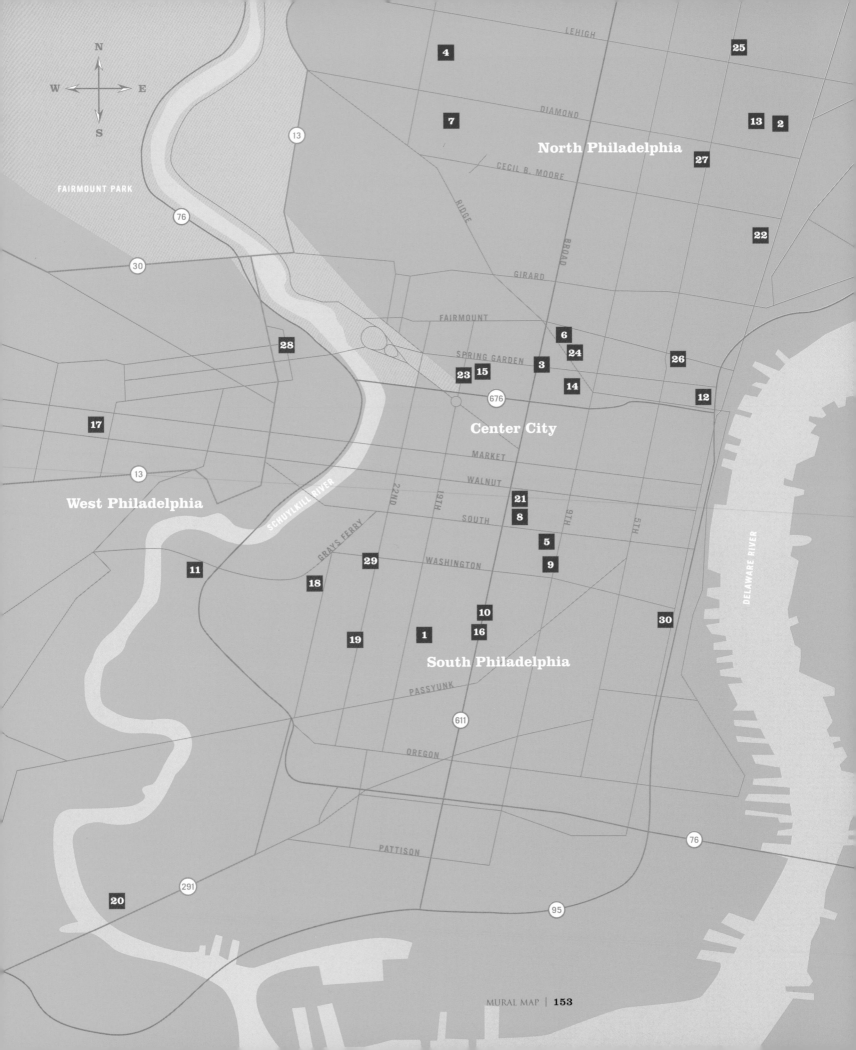

Note: Page numbers in *italics* indicate illustrations.

A

Abstract Expressionism, 84, 128
Abu-Jamal, Mumia, 101
Adonis, Dietrich, 6, 24, 40, 41, *41*, 45, 57, 80, 82, 83
African Americans, 46, 75, 118, 128, 135–138
African Wildlife (Jones), *31*
AIDS Quilt, The, 83, *86*
Albano, Rocco, 35–36, 37–39, *39*, 43, *81*
Allegorical murals, 21, 22, *22*, 24, *25*
American Street Empowerment Zone, 75
Amoroso, Nancy, 101
Anderson, Marian, 24, *26*, 90, 104
Angel Coming Down (Bastien), *74*
Anti-Graffiti Network. *See* Philadelphia Anti-Graffiti Network
Anti-Graffiti Task Force, 26
Aponte, Carmen, 75

B

BABY-ROCK (graffiti artist), 41
Baca, Judith, 8
Bach, Penny, 22, 25
Bagby, Rachel, 132–138, *148*
Bagby, William, 133, 135
Baraka, Amiri, 40
Bartlett, Beau, 100
Bastien, Frito, *74*
Bastille Art League, 46
Beasley Building, 23, *25*
Benjamin Franklin Parkway, 25
Bibleway Baptist Church, 94
Bierbaum, Ariel, *15*
Big Picture program, 58, 61, 93, 142–145
Black American Gothic (Golden), 23, *139*
Black Family Reunion (Golden & Adonis), 24
Bonham, J. Blaine, Jr., 69, 75, 135
Born Again (Eubanks), 150–151, *151*
Boy with Raised Arm (Goodman), *18–19*, 40–41, 82
Brown, Iris, 68, *68*, 73, 75
Buffing, 15
Burholme (section of Philadelphia), 89
Bush, George, Sr., 94
Butterflies of the Caribbean (Gonzalez), 74
Butterfly (Gonzalez), *64–65*
Byrd, Sam, 93

C

C K (graffiti artist), 36–37
Calder, Alexander Milne, 23
Cardinelli, Rosalie, 110
Carter, Jimmy, 94
Casa di Pazzo (Guinn & Smolen), 84
Center City, 23, *25*, 89
Chamberlain, Wilt, 24, 90
Charles Building, 120
Checker, Chubby, 93
Chicago murals, 7
Children's Crisis Center, *114–115*
Chinatown, 21, 22, 112
CIGNA, 86
Citywide Mural Project, Los Angeles, 30
Class differences, 42
Clinton, Bill, 94
Cloth murals, 16, *78–79*, *81*, 82, 127
Colorado Community Center, 139, 143, *143*
Colors of Light: Gateway to Chinatown (Sarantitis), *21*, 22
Common Ground (Sarantitis), *54–55*
Common Threads (Saligman), 116–119, *117, 118*, 121–126
Community conflicts, 87–90
Community Leaders (Jones), *148*
Community murals, 8–9
Community outreach program, of Philadelphia Museum of Art, 7, 25
Community pride, 7
Compassion (Malik), 46–47, *47*
Computer digitization, 127
COOL JANE (graffiti tag), 41
Cornbread (graffiti artist), 35
Corporate funding, 9, 14, 86
Crystal Snowscape (Guinn), 84, *85*
Cubism, 84, 94
Curtis Building, 22

D

Daly, Dennis, 70
Davis, Gene, 25
Day in the Life of West Philadelphia, A (Mason), *28–29*
Death on a Pale Horse (West), 22, *22*
DeCarlo, Patricia, 75
Dedications, 16
Department of Recreation, and Mural Arts Program, 80–93
Desiderio, Vincent, 82, *82*, 100
DiBella, Joe, 100, 101, 105
DiBerardinis, Michael, 52, 57, 80, 86, 89, 90–93

Dixon, Andrew, 149
Dixon, Donita, 149
Dondi (graffiti artist), 27
Donovan, Sam, *92*
Dotson, Florie, *140*
Dr. J (Twitchell), *78–79, 81*, 82
Dream Garden, The (Parrish), 22, *23*
Dream in Flight (Sarantitis), *60*
Drescher, Timothy W., 9
Drug Enforcement Agency, 94
Drugs, 94

E

Edmonds, Walter, 87, *87*
Education: A Key to the Future (Stancell), 94
Eight Signs of Fortune (Eubanks), 150
El Batey, 74
Environmental Art Programs, of Urban Outreach Program of Philadelphia Museum of Art, 25
Erving, Julius (Dr. J), *78–79, 81, 82*, 90
Eubanks, Cliff, Jr., 61, *138*, 150–151
EUL I (Experience UnLimited I) (graffiti artists), 26
Evans, Dwight, 119

F

Fabian, 93
Fairmount Park, 67
Farrakhan, Louis, 52
Father Paul Washington (Edmonds), 87, *87*
Feininger, Lyonel, 84
Finnegan Playground, 51, 52
Finnegan's Recreation Center, *51*
Flores, Alejandro, *71*, 72–73
Florie Dotson (Yoder), *140*
Ford, Gerald, 94
Forest Green (Malik), 46
Foundations, 14, 86
Francisville, 69
Frank Rizzo (Keller), 93, *99*, 99–101
Frank Sinatra (Keller), 87, 105–108, *107*
Franklin, Oliver, 34
Franklin's Footpath (Davis), 25
Frederick's (restaurant), 106
Freeman, William, 24, 46
Funding, 9, 14, 43, 86
Futura 2000 (graffiti artist), 27

G

Gangs, 26
Garden of Flowers (Uribe), 76
Gardens, *67,* 67–75, 135
Gateway (Saligman), 120–121, *121*
German Expressionism, 84, 128
Gishell, Barbara, 70
Giunta, Pietro, 101
GlaxoSmithKline, 86
Golden, Jane, *15,* 30–45, *39, 52, 53*
 and Bagby, Rachel, 133, 149
 and Big Picture program, 143–145
 Black American Gothic, 23
 Black Family Reunion, 24
 and *Common Threads,* 123
 and domestic violence mural, *130–131*
 illness of, 31
 introduction by, 10–11
 and Logan, Lloyd, 149
 Mt. Kilimanjaro, 69
 and Mural Arts Program, 80–93
 and Norris Square, 69–75
 Ocean Park Pier, 30
 and Peace Wall, 50–61
 and Philadelphia Anti-Graffiti Network,
 6, 8, 9, 20
 in South Philadelphia, 100
 Wall of Neighborhood Heroes,
 70–71, 93
Gonzalez, Salvador, *64–65,* 74
Goode, Wilson (Mayor), 20, 26, 27–30,
 34, 36, 93, 100
Goodman, Sidney, *18–19,* 40–41, 82
Government commissioned murals, 20
Graffiti, 26–30
Grays Ferry, 50–61
Grays Ferry United, 52, 54
Great Depression, 22, 30
"Greene Countrie Towne," 66, 68, 135
Gridding, 16, *16,* 112, 145
Griffin, William "Whip," 58–59
Groman, Mike, 67, 69
Guardian Angels (Slowick & Okdeh),
 56, 59
Guinn, David, 84–85, *108*

H

Hall, Rosa V., 138, 139
Haring, Keith, *90,* 93, 100
Harris, Theodore A., 26, *39,* 39–41, 43
Haverford Recreation Center, 26
Heath Brothers, 24, *26,* 104

Helman, Jim, 52, *56,* 59, 61
Heriza, Anthony, 50
Herman Wrice (McShane), *44*
HERO (Helping Energize and Rebuild
 Ourselves), 76
Hicks, Edward, 83
High Class Lunatics (graffiti artists), 37
History of Gray's Ferry, The (Sarantitis),
 59, 61
History of Immigration, The, 83, *86*
*History of Industry and Canals in
 Manayunk, The* (Ingersoll), 32
History of Puerto Rico, The, 70, *70*
History paintings, 22, 23, 24
Homelessness, 136
Hope Park Garden, 76
Horizon line, 126

I

Immigration and the Dignity of Labor
 (McShane), 53
Independence Foundation, 86, 136
Ingersoll, Tish (Patricia B.), 23, *24,*
 32–33, 93
Inside Out (McEneaney), 112, *113*
Iron Plantation Near Southwark, 1800
 (Larter), 22
Italian Americans, 98–101, 109–111
Italian Market, 100

J

Jackie Robinson (McShane), 24, 128, *129*
Jacovini's Funeral Home, 104
Jardel Recreation Center, 89
Jones, Cavin, 53, *133,* 144–146, *148,* 149
Jones, Euhri, *31*
Jones, LeRoi, 40
Jones, Roxanne, 24
Jones, Tameka, 118, 121–126, *122*
Jones Tabernacle AME Church, 132
Journey's, 114–115

K

Kaiser, Don, 25, 26
Katzive, David, 25
Keller, Diane, 24, 87, 93, 98, 99–104,
 102–103, 105–108, 110
Kid's Peace Wall, 51
Klee, Paul, 84
KNIFE (graffiti artist), 26, *39,* 39–41
KPMG, 86

L

LaBelle, Patti, 90, 93
Lady Pink (graffiti artist), 27
Landscape murals, 22, 24, 80–81
Lanza, Mario, 24, 90, 98, 101–104,
 102–103
Larter, Robert E., 22
Las Parcelas, 71
Ledge Wall, The, 82–83, *83*
Lewis, John, 24
Lighthouse Christian Church, 50
Lind, Samuel, 75
Liu, Qimin, 136–137
Lloyd, Gail, 94
Logan, Lloyd, 132–133, 138–142, *148*
Logan, Marcel, 139, 142, 143, *143,* 144
Logan, Rosa, 132, 138, 139
Logan Square, 89
LOS (graffiti artist), 37
Louden, Reverend Ellis, 132
Lyons, Andrea, 89

M

Makler Gallery, 27
Malik, Ras, 46–47, *144*
Manayunk Views (Ingersoll), 32–33, *33*
Mantua (section of West Philadelphia),
 10, 34
MAP. *See* Mural Arts Program
Mario Lanza (Keller), 24, 101–104,
 102–103
Mario Lanza Institute, 104
Mario Lanza Museum, 101–104, *104*
Market-Frankford El, 68
Mason, Max, *28–29*
Mayor's Office of Community Services
 (MOCS), 80
McEneaney, Sarah, 112–113, *134*
McShane, David, *16,* 24, *26, 44,* 53,
 104, 128–129, *141*
MEKA (graffiti artist), 26
Mill Creek, 87
MOCS. *See* Mayor's Office of Community
 Services
Morning Landscape (Eubanks), 61
Mosaics, 22, 62, *64–65*
Mt. Kilimanjaro (Golden), 69
Mural Arts Program (MAP), 6–7, 8
 Big Picture program of, 58, 61, 93,
 142–145
 Department of Recreation and, 80–93

Murals
history of, 20–21
oversaturation of, 90–93
personal impact of, 11
personal reflection on, 10–11
process of making, 14–16, *14–17*
purposes of, 20
symbolic level of, 11, 21
themes of, 22–24
My House, Summer '98 (McEneaney), 112

N

Needle Park, 68
Nichols, Mamie, *26,* 104
Nonwoven media, 127
Norris Square, 23, 46, 66–75
Norris Square Park, 68
NOT (Number One Terrorist) (graffiti
artist), 35, 37–39
Nutter, Michael, 90

O

Ocean Park Pier (Golden), 30
Okdeh, Eric, 59, 82, 93
"Operation Eyesore: Changing Our
Community One Day at a Time," 149
Outreach programs, 7, 9, 25–26, 31, 34

P

Pagast, Peter, 24, *35,* 57
PAGN. *See* Philadelphia Anti-Graffiti
Network
Papola, Mary Galanti, 104, *104*
Parachute cloth. *See* Cloth murals
Parks, 66–67
Parrish, Maxfield, 22, *23*
Passion Flower (Santoleri), 62–63
Pathology of Devotion, The (Desiderio),
82, *82,* 93, 100
Patti LaBelle (Byrd), 93
Paul Robeson (Pagast), 24, *35*
Peace Wall, The, 48–49, 50–61, *52*
Peaceable Kingdom, The (Hicks), 83
Penn, William, 23, 66
Pennsylvania Horticultural Society (PHS),
67, 68, 69, 75, 135
People of Point Breeze (McShane), 24,
26, 104
Pew Charitable Trusts, The, 68
Pew Fellowships in the Arts, 112
PEZ (graffiti artist), 35, 37–39, *39, 81*

Philadelphia (movie), 83
Philadelphia Anti-Graffiti Network
(PAGN), 6, 8, 20, 26, 30, 34–45, 80
Philadelphia Community Rehabilitation
Corporation, 134–135
Philadelphia Daily News, 105
Philadelphia Green, 67, 69, 75, 135
Philadelphia Horticultural Society, 76
Philadelphia Muses (Saligman),
124–125, 127
Philadelphia Museum of Art, community
outreach program of, 7, 25
Philadelphia on a Half-Tank (Santoleri),
62, *63*
Phillips, Adam, 123–126
Phillips, Doris, 76
Photorealism, 57
PHS. *See* Pennsylvania Horticultural
Society
Picasso, Pablo, 94
"Pledge, The," 27
Point Breeze, 68, 69
Political statements, murals as, 42–43
Politics, 126
Portable murals, 127
Portrait of an Anonymous Boy
(McShane), *141*
Portraits, 23–24, 42–43, 90–93, 98, 100
Preservation of murals, 21
Preston, Larissa, 16
Priming, 15
*Procession of St. Mary Magdalen de
Pazzi* (Keller), 110–111, *111*
Projection method, 16, *56,* 123, 127
Public Art in Philadelphia (Bach), 22
Puerto Ricans, 23, 46, 66–75

Q

Quakers, 53

R

Rachel Bagby Shared House, 135
Racial tension, 89–90
Racism, 36, 50–61
Raices (Roots), 23, 70, *70*
Raphael, 119
Ray, Lillian, 50, 53, 54, 61
Reach for the Stars (Saligman), 119–120
Reach High and You Will Go Far
(Sarantitis), *88,* 89

Recuerdos de Nuestra Tierra Encantada
(Memories of our Enchanted Land)
(Malik), 46
Reeves, Charles, 54, *56,* 58, 61
Rendell, Ed (Mayor), 44, 52, 80
Restoration, 93
Ridge, Tom, 101
Rittenhouse Square, 67
Rivera, Diego, 30, *38,* 128
Rizzo, Frank, 93, 98, *99,* 99–101
Robeson, Paul, 24, *35*
Robinson, Jackie, 24, 128, *129*
Rodriguez, Atiya, *130–131*
Romero, Tomasita, 68, *68, 73*
Roxanne Jones (Freeman & Pagast), 24

S

Saligman, Meg, 72, 116–127
Sanchez, Sonia, 40
Santoleri, Paul, 62–63, 126, *147*
Sarantitis, Josh, *21,* 22, *54–55, 59, 60,*
61, *88,* 89, *91*
Scaffolding, 15, 119, *119,* 150
Schiele, Egon, 128
School of Athens, The (Raphael), 119
Secret Book (Sarantitis), *91*
Sheffield, Dianna, 149
Shreveport, Louisiana, 127
Sinatra, Frank, 87, 90, 98, 105–108, *107*
Slowik, Jason, 59, 82, 126, *130–131*
Smith, Will, 93
Smolen, Barbara, 84, *130–131*
Social and Public Art Resource Center
of Los Angeles, 8
Somers Point, New Jersey, 34
Song of the Kites (Liu), 136, *137*
South Philadelphia, 98–111
Southwark Post Office, 22
Spencer, Tim, 26, 34, 36, 43, 44–45, 69
Spicer, Kevin, 51, 53, 58, 59–61
Spina, Anthony, 108–111
Spina, Carol, 108–111
Spray paint, 40
Spring Garden Street Bridge, 34, *39*
Stancell, Parris Craig, 42–43, 84, 87, 93,
94–95
Steppers (Jones), *133*
Stevens Administrative Building,
122–123
Stop the Violence (Stancell), 42–43, 94
Strawberry Mansion, 23, 69

Studio Winter '98-'99 (McEneaney), 112
Summer Garden (McEneaney), *134*
Sunflowers: A Tribute to Aimee Willard
 (Uribe), 76, *77*

T

Tagging. *See* Graffiti
Taller Puertorriqueno (Stancell), *89,* 93
Three Graces, The (Stancell), 94
Through Cracks in the Pavement
 (Santoleri), *147*
Tiburino, Ellen, 94
Tiburino, Joe, 94
Tiffany, Louis Comfort, 22
TRAN (graffiti artist), 36
Transfer methods, 16
Tribute to Diego Rivera, A (Adonis), 41
Tropical Landscape with Waterfall
 (Uribe), *72–73,* 76
Tuscan Landscape (Ingersoll), 23, *24,*
 32, 93
Twitchell, Kent, 30–31, *78–79,* 81–83,
 127
Tyler School of Art, 59

U

Underground Railroad, The (Jones), 53
Underground Railroad (Donovan), *92*
Urban Outreach Program, of
 Philadelphia Museum of Art, 25
Uribe, Ana, *15, 72–73,* 76–77, 81

V

Vandalism, 89, 101
Vare Recreation Center, 52, 57, 58
Vidi, Frederick, 106–107, 110
Village of Arts and Humanities, 94
Violence, 42–43, *130–131,* 132
Viso, Agnes, 100–101, 106, 109
Viveros, Cesar, 126

W

W. Wilson Goode (Bartlett), 100
Walker, Phyllis, 46
Wall of Neighborhood Heroes (Golden),
 68, 70–71, 93
Wall writers. *See* Graffiti
Washington, Father Paul, 87, *87*
Washington Square, 67
Waterfalls, 80–81, *81*

We the Youth: City Kids of Philadelphia
 and NYC (Haring), 93, 100
Weather conditions, 32, 146, 150
Webb, Michael, 23, *25*
Welcome to Mummer Land, 96–97
West, Benjamin, 21, 22, *22*
West Haggard, 68
Whitman, Walt, 40
Whitney, McGarrett, 144–146, 149
Wicket style of tagging, 26
Willard, Aimee, 76
Willard, Gayle, 76
William Penn Foundation, 53, 86
Williams, Annette, 52
Williams, Jewell, 139, 144–145, 149
Wilt Chamberlain (Lewis), 24
Wings of Hope (Flores), *71,* 73
Wood, Clarence, 25, 26
Works Project Administration, 30
Wrice, Herman, *44*

Y

Yankell, Stuart, 87, *87*
Yeh, Lily, 94
Yoder, Karl, *140*
Youth programs, 9, 31, 34

Authors
Jane Golden
Robin Rice
Monica Yant Kinney

Photographers
David Graham
Jack Ramsdale

Editorial Coordinator
Deidra A. Lyngard

MAP Photograph Archives Manager
Tish Ingersoll

Mural Map Researcher
Russell Meddin

Designer and Compositor
Jeff McKay with Phillip Unetic / 3r1 Group

Manuscript Editor and Project Manager
Jeannine Klobe

Production Director
Charles H. E. Ault

Acquiring Editor
Micah Kleit

The text of this book was set in Centaur and display headings were set in Clarendon, Franklin Gothic, Trade Gothic, and Trajan. Color separations were made by Mondadori Printing (Verona, Italy). The book was first printed in an edition of 3,000 copies on Creator Silk paper. It was printed and bound by Artes Gráficas (Toledo, Spain).